# HOLBEIN

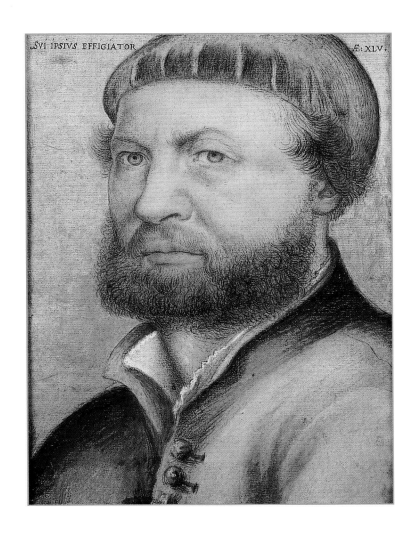

# *THE YOUNGER*

## Museums and other institutions mentioned in this book

Art Museum, Saint Louis, Missouri — Public Collection, Department of Engravings, Art Museum, Basel

Royal Collection, Windsor Castle — Louvre, Paris — Thyssen-Bornemisza Collection, Madrid

Museum of Historic Art, Vienna — National Gallery, London — National Gallery of Art, Washington DC

Metropolitan Museum of Art, New York — Uffizi Gallery, Florence — Pinacoteca Brera, Milan

Lord St. Oswald Collection, Nostell Priory — Hampton Court Palace — Galleria Nazionale, Rome

Church of All Saints, Florence — Staatliche Museen, Gemäldegalerie, Berlin — Wallace Collection, London

Rijksmuseum, Amsterdam — Museum of Historic Art, Lisbon — Alte Pinakothek, Munich

Art Museum, Philadelphia — National Gallery of Scotland, Edinburg — Museum of Fine Art, Strasbourg

Württembergische Landesbibliothek, Stuttgart — Staatliche Museen, Preußiger Kulturbesitz, Berlin

Cleveland Museum of Art, Ohio — Darmstadt Castle — Germanisches Nationalmuseum, Nuremberg

Frick Collection, New York — British Museum, London — Bibliothèque nationale, Paris — Drumlanrig Castle

University Library, Basel — Pinacoteca Vaticana, Rome — Vatican Museum, Rome — Art Museum, Toledo, Ohio

Photographic credits: unless otherwise specified, copyright on the works reproduced lies with the respective photographers. Despite intensive research, it has not always been possible to establish copyright ownership. Where this is the case, we would appreciate notification.

*Publishing Editor:* Jean-Paul Manzo

*Publishing Associate:* Cornelia Sontag

*Editor:* Barbara Vignaux

*Text:* Jeanette Zwingenberger

*Editorial Assistant:* Christina Müller

*Layout:* Kenny Géran

*Typesetting:* Karin Erskine

© Parkstone Press, London
Printed in Europe 1999

ISBN: 1 85995 492 8

# THE SHADOW OF DEATH

## IN THE WORK OF

# HANS HOLBEIN
# THE YOUNGER

JEANETTE
ZWINGENBERGER

PARKSTONE PRESS

# Contents

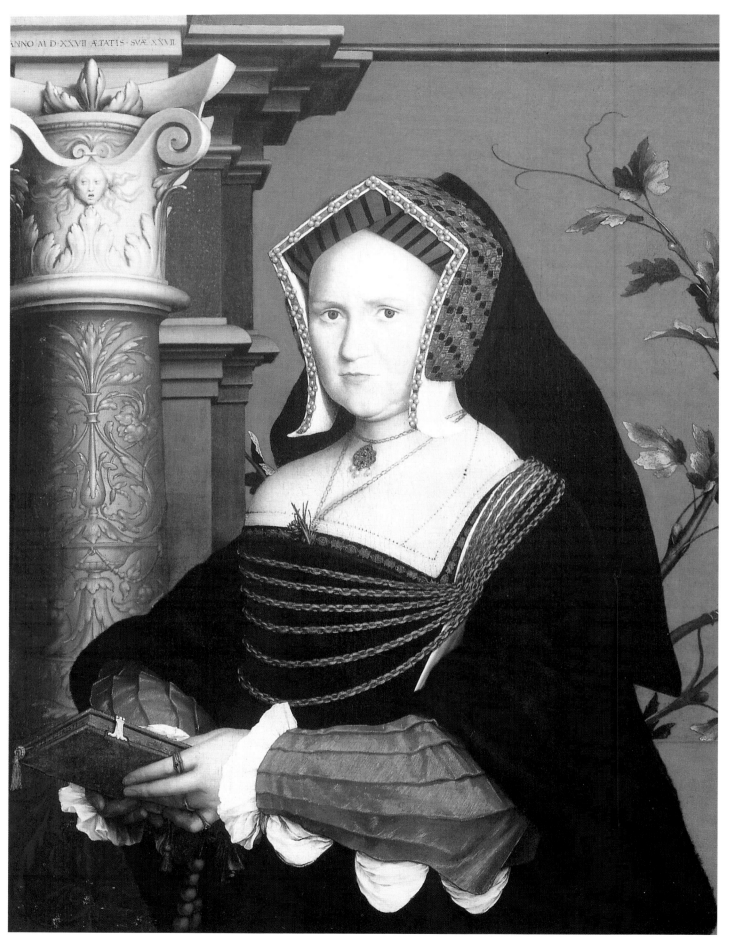

Hans Holbein the Younger
*Portrait of Mary Wotton. Lady Guildford*, 1527
Oil on wood, 80 x 65 cm
Art Museum, Saint Louis, Missouri

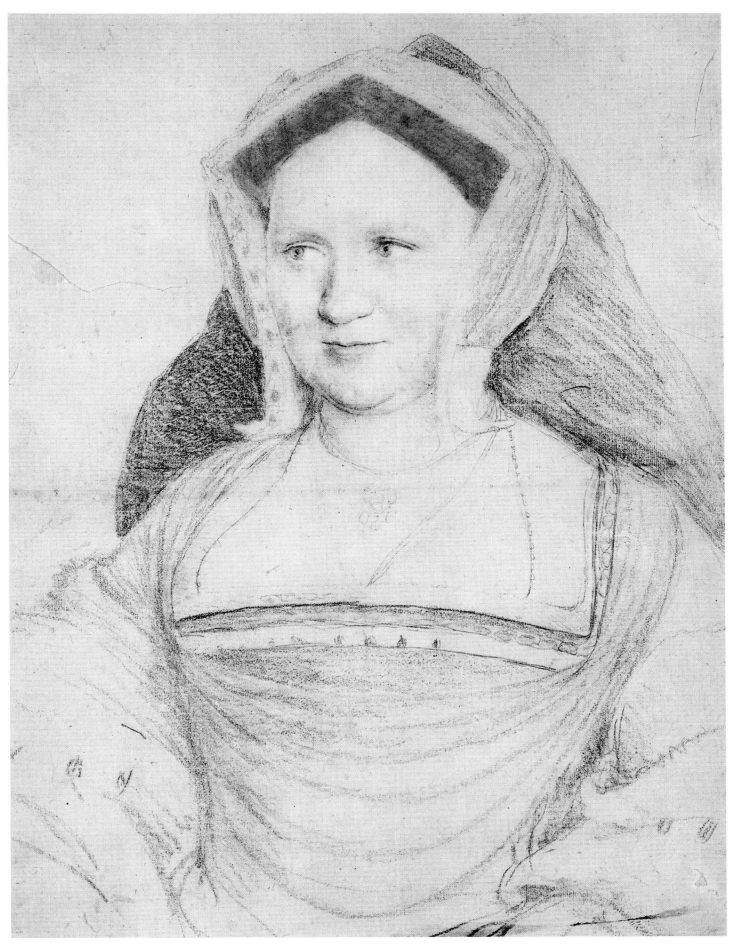

Hans Holbein the Younger
*Portrait of Mary Wotton. Lady Guildford*, 1527
Black and coloured chalks, 55,2 x 38,5 cm
Public collection, Department of Engravings,
Art Museum, Basel

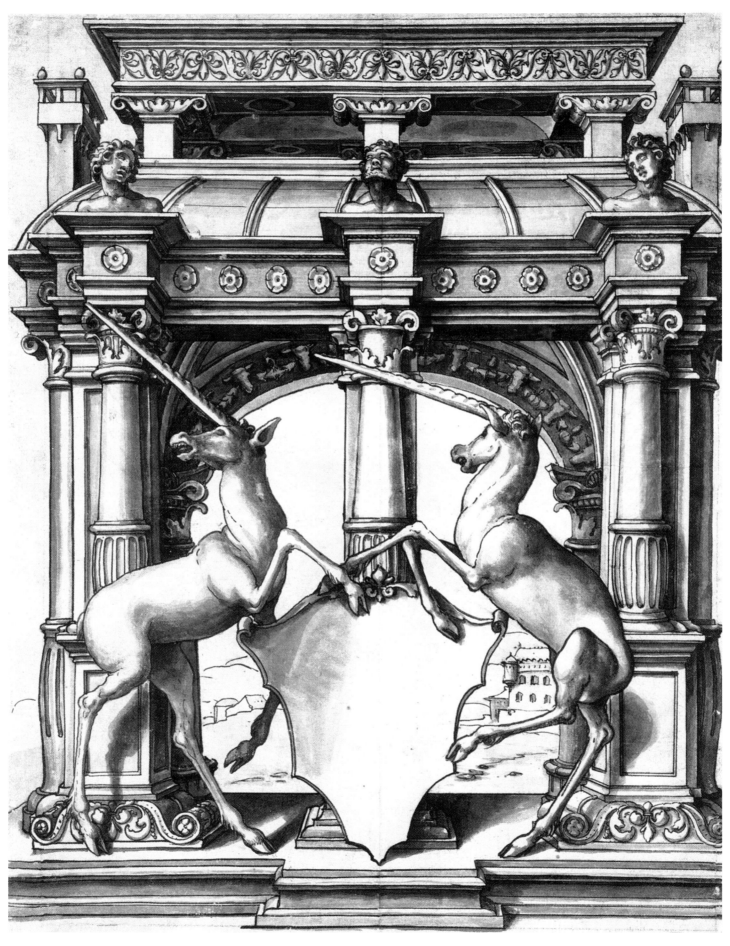

Hans Holbein the Younger
*Design for Stained Glass with Two Unicorns.* c. 1522/23
Pen and wash aquarelled, 41,9 x 31,5 cm
Public collection, Department of Engravings, Art Museum, Basel

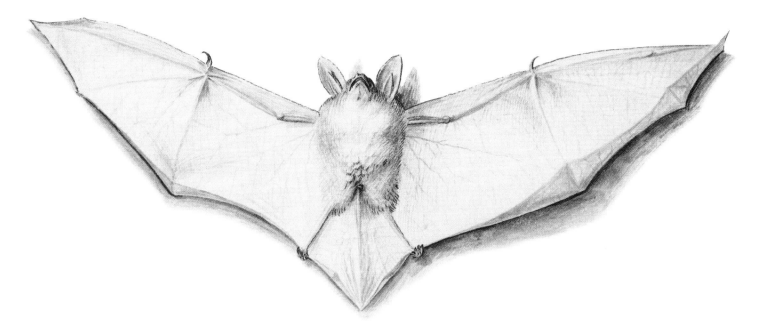

# INTRODUCTION

**H**ans Holbein the Younger is one of the greatest portrait painters of the 16th century. A keen observer of his era, Holbein painted not only his contemporaries in Basel and various German merchants, but also the most distinguished humanists of his day: Sir Thomas More, Erasmus, the astronomer Nicolas Kratzer, Archbishop William Warham, as well as the international nobility; subsequently he became the court painter of Henry VIII and his sundry wives. The breadth of his activities allows one to describe him as a genuine European artist.

What is striking about Holbein's true-to-life pictures is their miniature-like precision and the concomitant monumentality of their proportions. Holbein's wide range of pursuits included not only painting, drawing, book illustration and designing stained-glass windows, jewellery and luxury objects, but also fanciful *trompe l'oeil* murals and architecture.

But Holbein undermines the apparently objective representation of reality in his pictures with minute details, while intermingling various temporal dimensions and availing himself of diverse media, including images and text. As a result, an ambiguity of form and content characterizes his works, which might be termed "pictorial documents" of prevailing 16th-century ideas and of the innumerable notables he portrays.

Our methodological point of departure will be Holbein's picture of *The Ambassadors*, which will serve as a key to the artist's world. The anamorphosis in this picture will be taken as the crux of an interpretation involving the deliberate play on the coding and decoding of the image. The two different ways of looking

Hans Holbein the Younger
*Bat*
Black and coloured chalks, 16,8 x 28,1 cm
Art Museum, Basel

at the anamorphosis, i.e. in distorted or corrected form, are not just perceptual phenomena, but integral parts of a new conception of visual art. This conception is marked by dissociation from the level of mere illustration and by profound reflection on the artist's subjects. The world of the picture becomes a play on words and forms which, once decoded and articulated, yields a moral message which, however, cannot be taken as the only significance of the work.

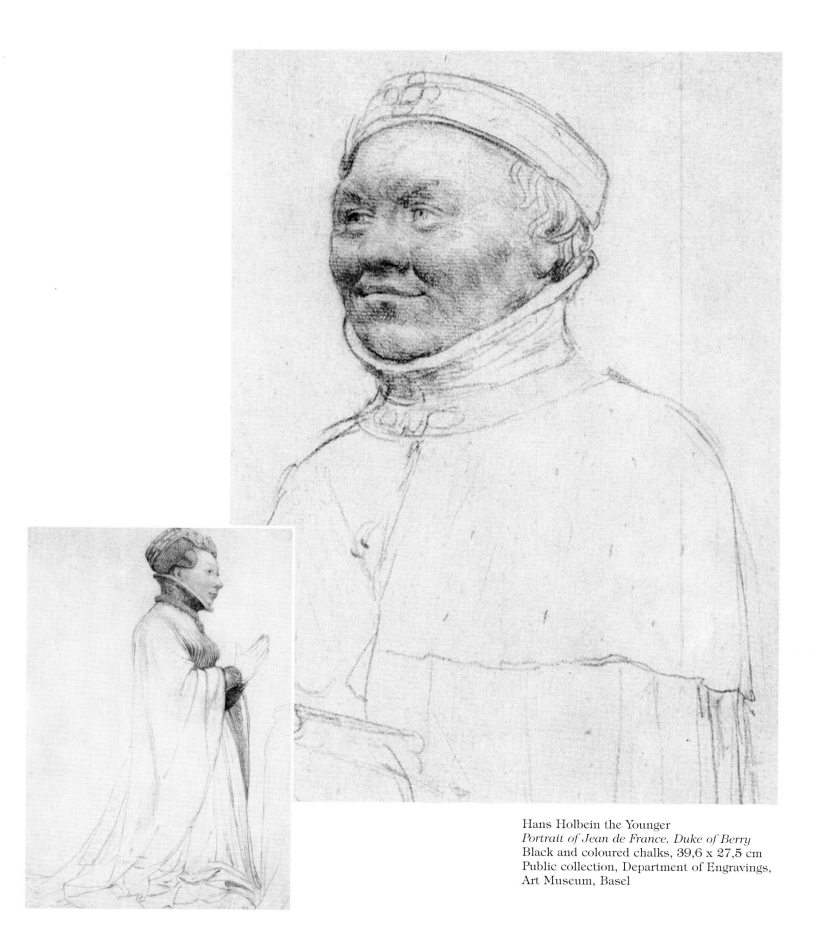

Hans Holbein the Younger
*Portrait of Jean de France. Duke of Berry*
Black and coloured chalks, 39,6 x 27,5 cm
Public collection, Department of Engravings,
Art Museum, Basel

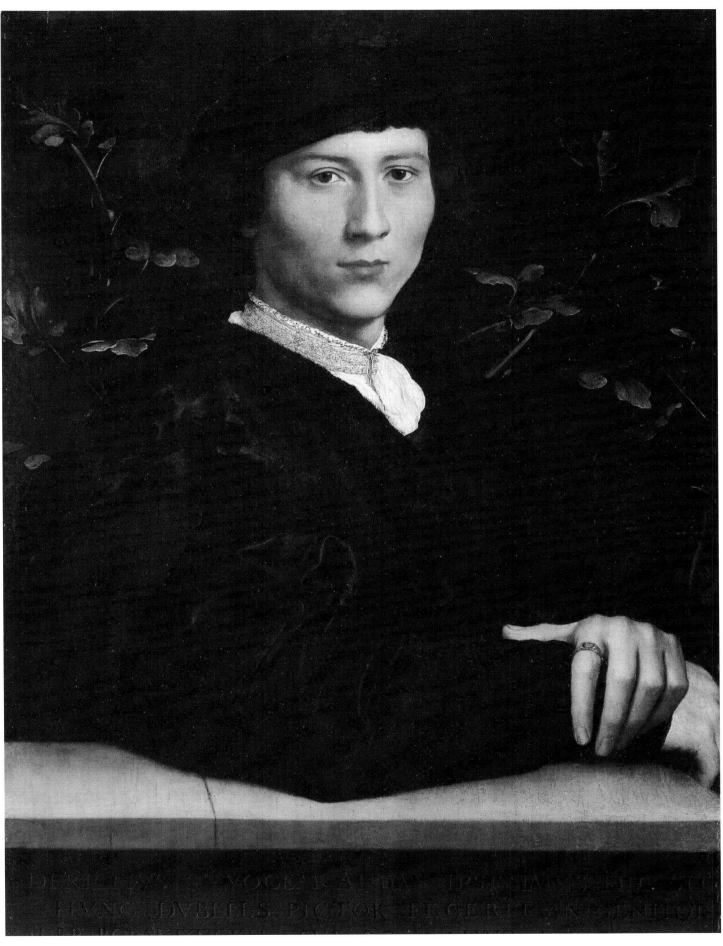

Opposite page, below:
Hans Holbein the Younger
*Portrait of Jeanne de Bologne. Duchess of Berry*
Black and coloured chalks, 39,6 x 27,5 cm
Public collection, Department of Engravings,
Art Museum, Basel

Hans Holbein the Younger
*Portrait of Derich Born*, 1533
Wood, 60,3 x 45,1 cm
Royal collection, Windsor Castle

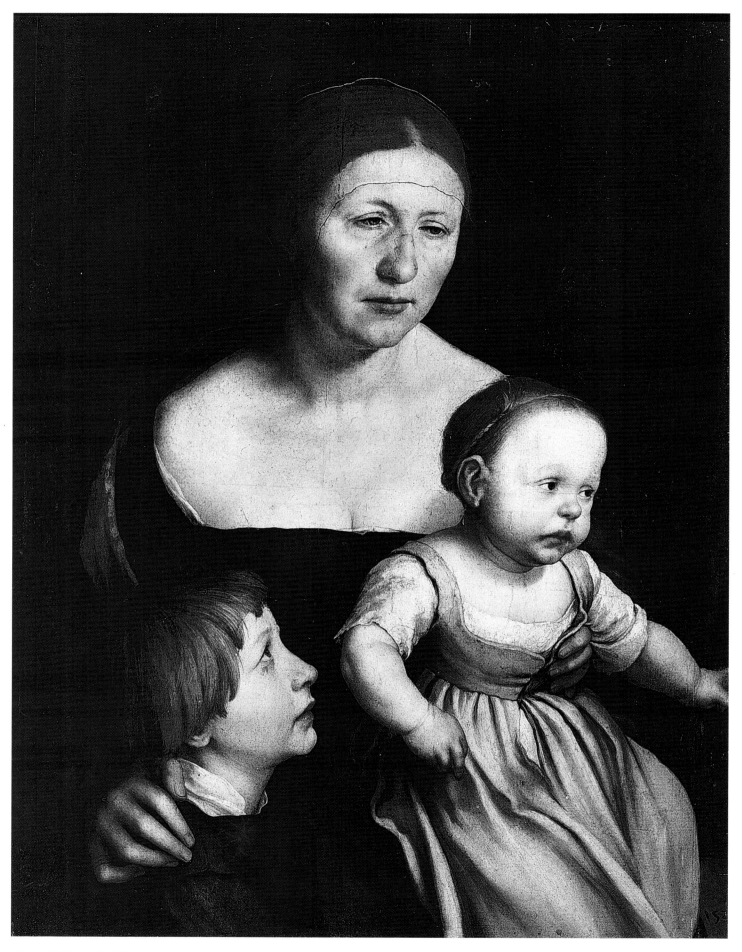

Hans Holbein the Younger
*Portrait of the Artist's Wife
and Two Sons*, 1528, 77 x 64 cm
Public collection, Art Museum, Basel

Hans Holbein the Younger
*The Greek Philosophers Aristotle.*
*Plato, Socrates and Pythagoras*
*Beside King Solomon.* 1523
Metal cut, Public collection,
Department of Engravings,
Art Museum, Basel

## Holbein's life

Hans Holbein the Younger was born in Augsburg in 1497/98. Hans and his older brother Ambrosius (c.1493/94–c.1519) first studied with their father, the renowned Southern German painter Hans Holbein the Elder (c.1465–1524). In 1515 the Holbein brothers were both working in the studio of Hans Herbst in Basel, Switzerland. That was the year in which the two of them executed the marginal drawings for a manuscript by Erasmus entitled *The Praise of Folie*. In 1517/18 they collaborated with their father in Lucerne on a large-scale mural for the mayor Jacob von Hertenstein. The title of master painter was conferred on Holbein in 1519, at which point he joined the *zum Himmel* (to the sky) painters' guild. That same year he married the widowed Elisabeth Binzenstock, who was to bear him two sons.

Holbein became a citizen of Basel in 1520 and painted the mural decorations of the new council chamber as well as the facades of the house *Zum Tanz* in Basel during the 1520s. It was also at that time that he first made contact with local publishers: Johannes Froben, Adam Petri, Thomas Wolff, Andreas Cratander, Valentinus Curio and Johann Bebel. From 1523 to 1526 Holbein fashioned a famous cycle of woodcuts known as the *Dance of Death*, which, however, were first printed, by Melchior and Gaspar Trechsel in Lyon in 1538, under the title *Les Simulachres et Historiées faces de la mort, autant élégamment portraites, que artificiellement imaginées*. Also published in Lyon in that year were his so-called Icones, 92 woodcuts Holbein had designed between 1524 and 1526, while still in Basel, based on subjects drawn from the Old Testament.

In 1524 Holbein, who had probably already visited Italy, made his first trip to France (Bourges)—as evidenced by his drawings of the praying statues of Jean de Berry and Jeanne de Boulogne in Bourges. Two years later he journeyed via Antwerp to England, where he resided at the home of Sir Thomas More. On his return to Basel in 1528, Holbein was faced with a devastating situation: the iconoclasts had begun destroying pictures. Yet in 1529 he received another commission: to finish painting the Great Council Chamber of the town hall. In 1532 Holbein went back to London, where in 1536 he became the official court painter of Henry VIII, who was to send him on a number of journeys to the Continent in the years to come. In 1543, at the height of his career, Holbein died of the plague in London.

Erasmus of Rotterdam
*The Praise of Folie.* 1515
J. Froben, fol. Q3v, Marginal drawing, Pen
Public collection, Department of Engravings,
Art Museum, Basel

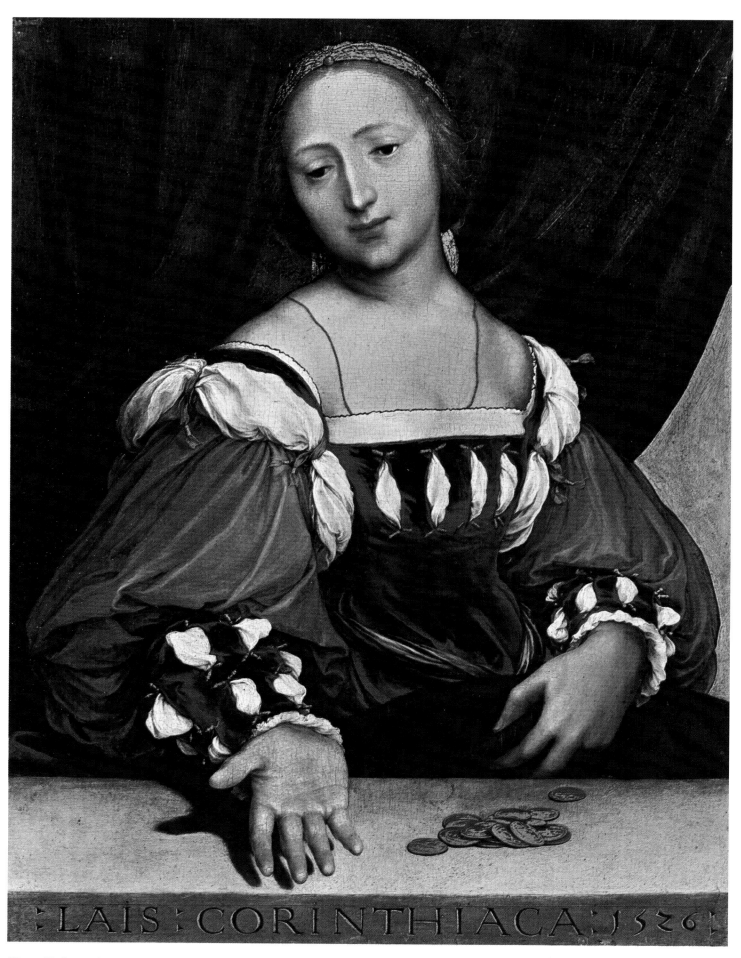

Hans Holbein the Younger
*Portrait of Laïs de Corinthe,* 1526
Oil on wood, 35,6 x 26,7 cm
Public collection, Art Museum, Basel

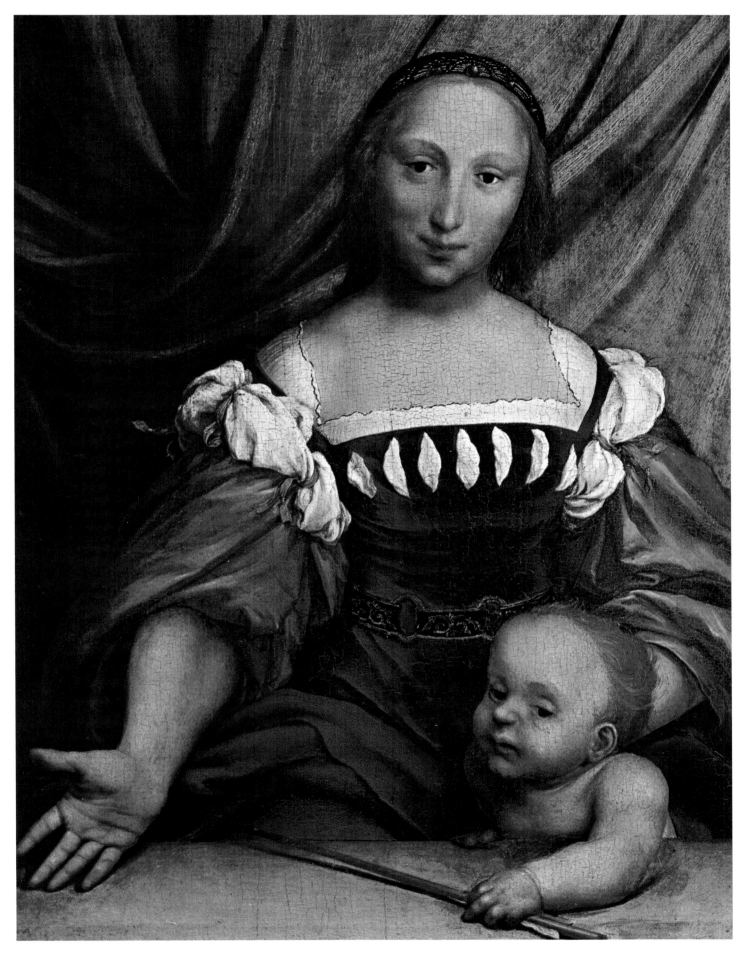

Hans Holbein the Younger
*Magdalena Offenburg as Venus*, 1526
Oil on wood, 34,5 x 26 cm
Public collection, Art Museum, Basel

Copy of Hans Holbein the Younger
Model of the house *Zum Tanz* (dance hall),  Reconstruction
Public collection, Department of Engravings, Art Museum, Basel

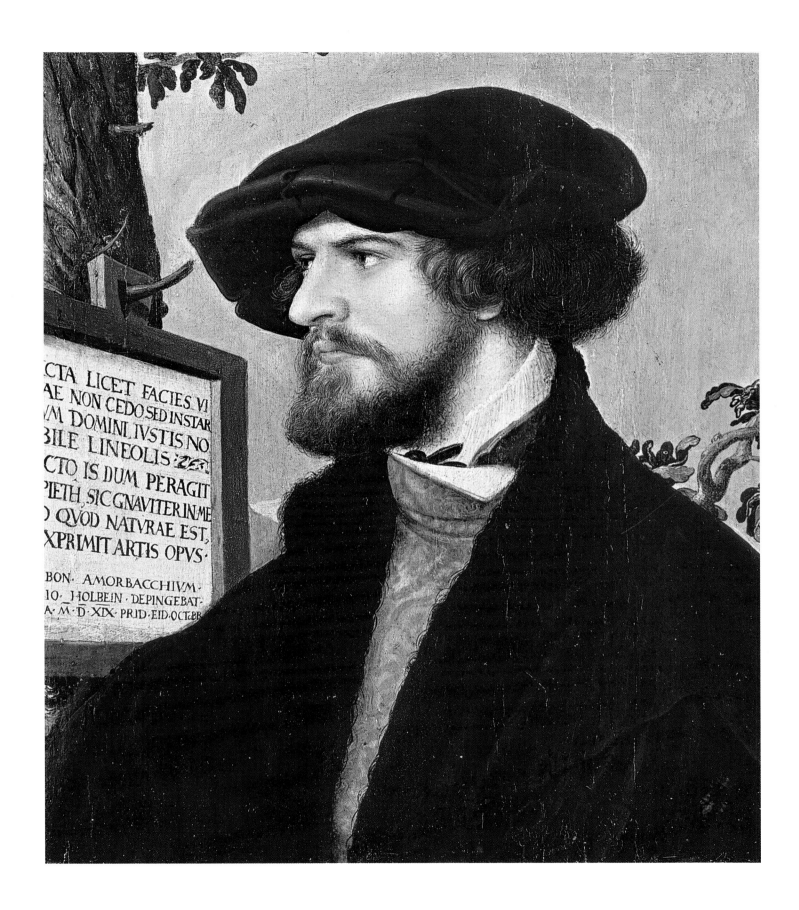

Hans Holbein the Younger
*Portrait of Bonifacius Amerbach*, 1519
Wood, 28,5 x 27,5 cm
Public collection, Department of Engravings,
Art Museum, Basel

Hans Holbein the Younger
*Solothurn Madonna.* 1522
Oil on wood, 140,5 x 102 cm
Art Museum, Solothurn

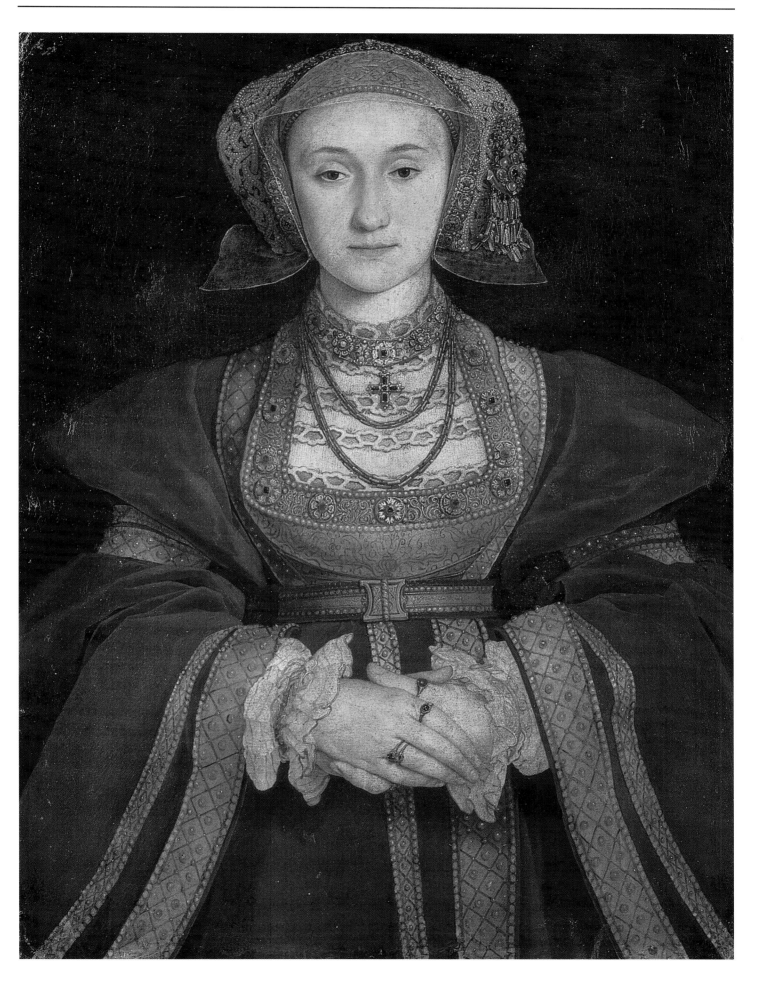

Hans Holbein the Younger
*Portrait of Anne of Cleves*, 1539
Wood, 65 x 48 cm
Louvre, Paris

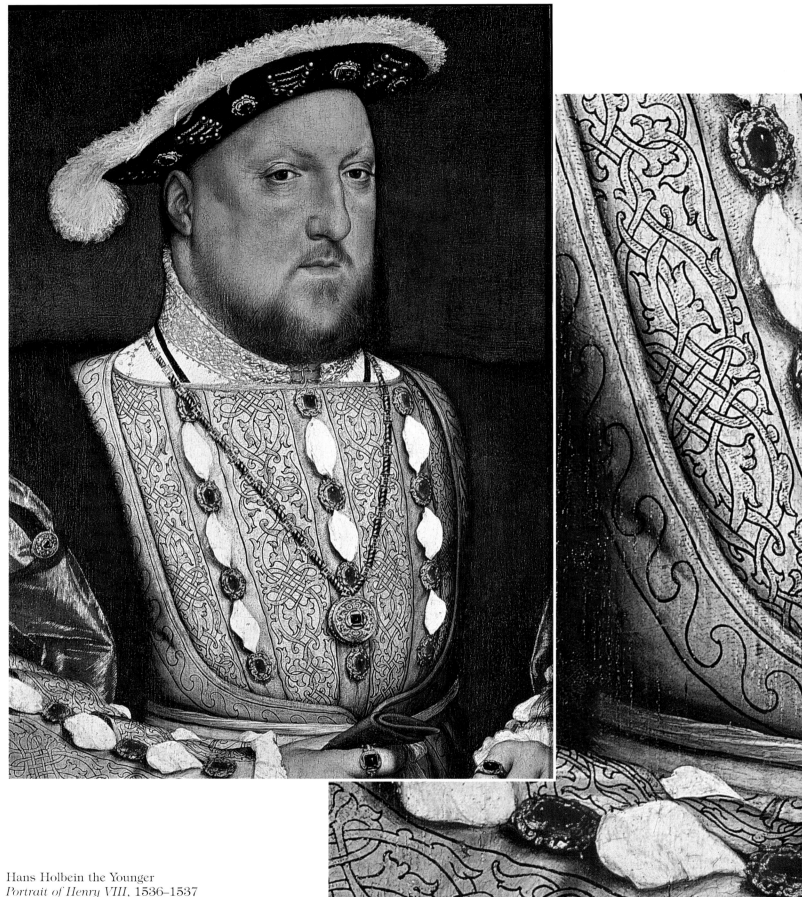

Hans Holbein the Younger
*Portrait of Henry VIII*, 1536–1537
Oak, 28 x 20 cm
Thyssen-Bornemisza Collection, Madrid

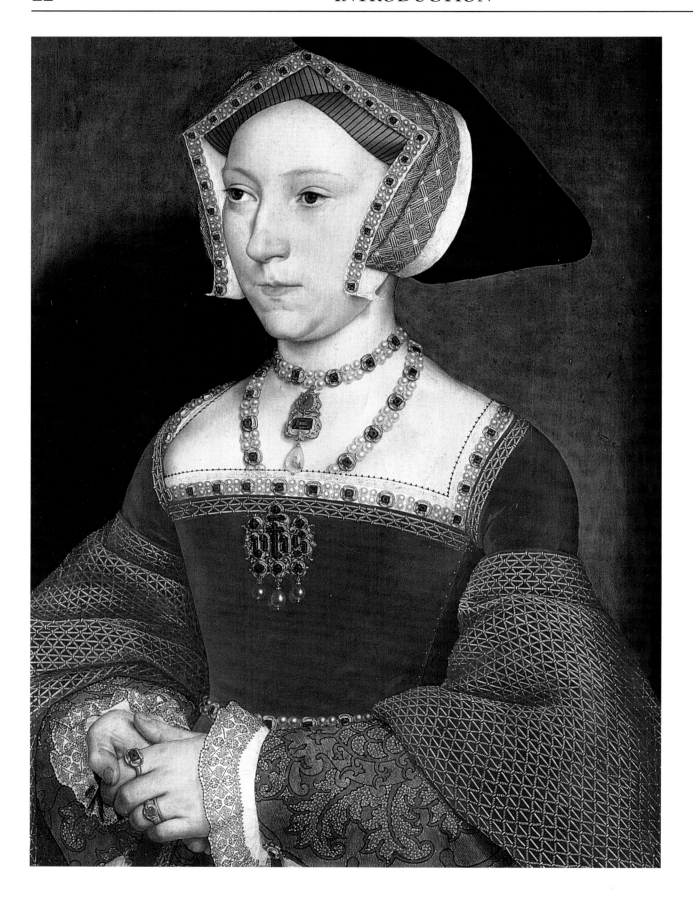

Hans Holbein the Younger
*Portrait of Jane Seymour,* 1536–1537
Oak, 26,3 x 18,7 cm
Museum of Historic Art, Painting Gallery, Vienna

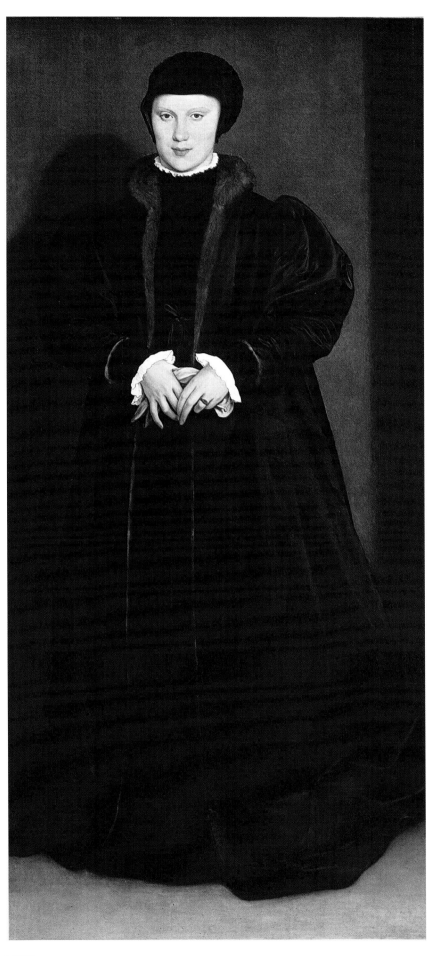

Hans Holbein the Younger
*Portrait of Christina of Denmark. Duchess of Milan.* 1538
Oil on wood, 179 x 82,5 cm
National Gallery, London

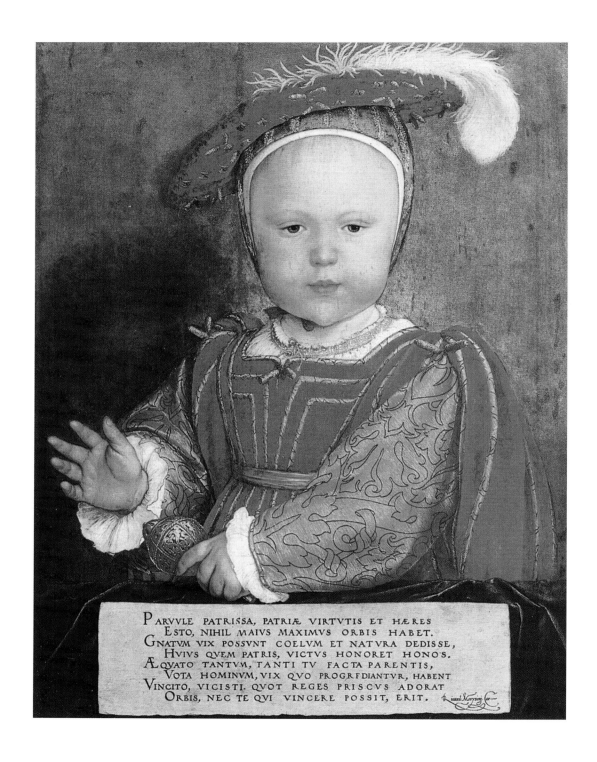

PARVVLE PATRISSA, PATRIÆ VIRTVTIS ET HÆRES
    ESTO, NIHIL MAIVS MAXIMVS ORBIS HABET.
GNATVM VIX POSSVNT COELVM ET NATVRA DEDISSE,
    HVIVS QVEM PATRIS, VICTVS HONORET HONOS.
ÆQVATO TANTVM, TANTI TV FACTA PARENTIS,
    VOTA HOMINVM, VIX QVO PROGREDIANTVR, HABENT
VINCITO, VICISTI. QVOT REGES PRISCVS ADORAT
    ORBIS, NEC TE QVI VINCERE POSSIT, ERIT.

Hans Holbein the Younger
*Portrait of Edward, Prince of Wales*, 1539
Oak, 57 x 44 cm
National Gallery of Art, Washington D.C.

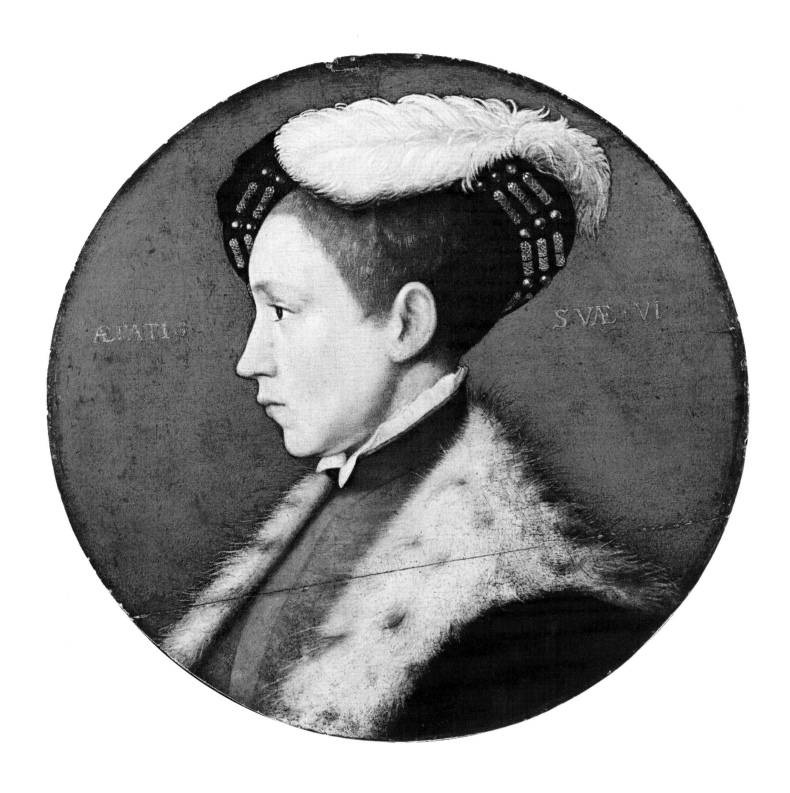

Hans Holbein the Younger
*Portrait of Edward, Prince of Wales,* 1543
Diam. 32.4 cm
Metropolitan Museum of Art, New York

Hans Holbein the Younger
*The Ambassadors*, 1533
Details (portraits of Jean de Dinteville
and Georges de Selve)

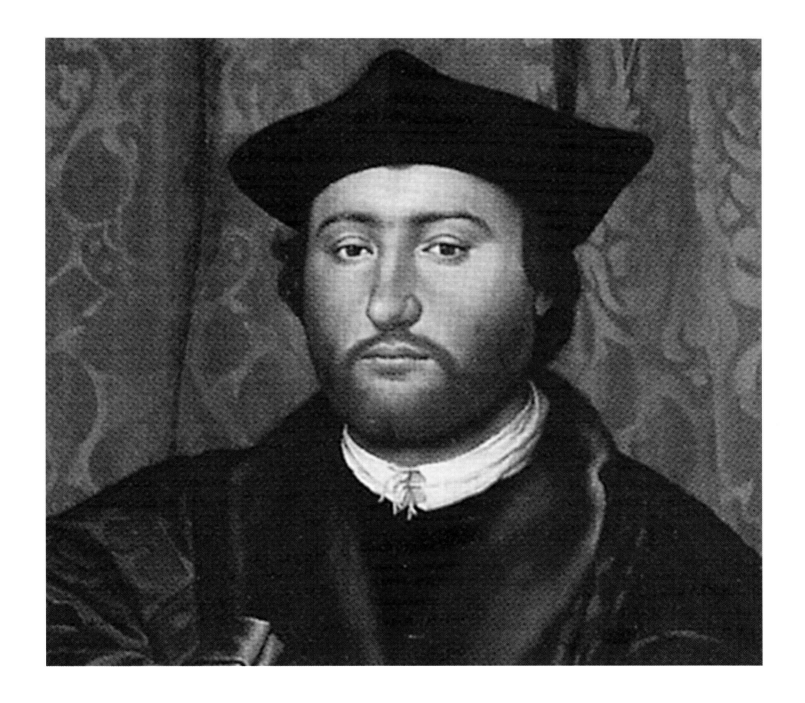

28

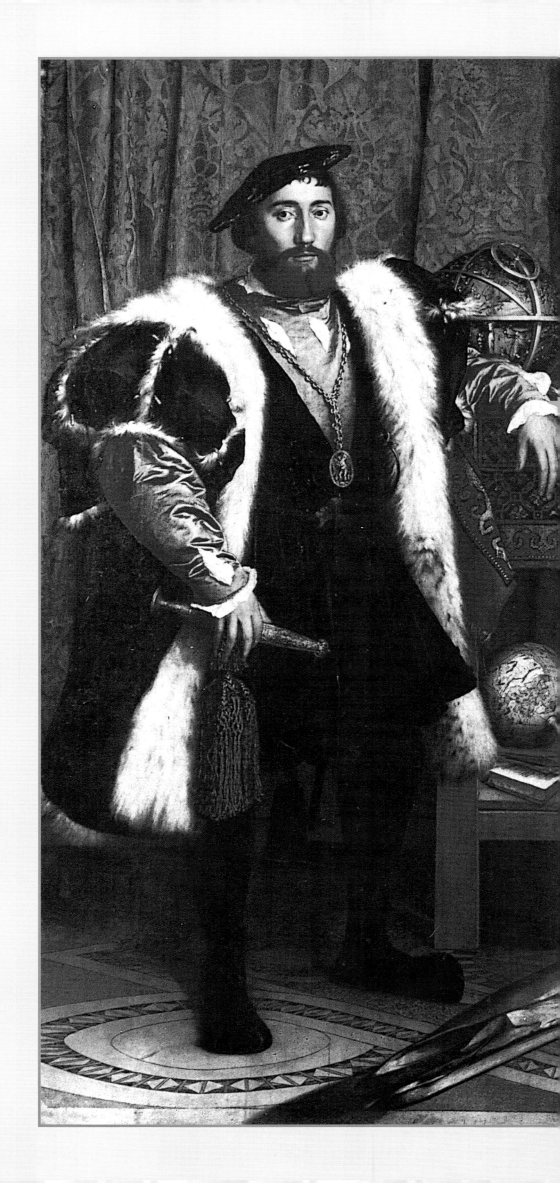

Hans Holbein the Younger
*The Ambassadors*, 1533
Oak, 207 x 209,5 cm
National Gallery, London

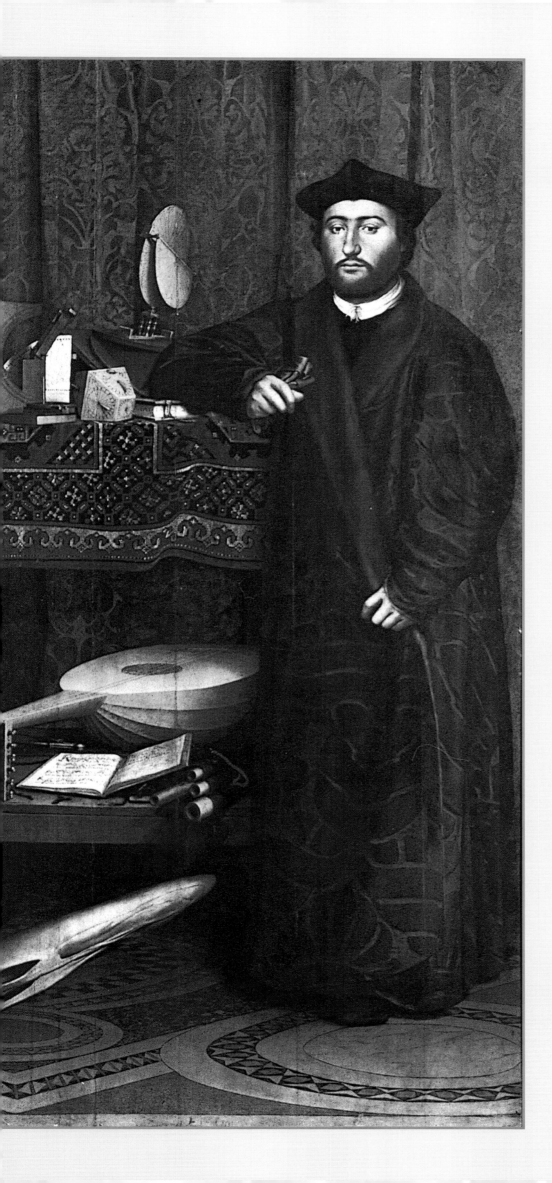

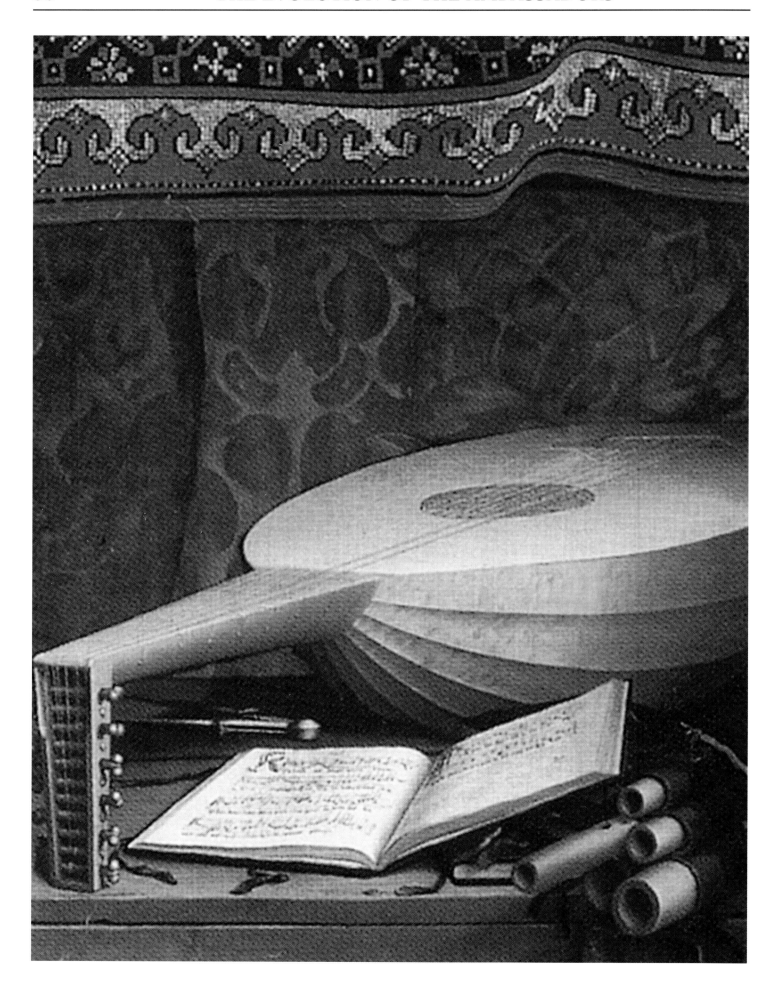

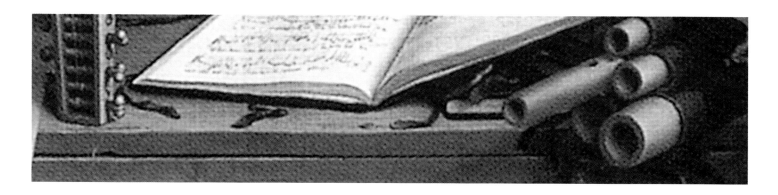

# THE EVOLUTION OF THE AMBASSADORS

J ean de Dinteville (1504–55), who commissioned the work, went to London in February 1533 as France's ambassador and stayed for nine months. In a letter dated 23 May to his brother François de Dinteville, the Bishop of Auxerre, Jean talks about an unofficial visit paid by his friend Georges de Selve (1509–42), the Bishop of Lavaur: "Monsignor de Lavaur did me the honour of paying me a visit, which delighted me. But it is not absolutely necessary for the Grand Master [Montmorency] to find out about that."[1]

Far from being kept secret, however, the meeting of the two friends in London was to be immortalized in one of the most celebrated portraits of all time.[2]

The year of the picture, moreover, coincides with a turning point in the history of England: the divorce of Henry VIII from his first wife, Catherine of Aragon, which gave rise to the schism between the Anglican Church and the Roman Catholic Church. Indeed, the Cosmati pavement in the picture is borrowed from the mosaic in the sanctuary of Westminster Abbey, which sets the double portrait in the context of the ensuing religious conflict, while the indication of the exact date renders the painted subjects witnesses to this critical moment in history.

*The Ambassadors*
Details

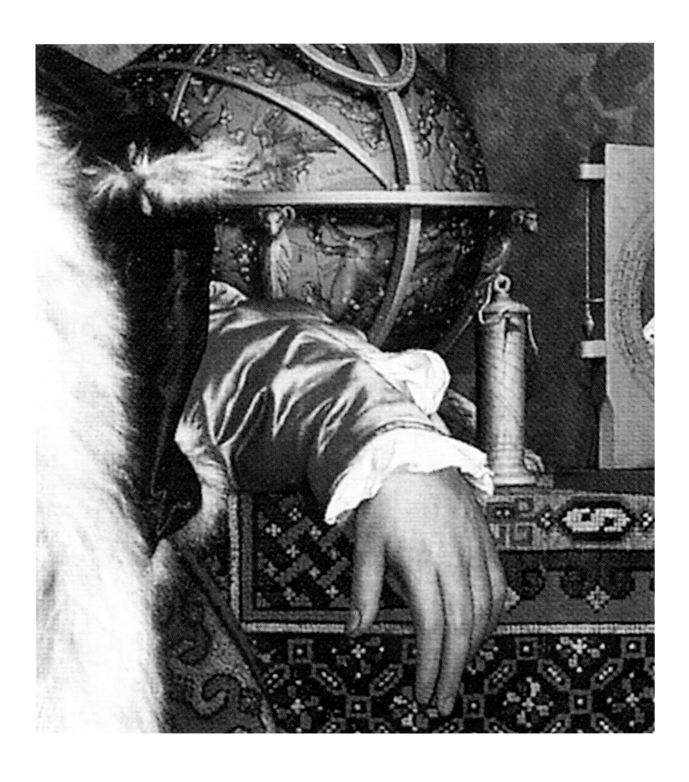

*The Ambassadors*
Detail

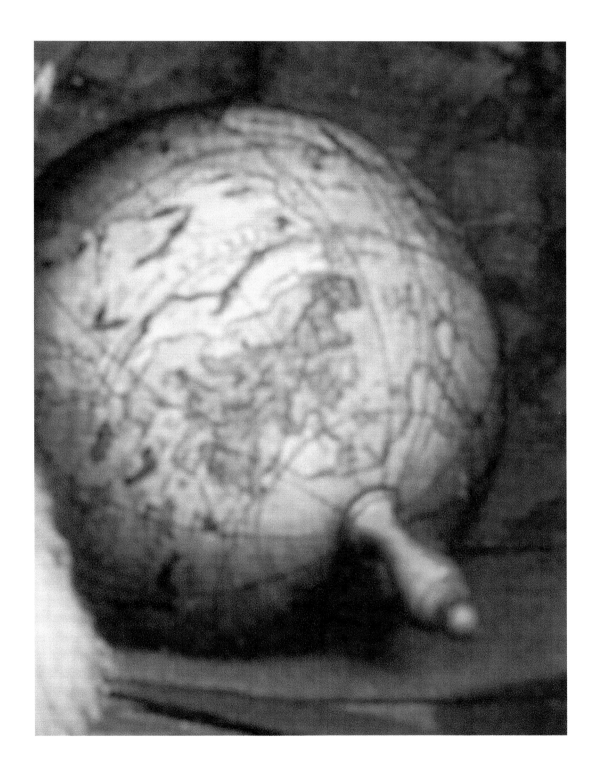

*The Ambassadors*
Detail

# Two protagonists

The two protagonists are Jean de Dinteville and Georges de Selve. Against this highly complex historical background, Jean de Dinteville, while sojourning in England, commissioned Holbein to portray the two friends. Holbein, who had spent another four years in Basel, had returned to a wholly altered situation in London: Sir Thomas More, who had been his host and procured a number of portrait commissions for him during his first stay in London, had fallen out of favour with the royal court because of his opposition to Henry VIII's divorce. Holbein, on the other hand, festively decorated the Steelyard for the procession attending Anne Boleyn's coronation on 31 May 1533.[3] In view of Holbein's allegiance to the Crown, Erasmus wrote a letter that same year complaining that Holbein had disappointed his friends in London.[4]

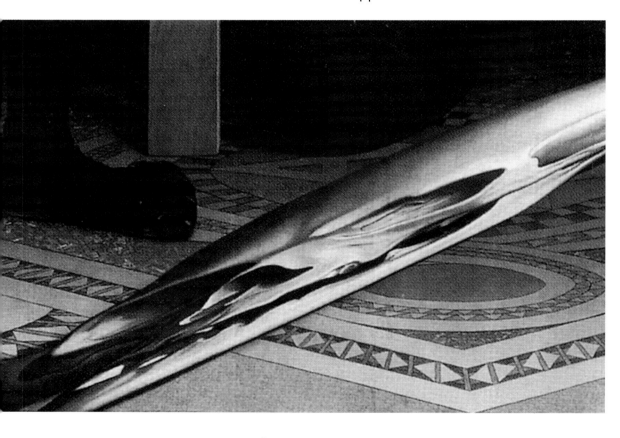

There is no documentation whatsoever regarding the association between Holbein and Jean de Dinteville. However, the middle-man may well have been Nicolas Bourbon, the court poet, an exile from France. Bourbon had lived in the circles of Margaret of Navarre before being invited to the English court by Anne Boleyn, his patroness. Bourbon's book of poetry *Nugae* includes a poem on the art of Holbein[5] as well as an epigram on the Seigneur de Polisy: *"In gratiam Ioan. Dintauilli Polysi, cum Christianis. Regis orator in Britannia ageret ... Temporibus cede, et uentis ne flantibus obsta. In domo clariss. Uirir D. Ioan. Dintauillae, quae uulgo etiam, orator appellatur."*[6] The picture of *The Ambassadors* was kept in the Dinteville family palace in the French town of Polisy (Troyes), but the palace was completely redesigned in 1544; consequently, there is no concrete evidence as to the painting's intended destination, nor has any document yet been found that would permit reconstruction of the painting's immediate surroundings. The format as well as the life-sized scale of the picture, however, predetermine the manner in which it should be hanged.

*The Ambassadors*
Detail

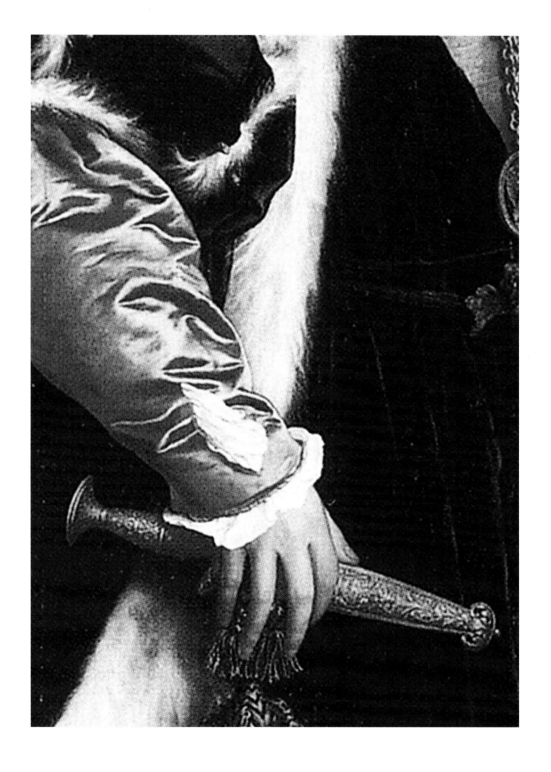

# Three different points of view

The perspective in *The Ambassadors* presents three different viewpoints, passing virtually seamlessly from a distant view to close-up and diagonal views. The pictorial reality alone makes it possible for these mutually exclusive perspectives to coexist. The overall effect of the picture is dominated by the imposing life-sized appearance of the two men, whose posture and gaze confront the viewer en face. The rich details of the still life elements and the crucifix above Jean de Dinteville in the upper left-hand corner need to be

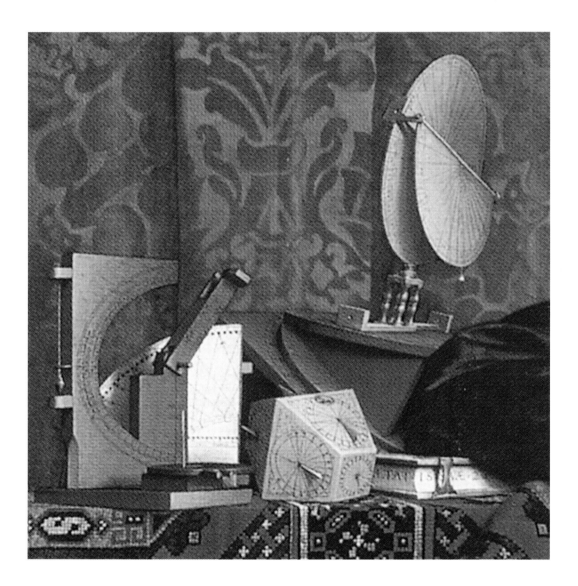

viewed close up. The anamorphosis, on the other hand, straightens out when the viewer relinquishes a head-on position and stands next to the picture at an angle,[7] to the right of Georges de Selve as it were, his head at the level of the crucifix.[8] Thus, the viewer becomes, in a manner of speaking, the third protagonist. The vantage point from which the viewer regards the skull is in the extension of a diagonal axis generated by the anamorphosis, to the right of the picture.

*The Ambassadors*
Detail

# From two-dimensional canvas to three-dimensional effect

To examine the two perspectives—frontal and lateral—let us begin with a description of the geometrical construction of the linear perspective. However, the idea is not to simulate the artist's reality and reconstruct the space and objects depicted, i.e. "what the artist was able to see",[9] but to gain a better understanding of the painting and its structure.

Specifically, the two-dimensionality of the surface of this picture, particularly that of the anamorphosis, is deliberately contrasted with the three-dimensionality of the space depicted. The illusion of depth is created by foreshortening the square pattern on the floor to a rhombus. The starting point of the middle perspective verticals is the apex of that rhombus in the foreground, which combines with the outermost lines of the rhombus to foreshorten the perspective. The vanishing point is the celestial globe, whose equator coincides with the horizon line.[10]

But the horizon line is below eye-level. The foreshortening of the two horizontal wooden shelves in the middle of the picture yields a view from above.[11] Furthermore, the oriental rug on the upper shelf has the effect of dislocating the instruments and objects on top of it from the ambient spatial perspective: the astronomical instruments, ranging from the foldout/collapsible torquetum to the octagonal sundial, are interlocked in a quasi-cubistic manner and seem to drift away from the ambient space created by the centralized perspective. They are isolated from the picture as a whole, constituting an entirely separate pictorial level.

Another field of vision is engendered by the lines of the prayer book on the lower shelf, which intersect with the rosette of the lute. A separate complex of angles is formed by the apex of the set square, the wooden handle of the globe and the pegbox of the lute.

But how is the anamorphosis incorporated into the picture? Two sources of light serve to underscore the separation of the different pictorial levels.[12] The shadow of Jean de Dinteville on the floor and the shadows of the lute and recorders are cast by light shining frontally from above on the right-hand side. The shadow cast by the anamorphosis, however, suggests a second light source, situated at an acute angle to the surface of the picture in the extension of the axis of the anamorphosis to the right of the picture. The shadows place the two men and the objects in the illusory pictorial space, which is lent a level of reality by the plasticity created by the lighting. By dint of its elliptical shape, the anamorphosis to the fore appears to be suspended weightlessly. Only the shadow it casts anchors it as an object in space.[13] Its shadow detaches it from the surface and assigns it a background function. The upshot is a dialectic between the object and its shadow. The shadow places the intangible shape of the anamorphosis as a tangible object in three-dimensional space, thus giving it a temporal and spatial dimension.

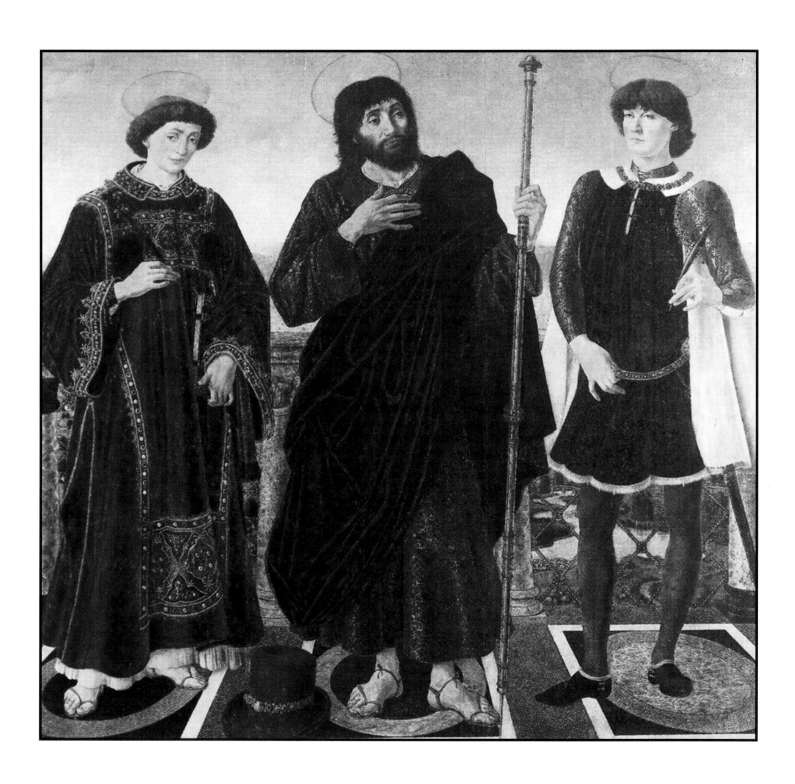

Antonio and Piero Pollaiolo
*The Three Patron Saints*, 1467–1468
Tempera on wood, 172 x 179 cm
Uffizi Gallery, Florence

# POSSIBLE ARTISTIC SOURCES

T he *Ambassadors* might possibly have been modelled on an altarpiece by Antonio and Piero Pollaiolo dating from 1467–68 in the mortuary Chapel of the Cardinal of Portugal in the church of San Miniato al Monte in Florence. The altarpiece is interesting not only on account of the life-sized frontal representation (172 x 179 cm) of the *Three Patron Saints*,[14] but also on account of the decorative Cosmati work in the chapel.[15]

Another Italian model might be Bramante's double portrait of *Heracleitus and Democritus*. The still life with the open manuscripts, ink-well, quill and the huge globe between the two heads would seem to suggest that the philosophers are discussing matters of scholarship, God and the world. Whereas Heracleitus, with folded hands and a bitter expression on his face, succumbs to tears, the laughing Democritus is touching the globe as if it were a ball.[16] This picture of two friends, according to Franco Borsi, an Italian art historian, might well represent Bramante and Leonardo da Vinci in their mutually opposed world views.[17] The arrangement of Bramante's *Heracleitus and Democritus*, with the rectangular door in the middle and life-sized human figures on each side might have influenced the composition of Holbein's portrait of the family of Henry VIII.[18]

Another possible visual source is the representation of scholars in various treatises on astronomy. What they have in common with *The Ambassadors* is the presentation of full-figure subjects in pairs with sundry instruments displayed between them. Peter Apian's *Instrumentum Primi Nobilis* (Nuremberg 1534), for instance, contains an engraving of two astronomers with a table in the shape of a seven-pointed star between them and a cube on top of the table. But of greater interest for our purposes is *Folium Populi*, a book of a more popular slant published in 1533 in German and Latin, about the astronomical instruments invented by Peter Apian.[19] Indeed, the still life in *The Ambassadors* includes a book by the selfsame scholar.[20]

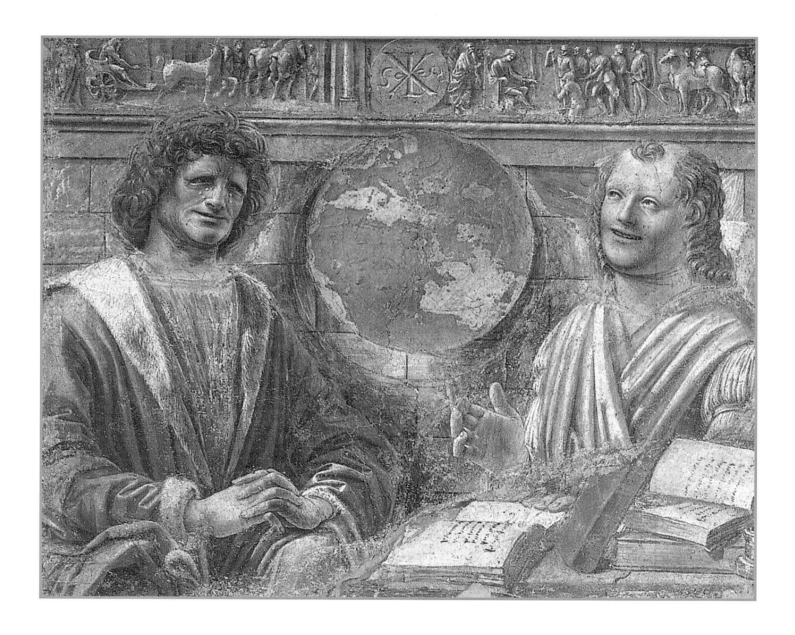

Donato d'Angelo Bramante
*Heracleitus and Democritus*
Fresco, 102 x 127cm
Pinacoteca Brera, Milan

Donato d'Angelo Bramante
*Heracleitus and Democritus*
Reconstruction of the location of the painting
at the Casa Panigarola of F. Borsi

The woodcut shows Ptolemy on the left with a compass and a planetarium instrument, and a scholar on the right in contemporary attire with a quadrant. In the middle is a surveying instrument used to calculate projections. Holbein was close to the astronomer Nicolas Kratzer, of whom he painted a famous portrait. Kratzer, in turn, added inscriptions to a drawing of the More family for Erasmus. This testifies to the interchange between artists and scientists in Holbein's day. Not only did Holbein include in *The Ambassadors* the scientific instruments described in the aforesaid books, he also drew inspiration from their illustrations.

Peter Apian, '*Folium Populi instrumentum*', Ingolstadt, 1533
Flyleaf: *Two Astronomers*
Engraving of Hans Brosamer, 15,8 x 15,8 cm

Peter Apian, '*Folium Populi Instrumentum*',
Ingoldstadt, 1533
Anonymous engraving, *Two Astronomers*

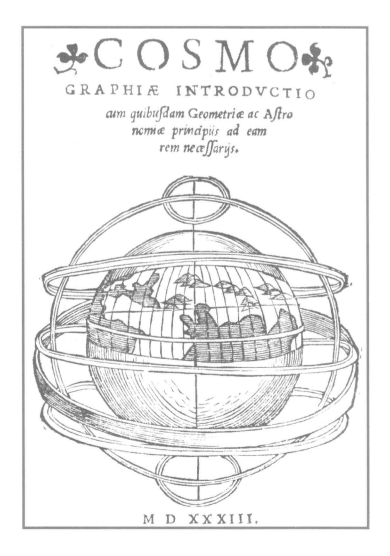

Peter Apian, '*Cosmo Graphiae Introductio*',
Ingolstadt, 1529
Right: Flyleaf
Right above: Back of the flyleaf
(representing the cosmography)

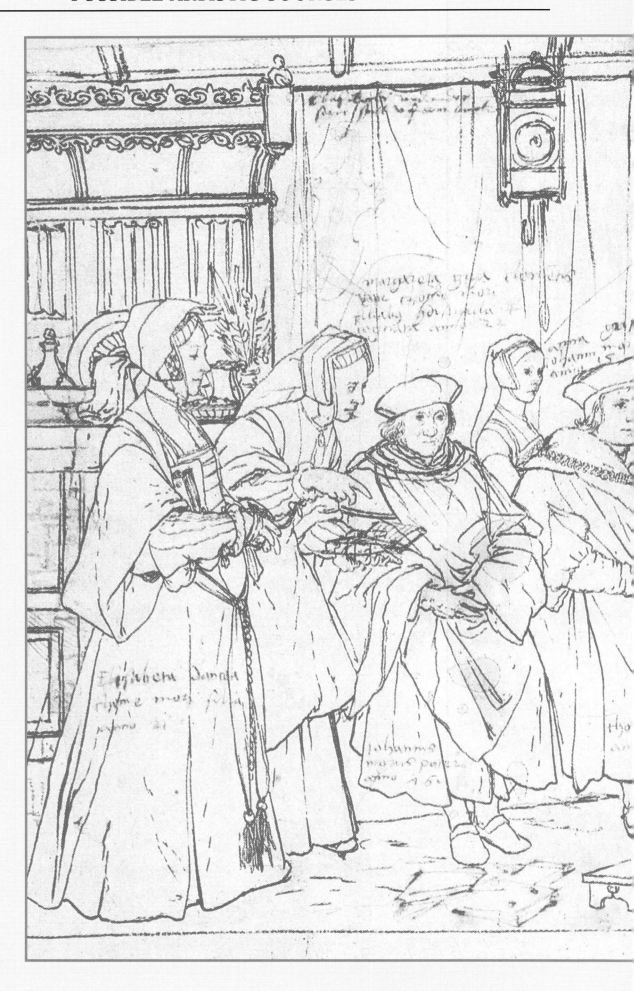

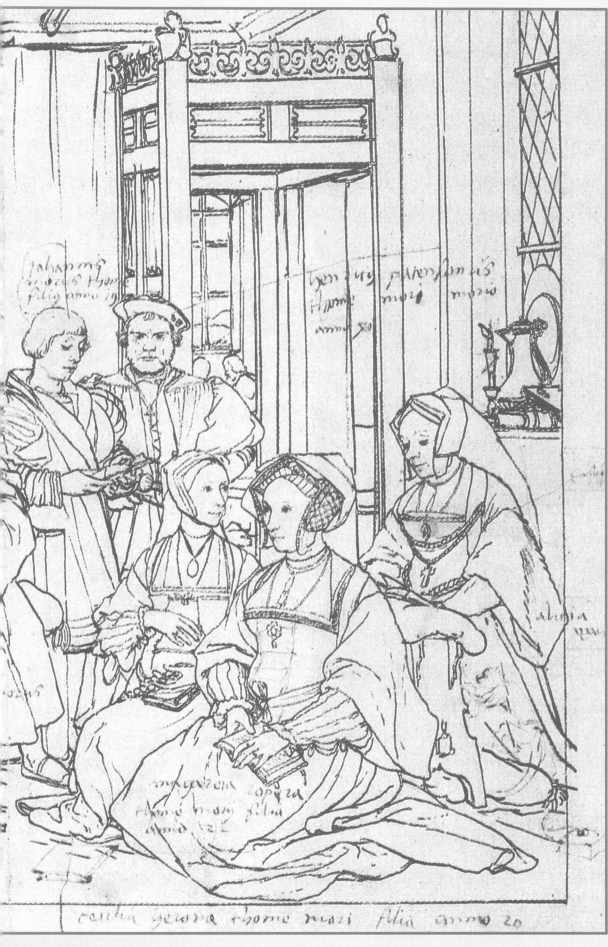

Hans Holbein the Younger
*Portrait of the Family of Sir Thomas More*, 1526–1527
Pen and brush drawing, 38,9 x 52,4 cm
Art Museum, Basel

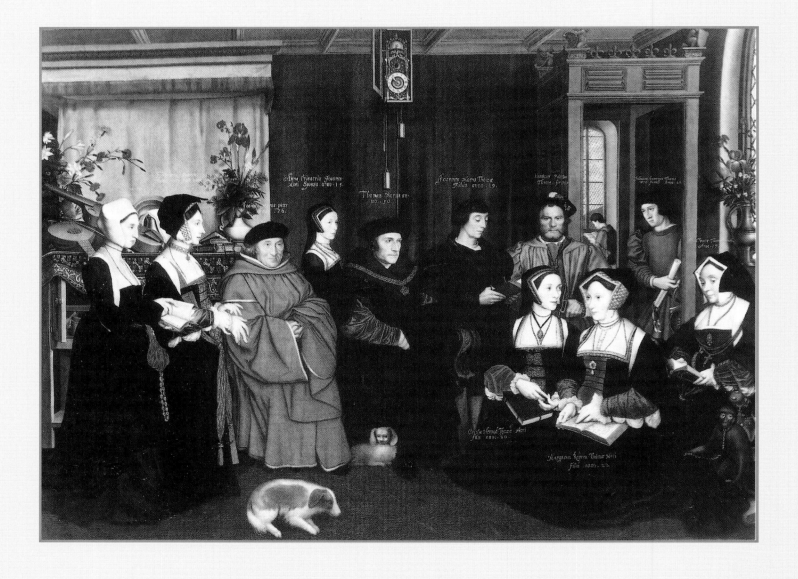

Rowland Lockey, Copy of Hans Holbein the Younger,
*Portrait of the Family of Sir Thomas More*, 1592
Oil on canvas
Collection of Lord St. Oswald, Nostell Priory

# The portrait of Sir Thomas More's family

Another possible source of *The Ambassadors* is the portrait of More's family (1527–28), given the life-sized representation of its subjects and its life-sized dimensions.[21] Karel van Mander, a 16th-century Dutch painter and writer, described the portrait thus: "A large watercolour picture on canvas showing the full life-sized seated figures of the learned and famous Thomas More with his wife, sons and daughters, a well-composed picture that is worth seeing and cannot be praised too highly."[22] The painting is now lost; all we have to go on is a drawing by Holbein, which More gave to his friend Erasmus, and various copies—in particular one by the painter Rowland Lockey.[23] Sir Thomas More, at the time chancellor of the Duchy of Lancaster, is seated to the right of his father, Sir John More, judge of the King's Bench, in the parlour. Assembled around the two paterfamiliases are Sir Thomas More's daughters, wife and son. There are some books and a footrest in the foreground, and in the background a clock above the head of the elder More, suggestive of the transience of the moment captured in the picture. As employed later in *The Ambassadors*, a curtain serves to enclose this scene from behind. A cabinet holding pitchers, bowls, flowers in a vase, books and a lute imbues the scene with familial cosiness. On the drawing Nicolas Kratzer had indicated the name and age of each of the subjects. The inscriptions on the curtain above the heads of the sitters and on their robes are also found in Lockey's copy, so they may be assumed to have been in the original as well.

This family portrait calls to mind the nascent Reformation style of portraying the Holy Family as a contemporary family. With the exception of the two heads of the family sitting pensively on the bench, nearly everyone else holds a book. People of the age were impressed by More's daughters, whom he raised in a spirit of rigorous scholarship. Elizabeth Dauncey, his second daughter, on the left-hand side of the picture, is holding a book under her arm. Next to her Margaret Giggs, Frau Klemens More's foster-daughter, is looking at her father while pointing with her index finger at the opened page. To More's left, his son, John, is also perusing a book. His youngest daughter, Cicely Heron, with a rosary in her hand, looks up from her book; his eldest daughter is looking at More's second wife with her hand resting on a book, and Lady Alice More is kneeling in front of a prayer bench, wholly absorbed in her study of the Scriptures.[24] The reading motif is ubiquitous. An open door in the background on the right reveals a person immersed in study: the famulus Johannes Heresius. This glimpse of the diligent student symbolically reinforces the theme of the family absorbed in intellectual endeavour.

But to do justice to Holbein's pictorial inventiveness, one amusing detail should be mentioned as well.[25] The only ones not engaged in the family's exemplary pursuits are More's private jester, Henry Paterson, in his slit aristocratic apparel,[26] and a monkey on a leash. The monkey is playing at Lady More's feet, although in the copy by Lockey it is staring at the viewer. His gaze outwards from within the scene depicted, like that of the jester, establishes the connection between the outer world of the viewer and the inner world of the picture, which is shut off from the viewer. The jester marks a disjunction in the depicted scene, calling it into question by his very person. He engenders an ironical detachment from what is going on in the picture, and his gaze answers the prying scrutiny of the viewer. The monkey is likewise a traditionally ironical figure that imitates human action and, in so doing, produces the antithesis: a distorted view of man.

The presence of the jester, or fool, is also a play on the name More, which is traced back to the Greek word *moria*, meaning "folly" or "foolery".[27] Indeed, this pun inspired Erasmus to write *The Praise of Folie*, which he dedicated to his friend More, expressing the wish that the latter fully accept and nurture the foolish side of his nature.

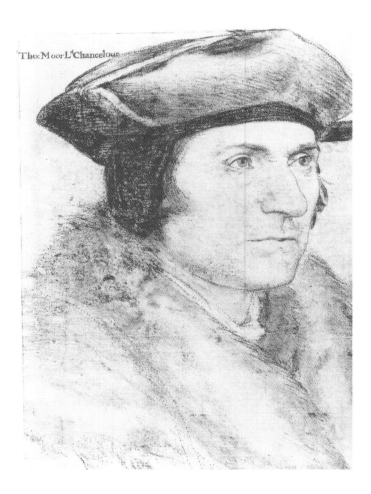

Hans Holbein the Younger
*Drawings*, 1526–27
Black crayon and pencil
Royal Library, Windsor Castle
*Sir Thomas More* (39,7 x 29,9 cm)

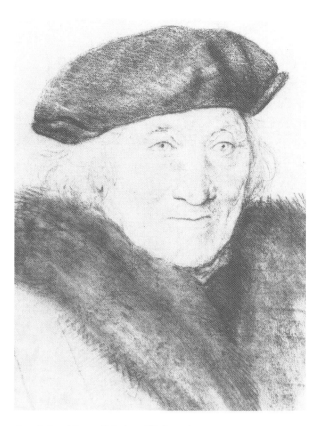

*Sir John More* (35,1 x 27,3 cm)

*Anna Cresacre* (37,3 x 26,7 cm)

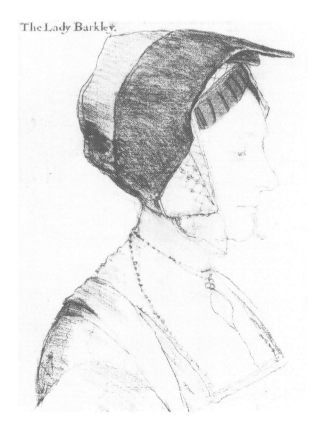

*Elizabeth Dauncey* (36,7 x 25,9 cm)

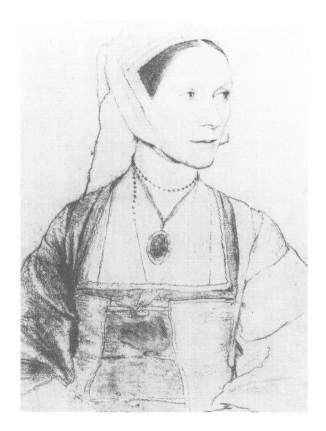

*Cecily Heron* (37,8 x 28,1 cm)

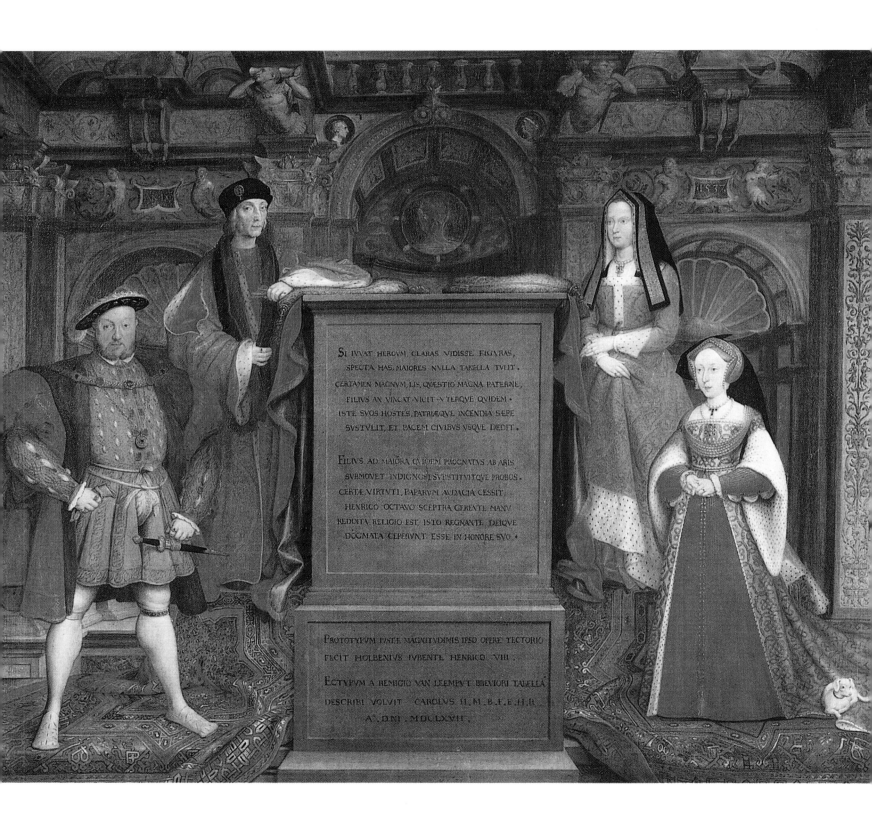

Remigius van Leemput
Copy of Hans Holbein, *Royal Portrait of Henry VII with Elizabeth of York, Henry VIII and Jane Seymour*, 1537
Oil on canvas, 88 x 98,7 cm
Royal Windsor Collection, Hampton Court Palace

# The portrait of Henry VIII

As mentioned before, the representative poses of *The Ambassadors* give their appearance the nature of a courtly ceremonial reception.[28] There is something presumptuous about this life-sized portrayal of two nobles, however, for this form of representation was traditionally reserved for the king. In his life-size statue of Charles V, Titian in 1532/33 provided the prototype for this manner of portraying sovereigns.

A second comparable portrayal is Holbein's painting of Henry VII with Elizabeth of York, Henry VIII and Jane Seymour. The fresco, which perished in a fire, is preserved solely in a faithful copy by Leemput.[29]

Holbein painted the royal portrait, which was intended for the Privy Chamber in Whitehall, four years after *The Ambassadors*.[30] This picture is also highly innovative. Before Holbein, only Mantegna, a painter he much admired, had executed a group portrait on such a large scale—of the princely Gonzaga family.

Set in a richly decorated Renaissance hall, the regal painting in question shows Henry VII and Henry VIII on the left and their wives, Elizabeth of York and Jane Seymour, on the right. The male sovereigns occupy the place of honour, i.e. the right side as viewed from their perspective. The centre of the picture, however, is occupied by an altar-like pedestal. Stephanie Buck, a German art historian, shows how, with his character-istic combinatorial acumen, Holbein exchanged motifs between this portrait and *The Ambassadors*, substituting the table and skull for the inscription and the curtain for the rear wall.[31]

The common feature to be emphasized for our present purposes, however, is the life-sized portrayal and the arrangement of the individuals on each side of an inanimate centre. The presentation of the monarchs, which is coupled with a memorial inscription, calls into question the prevailing conception of royal portraiture. Sovereigns were traditionally shown as "divinely anointed" in their *corpus repraesentatum*, for which the portrait served as a representative substitute.[32]

*Royal Portrait*
Detail

In the portrait of Henry VIII the king's presence is no longer deemed sufficient, for Holbein has them grouped around the inscribed panel. The rules of private portraiture—representation of the true person (*vera persona*), of the mortal body (*corpus naturale*) that is subject to the laws of time—are here applied to the representative portrayal of the English king. The inscribed panel, on the other hand, brings up the much-mooted problem of the empty centre, which is regarded as a deficiency or lack of substance in Holbein's vocabulary of form.[33]

The inscriptions, though, may relate to the two-picture principle that was widespread in Protestant countries, which distinguishes between man's transient depictable body and his textual body, the unportrayable spirit. The medallion of Erasmus by Quentin Massys, for example, which dates from 1519, bears the following inscription: "Written works will show the better picture; the image is based on the living model." Thus, Holbein's pictorial composition reflects a revalorization of writing and denigration of painting, since the latter needs to be supplemented by a textual message.

The inscribed panel provides the programme for the picture.[34] First it praises the artistic value of what is being seen. Everyone who delights in heroic figures should look at this portrait. Then it asks who is greater, the father or the son. Clearly, both are great men. The father, burning with patriotism, often vanquished his foes and ultimately gave his people peace.

The son, however, was born for greater feats. He dismissed the unworthy from the altar and put worthy men in their place. Firm virtue has subdued papal presumption. And as long as Henry VIII holds the sceptre in his hand, religion will be renewed and God's laws honoured again.[35] Of doctrinal as well as propaganda import, the text underscores Henry VIII's role as a crusader for a new religion in conflict with the Roman Catholic Church.

Right page:
Hans Holbein the Younger
*Portrait of Henry VIII*. 1539–1540
88.3 x 74.9 cm
Galleria Nazionale, Rome

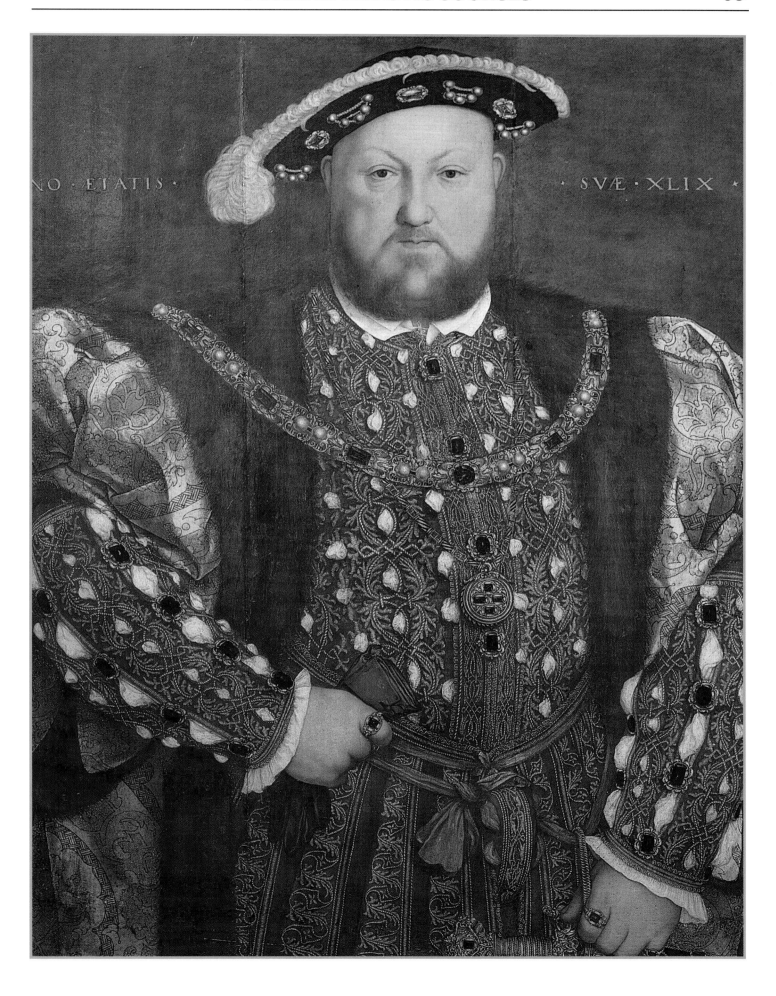

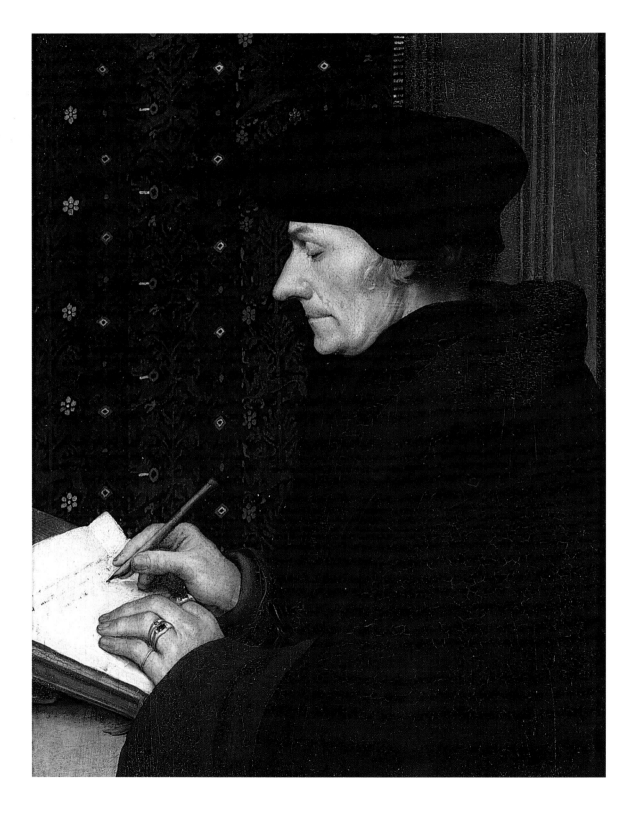

Hans Holbein the Younger
*Portrait of Erasmus of Rotterdam.* 1523
Tempera on marouflé on wood, 43 x 33 cm
Louvre, Paris

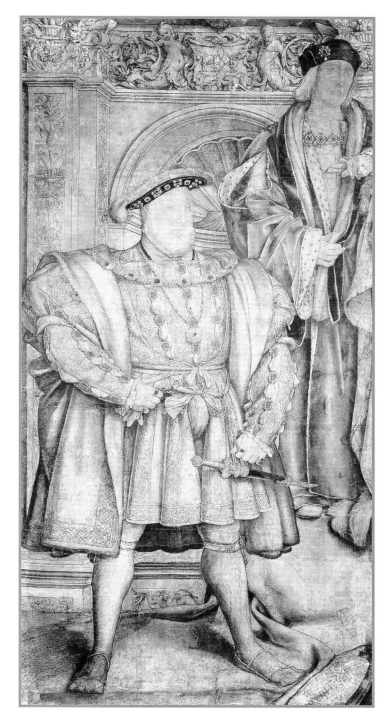

Hans Holbein the Younger, *Board for the Mural in Whitehall Palace.* 1537
Pen and ink on marouflé, 257,8 x 137,1 cm
National Gallery, London

Domenico Ghirlandajo
*Saint Jerome,* c. 1480
Fresco, 184 x 119 cm
Church of All Saints, Florence

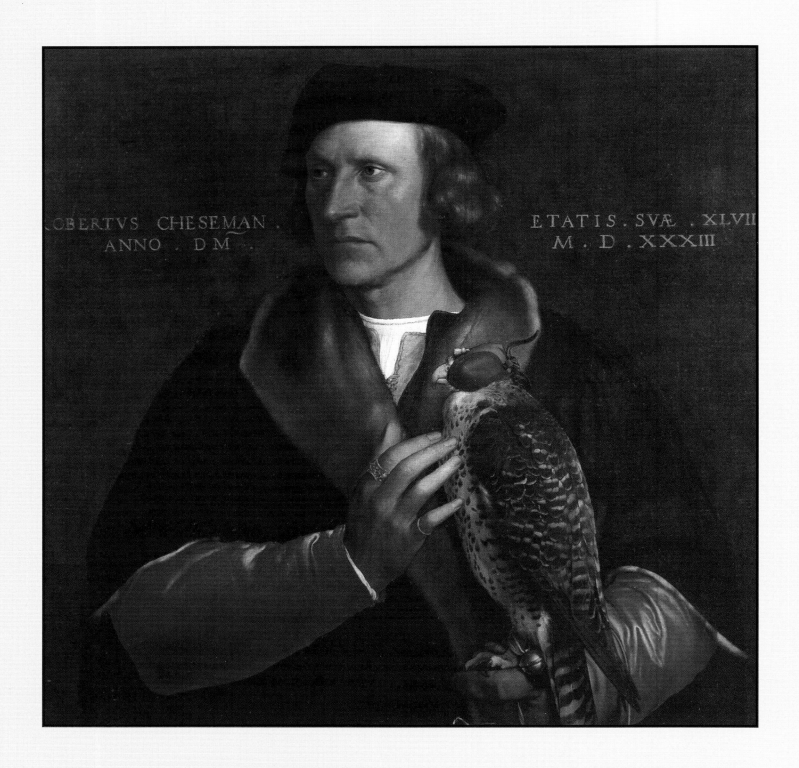

Hans Holbein the Younger
*Portrait of Robert Chesman*, 1533
Oak, 59,1 x 62,5 cm
The Hague, Mauritshuis

# JUXTAPOSITION OF IMAGE AND TEXT

The inscription transforms the Whitehall picture into an epitaph.[36] A person's appearance, which changes over the course of life, is juxtaposed with the slice of that person's life that is fixed in the portrait. A horizontal banderole frames the faces of the subjects in the portraits of Anthony the Good, Duke of Lorraine; Edward VI, successor to the throne; John Chambers; and Henry VIII, to name but a few.

In the portrait of Hermann Wedigh, a Cologne merchant, the year is indicated on the left, his age on the right. *Anno 1532* (year 1532) refers to the Christian calendar, the year of the Lord, whereas *aetatis suae 29* (age of 29) indicates the merchant's age, the time elapsed since his birth.[37] The horizontal inscription that cuts across the sitter's face at cheek, eye or mouth level emphasizes that part of the face for, as Dürer had already discovered, "the most noble part of man or woman is the face".[38]

Two dimensions collide: the two-dimensionality of the writing and the life-reflecting three-dimensionality of the person. These different media, used both in the portrait of More's family and in that of Henry VIII, involve reading as well as viewing. This takes up a *leitmotiv* in Holbein's work: the two different ways of approaching pictures. Tension is created by deliberately juxtaposing writing, epitomizing the world of ideas, with the minute details reproduced from the phenomenal world. If the portrait keeps the viewer's eye at a distance, the writing requires him to relinquish his eye-contact with the extremely realistic subject and to step right up to the canvas to read the inscriptions. Thus, the writing establishes the supremacy of the text, exposing the three-dimensional fiction of what is depicted.

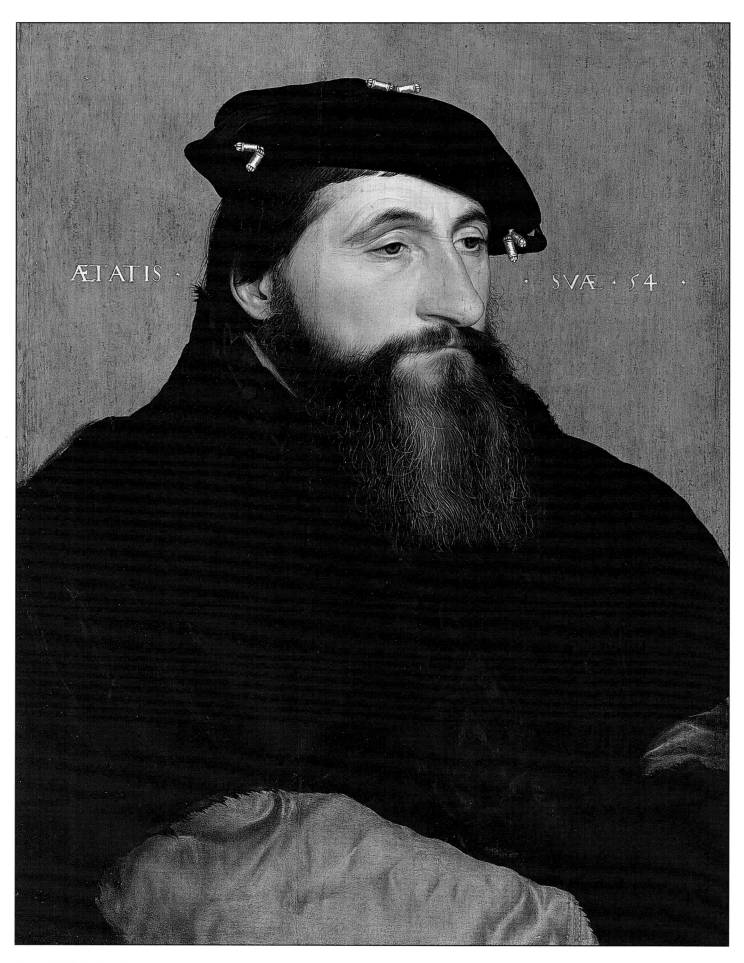

ÆTATIS ·          · SVÆ · 54 ·

Hans Holbein the Younger
*Portrait of Anthony the Good*, 1543
Oak, 51 x 37 cm
Staatliche Museen, Gemäldegalerie, Berlin

Likewise in *The Ambassadors* as viewed from the front: the anamorphosis, in its flat two-dimensionality, negates the portrayed three-dimensionality. The juxtaposition of picture and text—in the form of a cross—brings out the opposition between the physical presence of the picture and the commemorative aspect of writing. The horizontal banderole cuts off the animated verticals of the individual, draining the representation of its vitality and consigning this moment in time to the past. The horizontal inscriptions are found on the memorial coins as well as on the effigies carved in stone. A banderole either frames the figure or runs above, below or parallel to the figure, sealing it with death.[39]

# The studiolo pictures

Various domains collide in *The Ambassadors*: i.e. the official scene presented to the viewer—indicated by the Cosmati flooring—and the still life, which is part of the scholars' private domain or *studiolo*. Recall the letter from Jean de Dinteville to his brother about the visit, which is unofficial and therefore to be kept secret, but which he commemorates by commissioning the double portrait. The ambivalent nature of this picture is shared by numerous portraits in which individuals pose for all the world to see, while the letters incorporated into the composition preserve a sense of intimacy. Being more or less legible, these missives entreat the viewer's complicity.[40]

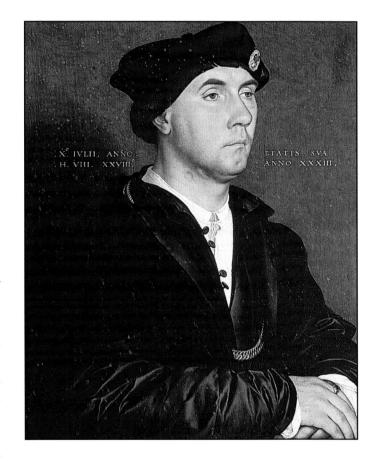

In the *Portrait of the Merchant Georg Gisze* (*cf.* p 92), Gisze is portrayed by Holbein while opening a letter. The letter is from his brother and is addressed "care of my brother, the honourable Georg Gisze of London, England". On the right-hand side of the picture are other letters whose intended recipients are not divulged to the viewer, save one bearing Gisze's address in Cologne.[41] These depicted letters re-invest the sitter's appearance with an inner life that is not accessible via the image. One of the many examples is the portrait of Dirk Tybis, another member of the Steelyard Merchants. He, too, is holding a letter from his brother in his hand, addressed "To the honourable Deryck Tybis van Duysborch". The sheet of white paper bears the date mid-March 1533, the name Dirk Tybis of Duisburg, and his age, 33 years. Thus, the letter lends the portrait a testamentary quality.[42] The address places the subject at a specific location, the date at a specific point in time. This temporal pinpointing concomitantly reflects the heightened awareness in that epoch of the mutability of the human form.[43]

Hans Holbein the Younger
*Portrait of Sir Richard Southwell*, 1536
Oil on wood, 47,5 x 38 cm
Uffizi Gallery, Florence

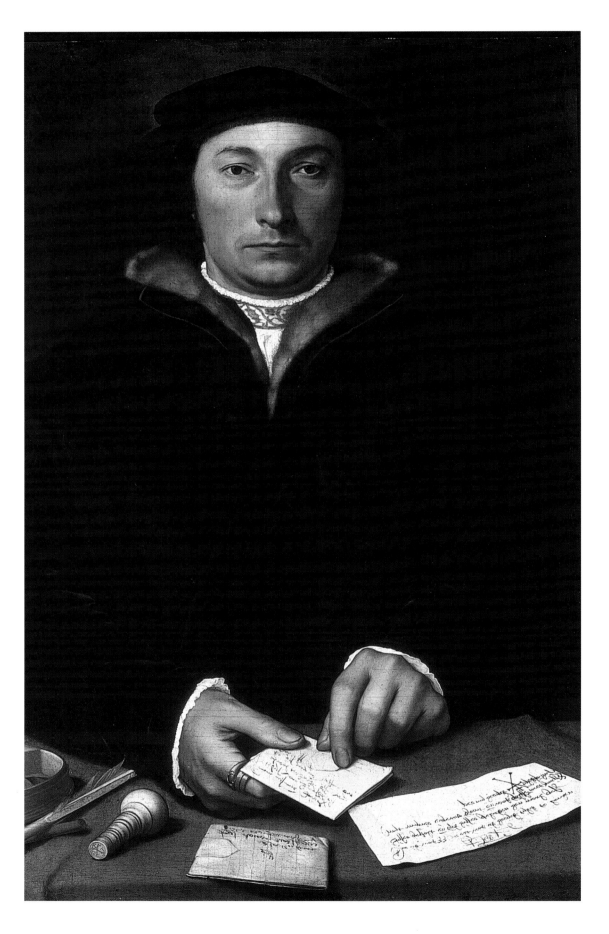

Hans Holbein the Younger
*Portrait of Dirk Tybis*, 1533
Oil on wood, 48 x 35 cm
Museum of Historic Art, Vienna

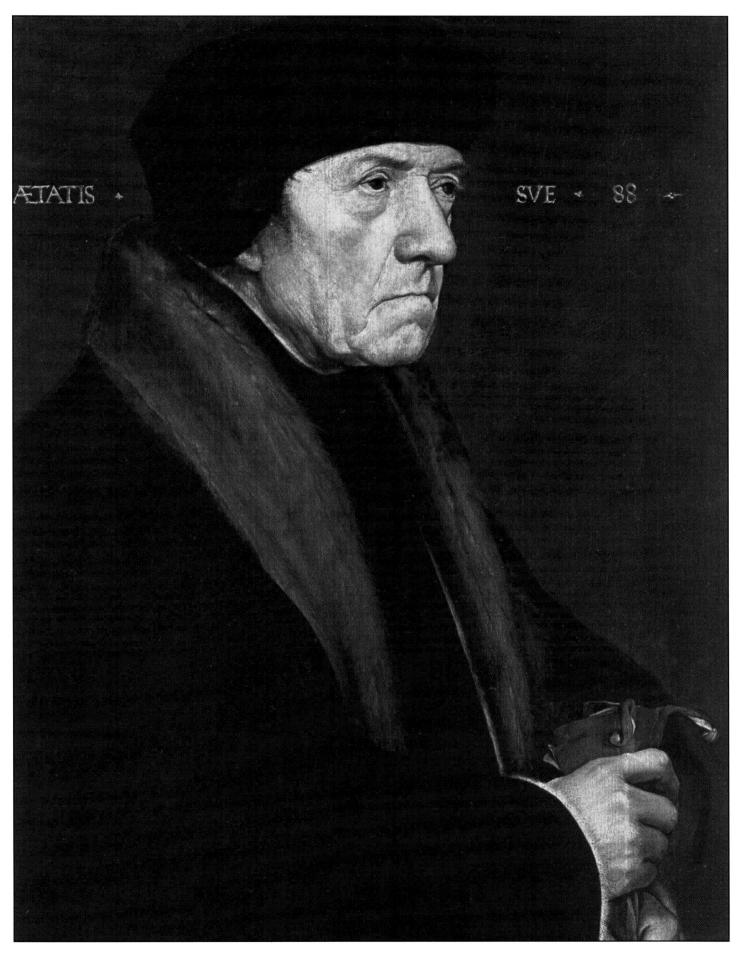

Hans Holbein the Younger
*Portrait of John Chambers*, 1541–43
Wood, 57,8 x 39,7 cm
Museum of Historic Art, Vienna

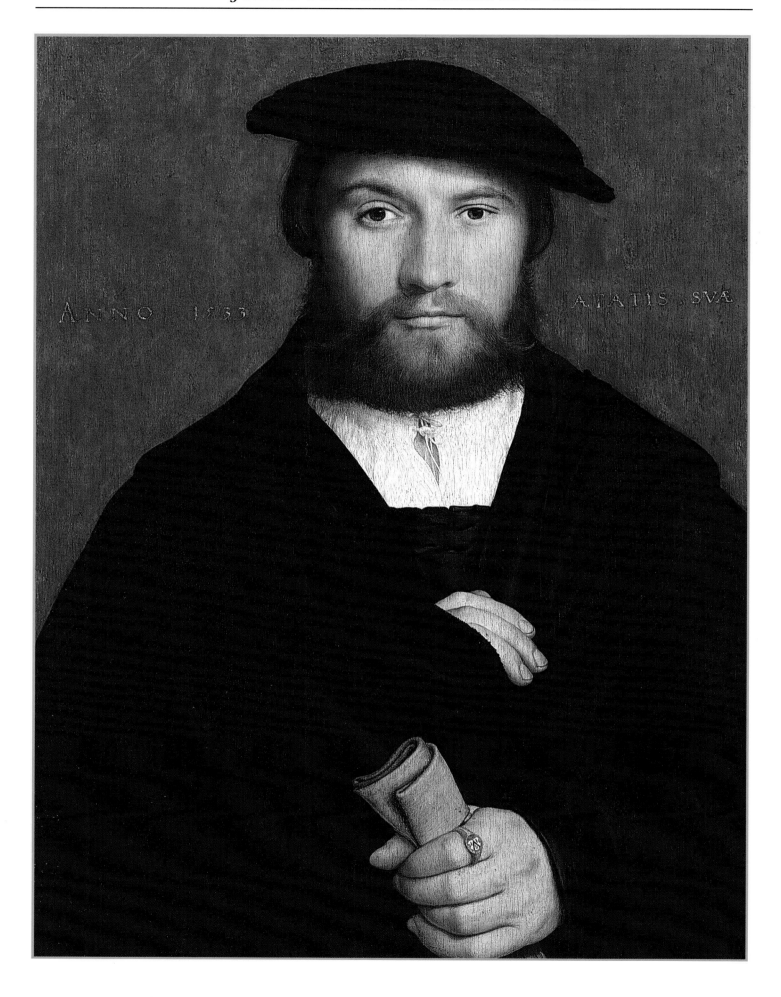

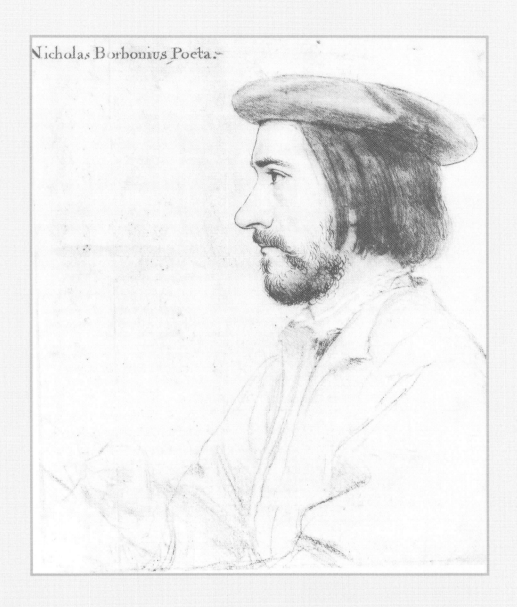

Nicholas Borbonius Poeta.

Opposite page:
Hans Holbein the Younger
*Portrait of Hermann Hillebrandt Wedigh*, 1533
Wood, 39 x 30 cm
Staatliche Museen, Gemäldegalerie, Berlin

Hans Holbein the Younger
*Portrait of Nicolas Bourbon*, c. 1535
Black, white and coloured chalk, pen and black ink
on rose-tinted paper, 30,9 x 26 cm
Royal Collection, Windsor Castle

This novel type of portrait is characterized by the enclosed nature of the background, which thrusts the subject to the fore, a half-length figure seated at a table or behind a railing. In the portrait of Cyriakus Kale, the latter is shown with two letters. The importance of the documents is underscored by the hand gestures of the subject, who is directly facing the viewer. Both letters bear the same address: "This letter is to the honourable Syriacuss Kalen in London." The viewer bears witness to the epistolary contact between the subject of the portrait and someone outside the picture. The scene depicted is also opened up at another level: that of the notional eye-contact between the subject and viewer.

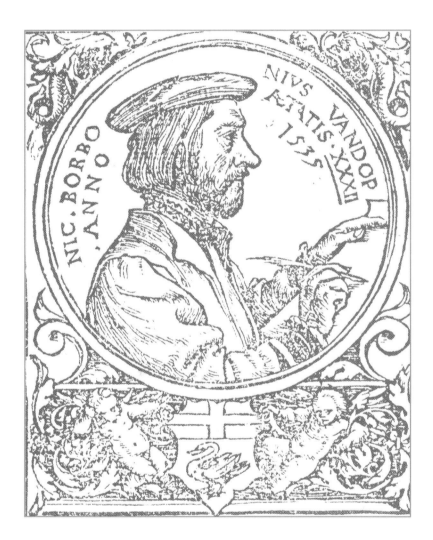

But documents have still another function. Paper and pen make the subject an active person who writes and receives letters. This active role is also indicated in the portrait of Gisze, in which the subject himself takes up the quill to set down his motto, as borne out by the inscription on the light-green rear wall: "*Nulla sine merore voluptas*" (No pleasure without price). The sitter shows himself in his best light, conscientiously attending to his day-to-day business.

As in the word graphein, moreover, which refers to both painting and writing, artistic and scholastic activity overlap in these portraits. Pomponius Gauricus writes in his treatise *De sculptura*: "*Graphicen uero quam nostri in Scriptore Descriptionem, In Pictore et Designationem uocauerunt, nam Lineationem …*"; in other words, what 'graphics' means to the writer is description, whereas to the painter it is drawing with lines.[46] In the most renowned multilingual dictionary of its day, the Italian lexicographer Ambrogio Calepino notes under the keyword *scribo*: "quandoque ponitur pro pinger". One can use this word also for the verb to paint.[47]

*Nugae*, a book of poetry by Nicolas Bourbon, contains two portraits of Bourbon. In one half-length portrait in the 1539 edition, Holbein shows the poet writing with a quill in his hand, with the following lines underneath: "The painter knew how to give appearance to physical appearance by means of his art; no artist can represent the shape of the

Woodcut by an anonymous artist after Hans Holbein the Younger, *Portrait of Nicolas Bourbon*. 1535, 30,7 x 26 cm
Extract from *Nugae* by Nicolas Bourbon, 1535
M. and G. Trechsel for J. and F. Frellon, 4°, Lyon

soul. You see the body in the light of your mortal eyes, O man; God alone knows the stamp of our heart."

On the last page is a woodcut by Holbein of Bourbon, likewise in profile, this time his head adorned with laurels as on an ancient medallion. With its dark round inner opening, the oculus in the background frames the face alone—from eye-level up. The forehead corresponds to a second frame, the hairline a third. The poet's hand rests with extended index finger on the outermost frame of the oculus.

Holbein has skilfully juxtaposed the profile portrait with the architectonic 'eye-opening' of the oculus directed towards a central vanishing point and hence frontally towards the viewer. The emphasis is on the gesturing hand, in contrast to the face that is diverted from the viewer's gaze.

## Holbein's self-portraits

Not until the third edition of *Historiarum veteris instrumenti icones ad vivum expressae*[48] was Holbein credited in the foreword as the designer of this illustrated Bible. Nicolas Bourbon writes: "*Cernere uis, hospes, simulacra simillima vivo? Hoc opus Holbeinae nobile cerne manus*" (Look my guest, if you want to see a similar picture, there is the wonderful work from the hand of Holbein). This accentuation of the artist's skilled hand can also be made out in Holbein's self-portrait,[49] which bears the following inscription at the top: "IOANNES HOLPENIUS BASILEENSIS SUI IPSIUS EFFIGIATOR AE XLV." (Hans Holbein from Basle made this effigies at the age of 45). *Hol-penius*, the Latin neologism for Holbein, suggests the Latin word *penna* (feather), from which derives the English word pen.

Despite the controversy concerning the four self-portrait miniatures dating from 1542/43, they should be taken into consideration here. Of decisive importance is the fact that in all four of them the artist shows himself in three-quarter profile with a paintbrush in his hand. The tondo takes its cue from the portrait of Bourbon, as does the disposition of the hands. The difference is, however, that rather than striking the memorial pose of profile as in the Bourbon picture, Holbein shows himself in the process of painting, seizing the viewer, a notional sitter or his own reflection in the mirror, with an immediacy of presence that is proverbial of Holbein's works. It is interesting to note that both the portrait of Bourbon and the self-portrait show the subject holding a quill or paintbrush in his hand. Like the Greek *graphein* discussed earlier, the Latin word *penius* applies to both painting and writing. Pierre Gilles of Antwerp was playing on precisely this overlap when he remarked that Sir Thomas More sets the scene of his *Utopia* so precisely with his brush that the reader thinks he is seeing it with his own eyes.[50]

Hans Holbein the Younger
*Portrait of Nicolas Bourbon*
Woodcut
Extract from *Nugae* by Nicolas Bourbon, 1539
M. and G. Trechsel for J. and F. Frellon, 4°, Lyon

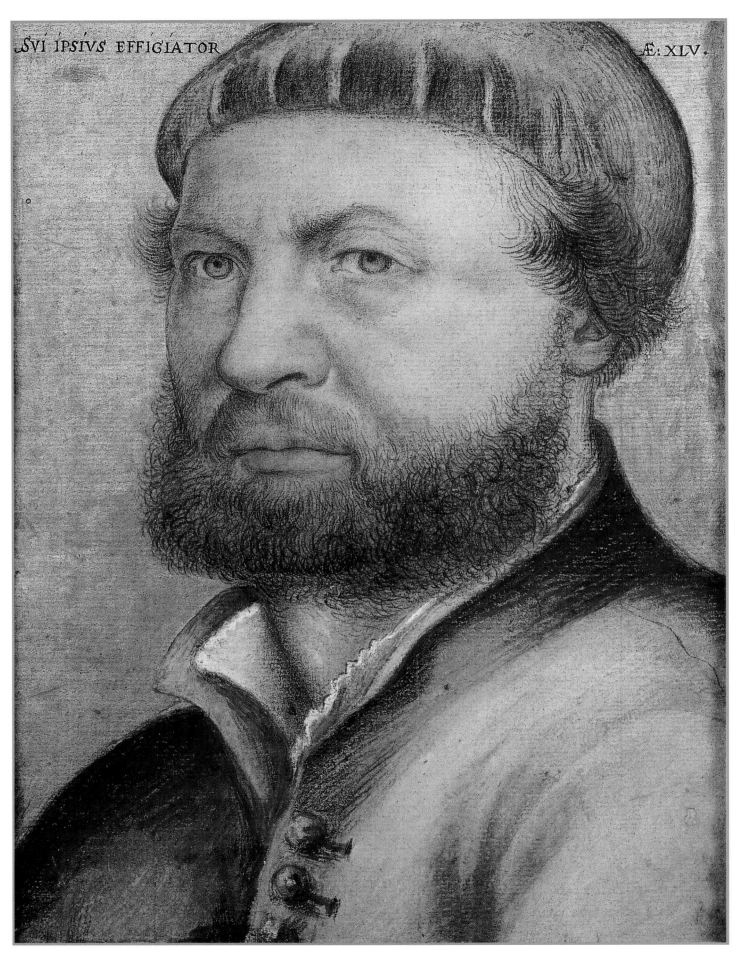

Hans Holbein the Younger
*Self-portrait,* 1542–1543
Chalk, 23 x 18 cm
Uffizi Gallery, Florence

The wish expressed by Conrad Celti "that two trained hands—scholar and artist—work for each other, the one with the pen, the other with the paintbrush" also applies to Holbein, who worked alongside Erasmus and More.[31] Of fundamental importance is the intellectual revalorization of manual activity, as expressed by Cicero in *De natura deorum*, in which the latter proclaims that with our hands we create clothing, buildings and temples, work the soil, chop down woods and control the sea.[52] A famous phrase to this effect is that of Dürer, who in his portrait engraving of the German Humanist and Reformer Philipp Melanchthon praises his own hand as a *docta manus* (wise hand).[53]

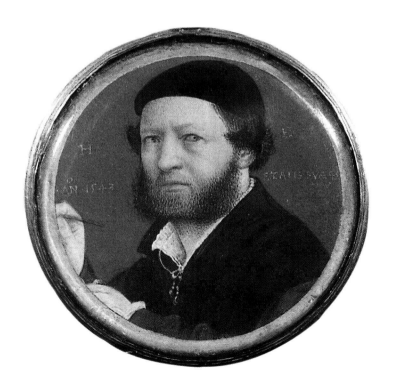

Hans Holbein the Younger
*Self-portrait.* Miniature
Wallace Collection, London

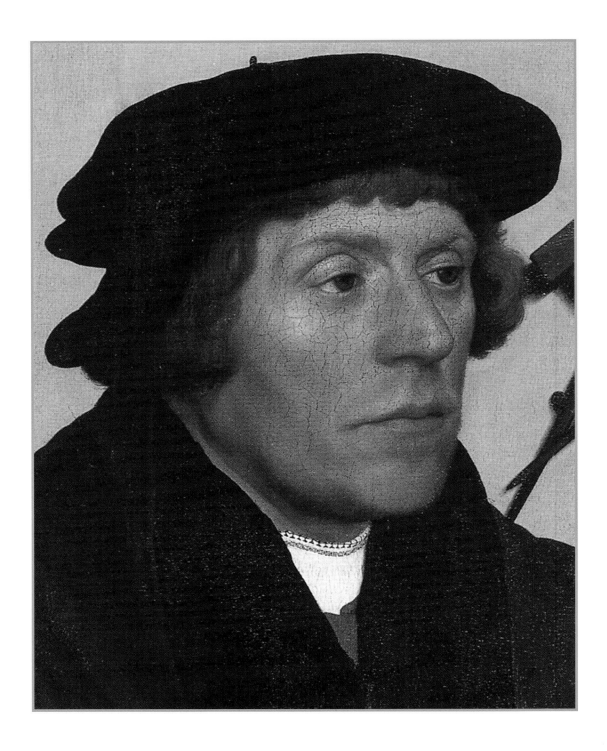

Hans Holbein the Younger
*Portrait of Nicolas Kratzer*, 1528
Oak, 83 x 67 cm
Louvre, Paris

# A STILL LIFE OF SCIENTIFIC INSTRUMENTS

The instruments depicted in *The Ambassadors* are there for a reason:[54] they provide key information about Jean de Dinteville and about the time and location of the reunion of the two friends. This precise information gives the portrait a historical cast. The still life in *The Ambassadors* covers the four classical scientific disciplines of the medieval quadrivium:[55] astronomy, geometry, arithmetic and music.[56] The upper area shows various instruments used to observe the heavens, while the lower is confined to earthly endeavours. In contrast to the sober wooden rack, the oriental rug adorned with geometric patterns underscores the cosmic aspect of the upper level of the picture. A celestial globe is positioned behind the left arm of Jean de Dinteville leaning on the rack. It is set at a latitude of 42 or 43 degrees, that of Southern Europe. The zodiacal constellations of the time show: GALACIA (the Milky Way), GALLINA or CYGNUS (the Rooster or Swan), VVLTVR CADENS (the Falling Vulture) DRACO (the Dragon), CEPHEVS, PERSEVS, ANDROMEDA, [CAS]SIOPEIA, EQVVS (the Horse), PEGASVS (the Flying Horse), [DEL]PHINVS (the Dolphin) VVLTVR VOLA[NS] (the Flying Vulture), PISCES (the Fishes), HERCVLES, AU[RIGA] (the Charioteer), VRS[A MIN]O[R] (the Little Bear) and [URSA] MAIO[R] (the Great Bear). Next to the celestial globe is a cylindrical, portable shepherd's sundial with the signs of the zodiac, bearing the date 11 April.[57] To its right we see a semicircular alidade fitted with a plumb line, and behind that a quadrant bearing an upside-down inscription: umbra versa. A sundial on the four sides of the polyhedron indicates the time: 9:30, 10:30 and again 10:30. Folded out aslant on every side the torquetum,[58] on which Georges de Selve is leaning, bears the words AXIS SODIACI (Zodiacal Axis) and LINEA (Ecliptic) A; the elevation is set at 0 and 10. That these instruments for observing the sun and constellations should work in the depicted interior is paradoxical, but in accord with the fiction of the picture and its message to the viewer.

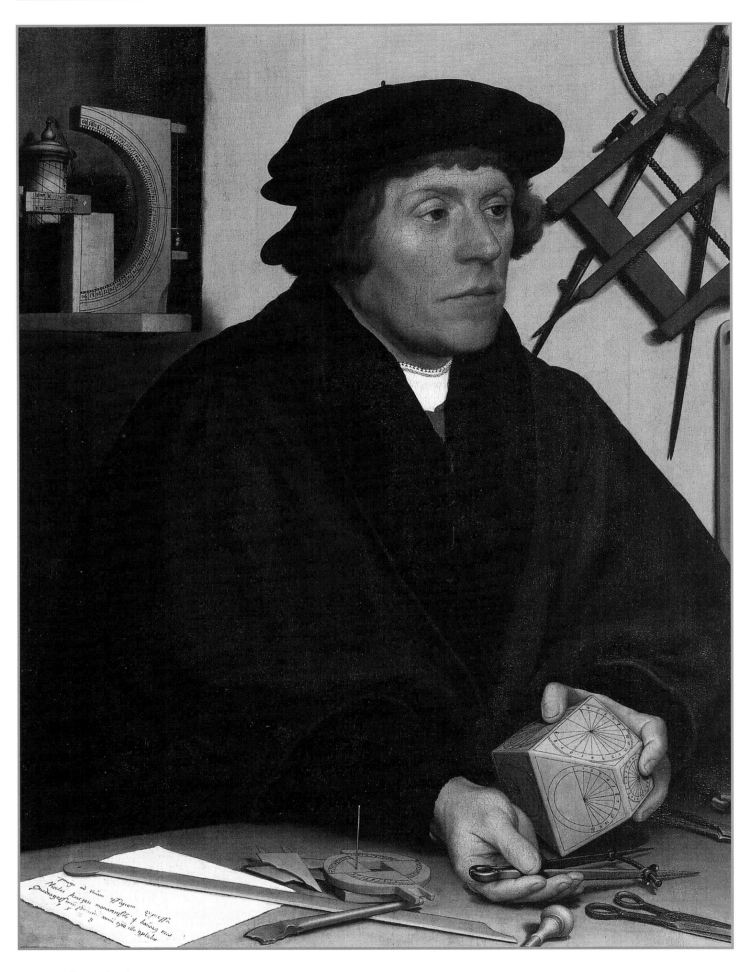

Hans Holbein the Younger
*Portrait of Nicolas Kratzer*, 1528
Oak, 83 x 67 cm
Louvre, Paris

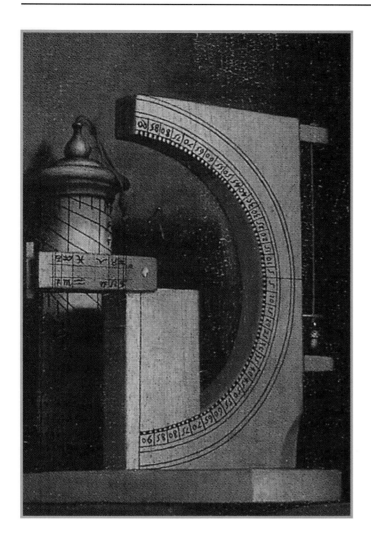

Hans Holbein the Younger
*Portrait of Nicolas Kratzer*
Details

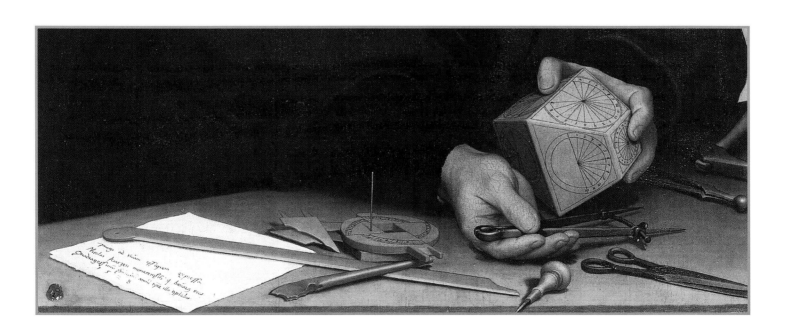

To appreciate in full what these various objects signified to Holbein, his patron and the subjects, one needs to take a closer look at the underlying references. The books and instruments can be ascribed to different owners. The polyhedral pocket sundial, for example, as well as the cylindrical sundial and the compass were previously included in Holbein's portrait of Nicolas Kratzer.[59] Kratzer, a mathematician and astronomer from Munich, studied in Cologne and Wittenberg before accepting a post at Corpus Christi College in Oxford. In 1519 Henry VIII appointed him "deviser of the King's horloges". His circle of acquaintances included not only Erasmus and More, but also the Bishop of Kulm, a close friend of Copernicus'. In 1520 Dürer too had done a portrait of Kratzer.

Hans Holbein the Younger
*Depictions of Solar and Lunar Eclipses*
Woodcut, Extract from Sebastian Münster
'*Canones super novum instrumentum luminarum*', 1534
A. Cratander, 8°, Art Museum, Basel

The terrestrial globe underneath the celestial one is attributed to Johann Schöner. Here Holbein has added a number of other localities of significance in the life of Jean de Dinteville, such as POLISY, BARIS (Paris), LEON (Lyon), BAION (Bayonne), NORMA (Normandy), PRITANN/IA (Great Britain), AVERN (Auvergne), BVRGVND (Burgundy), LANGVEDOC, ROMA (Rome), GENVA (Navarre), GRANA (Granada), SAXONIA, POLONIA (Bologna), SERVIA (Serbia).[60] There were other models in existence at the time, in particular, globes by Franciscus Monarchus (1526) and Gemma Frisius (1530).

In front of the globe is a merchants' manual by Peter Apian, published in 1527, entitled *Rechenbuch Eyn Newe und wolgegründte underweysung aller Kauffmanns Rechnung* (Book of Calculation/Computing for the Merchant). The set square marks the eighth page of the third book, which deals with the subject of division.[61]

The lute with a broken string is drawn from the first edition of *Emblemata* by Alciati, which was published in Holbein's native town, Augsburg, in 1531.[62] The dark lute case, on the other hand,

is stowed under the wooden table. In front of the lute itself is the earliest Protestant hymnal, the *Geystliches Gesangk-Buchleyn*, edited by Johann Walther and printed in Wittenberg in 1524. According to Markus Jenny, this is a copy of the 1525 second edition from Worms. The open pages and the numbers II and XIX do not tally with the book in question, but represent two deliberately selected and paired hymns. The page on the left shows the first verse of *Veni Creator Spiritu* and on the right is the beginning of *Die Zehn Gebote* (The Ten Commandments).[63] The ownership of the German hymnal remains unclear. Konrad Hoffmann[64] ascribes the book to Georges de Selve and his latent Protestantism.

Hans Holbein the Younger
*Instrument of Both Lights (sundial)*
Woodcut, 64,9 x 46,2 cm
Extract from Sebastian Münster
*'Canones super novum instrumentum luminarum'*, 1534
A. Cratander, 8°, Art Museum, Basel

Prior to 1534, however, France was by no means hostile to the Protestant movement. Within Holbein's closer circle of acquaintances, Erasmus had employed one of the most prominent figures in French Protestantism, Gilbert Cousin, as a servant at his house in the town of Freiburg in Breisgau from 1530 to 1533.[65] A compass is visible behind the hymnal.[66]

Finally, on Georges de Selve's side is a case containing woodwind instruments; recorder music, we should note in passing, is associated with conflict and war.[67] This still life should be considered in connection with the increasingly widespread passion for collecting cabinet pieces, i.e. art works as well as natural curios,[68] in an age that was growing more familiar with material objects and turning away from the scholastic wisdom of books.[69]

# The artist as a disseminator of knowledge

In 1532 Holbein drew for Sebastian Münster a picture, called *The Instrument of Both Lights*, of an instrument used in the computation of lunar and solar eclipses. Holbein's woodcuts in the horological books of Basel show mathematical and geometrical perspectives with painstaking precision. The calculation and prediction of eclipses was the central scientific preoccupation of the day, but there were also fears that the end of the world was approaching. In 1530 Holbein had drawn various sundials for Münster. Knowledge of abstract mathematical forms in particular made not only the scholar, but also the artist as his assistant, a "master of the measurement of time".

Opposite page:
Hans Holbein the Younger
Woodcuts, c. 1530
Extracts from Sebastian Münster, *'De horologiorum'*, 1531
H. Petri, 4°, Basel

a

b

c

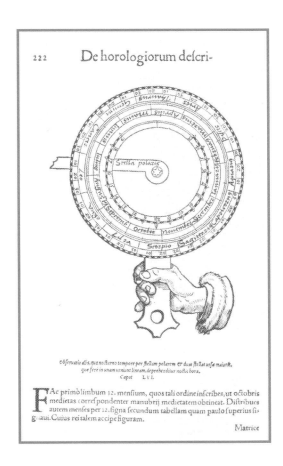

d

a. *Sundial*
b. *Cylindrical Sundial*
c. *Concave Sundial*
d. *Noctural*

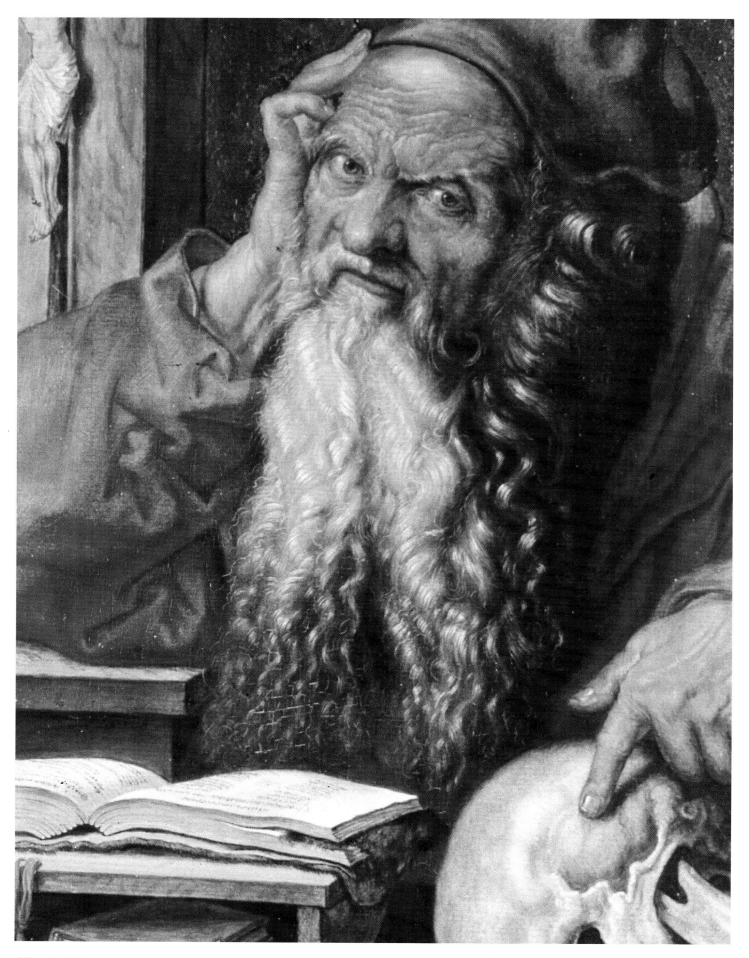

Albrecht Dürer
*Saint Jerome*
Wood, 59,5 x 48,5 cm
Museum of Historic Art, Lisbon

# THE ANAMORPHOSIS
# OF THE SKULL

The death's-head is at once part of the still life and part of the portrait. Sitters are paired with a death's-head by various portrait painters of the period—from Bartholomäus Bruyn the Elder to Lucas van Leyden. The immortalized subject puts his hand on a skull as a symbol of his own transience. The skull thus becomes the antithesis of the eternalized portrait.

In *The Ambassadors*, on the other hand, the anamorphosis dissimulates the view of the death's-head, which forms a separate pictorial level from that of the still life and that of the subjects. The two-dimensionality of the anamorphosis is suggestive of a tondo, a mirror or a coat of arms, on which something is reflected.

In contrast to this symbolic representation of human mortality, the faithful in the days of Jan van Eyck were confronted with the image of a terrifying beast of death. Depicted as a winged skeleton, this hybrid beast personified death and the underworld and dwelt, according to the Bible, "in the lake of fire and brimstone" (Revelation 20:10).[70] Columbus and Magellan, the great circumnavigators of the earth, had not come across this underworld, which they believed to exist, and struck this domain off the map of the world. The vision of heaven and hell was superseded by an admonitory picture of man's own physical corruption, the tragic, but utterly human, downfall of the individual.[71]

Bartholomäus Bruyn the Elder
*Portrait of a Knight*, 1531
Wood, 63 x 47 cm
Museum of Historic Art, Vienna

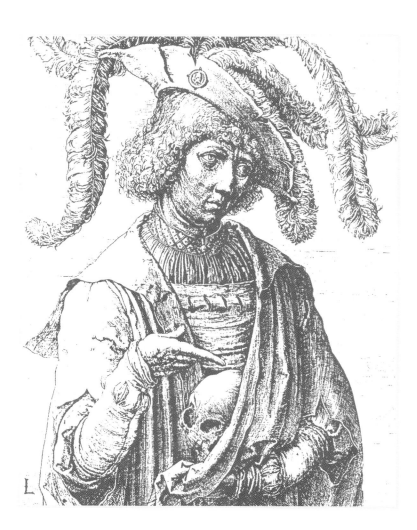

Lucas van Leyden
*Young Man with Death's-head*, 1519
Rijksmuseum, Amsterdam

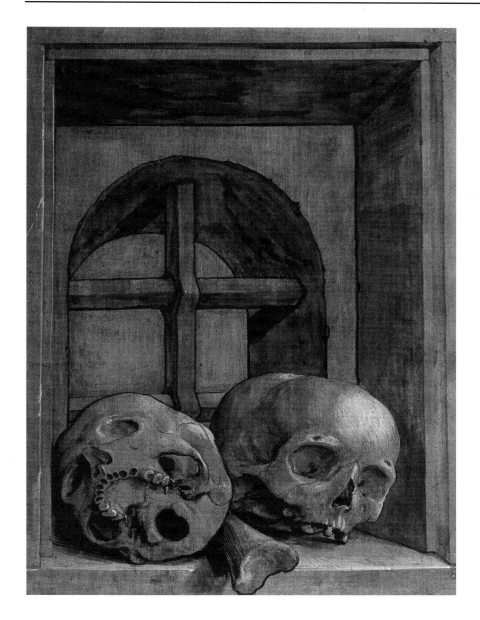

Hans Holbein the Younger
*Two Death's-heads on the Embrasure of a Window*
Tempera vernished on wood, 33 x 25 cm
Public collection, Art Museum, Basel

Henkel / A. Schöne
*A Scholar and Death, 'Emblemata'*
Roll. I, N°. I

There is a parallel shift from the allegorical representation of the beast of death to the symbolism of the skull. The death's-head is shorn of its emotional connotations, as enjoined by Erasmus in his *Preparatione ad mortem* (Preparation for Dying) (1533), in which he condemns the preachers for seeking to terrify the faithful with their descriptions of hell.

Theologians of the period coined the concept of the sleep of the soul. In 1524 Luther declared in a sermon that after death the soul sleeps until God awakens both body and soul for the Last Judgement.[72]

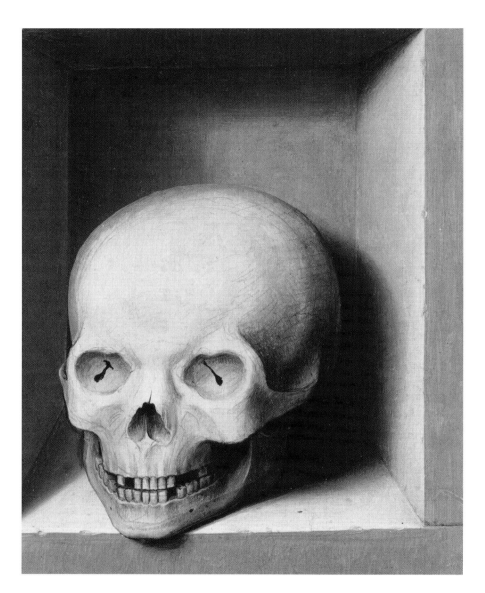

Erasmus urged the individual to meet death with stoic serenity and liberate himself from all pathos. In his eyes, private meditation should take the place of formal confession. Dispensing with heaven and hell as counterparts to this world, he held the individual accountable solely to the world in which he lives. Erasmus mocked all those who went on pilgrimages to Jerusalem or Rome, for instance, on the grounds that they had no business being there and leaving their wives and children in the behind.[73]

## The death's-head as an object of meditation

The skull in *The Ambassadors* is placed in the foreground and a small silver cross is hung on the left side of the frame.[74] The death's-head and crucifix are integral iconographic elements of portraits of St. Jerome. Dürer's painting of St. Jerome pointing to a death's-head, with a crucifix in the upper left corner of the backdrop, might have served as a model.[75] But the proportions of the crucifix and death's-head in traditional crucifixion scenes are reversed here. In accordance with the theological antithesis between death and resurrection, a life-sized cross symbolizes the twofold nature of Jesus as a man and the Son of God, in contrast to the small death's-head of Adam lying on the ground, as, for example, in the *Crucifixion* by Rogier van der Weyden.

Hans Memling
*Diptych with St John and St Veronica*, c. 1483
Oak, 31,6 x 31,2 cm
Alte Pinakothek, Munich
Detail

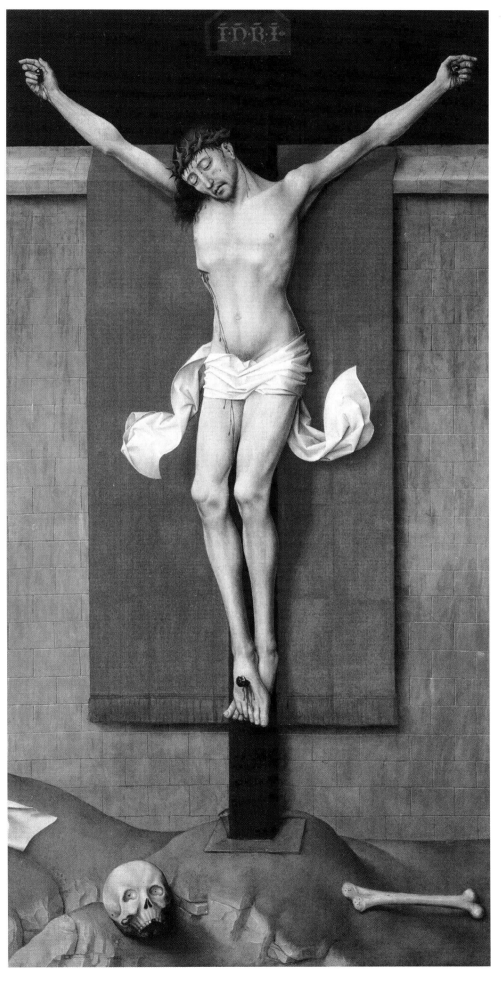

Rogier van der Weyden
*Crucifixion.* c. 1460
Oak, 180,3 x 92,3 cm
John G. Johnson Collection
Art Museum, Philadelphia

Hugo van der Goes
*Holy Trinity.* c. 1475–1479
Oak, 202 x 100,5 cm
Royal Collection, National Gallery of
Scotland, Edinburgh Panels, Edinburgh

Opposite page:
*French Book of Hours of
the Tourottes Family*
Miniature of Walters, 222,
fols 1v–2, Cat. N° 45

By dying on the cross, Christ conquered death, which had been brought into the world by Adam's original sin. In Dürer's picture of the small crucifix and relatively large skull, on the other hand, the latter refers to the mortality of the saint, who in the Bible gains access to the divine realm.[76] The crucifix and the page with the Last Judgement are symbolic indications of inward readiness for meditation. Moreover, Saint Jerome urges the viewer to follow his example. "You, too, shall die" (*morieris*), warns the death's-head on the outside panel of a diptych by Hans Memling. Paradoxically, it is the prospect of non-existence that creates a direct link between the subject and viewer. The skull, whose identity can no longer be established—for it could be anyone— appeals in terms of "thou and me" to the conscience of each viewer as a distinct individual. The tradition of the speaking skull or sepulchre is taken up in a poem by Michelangelo Buonarroti in memory of Cecchino Bracci: ... *la sepoltura parla a chi leggi questi ver*si. The grave speaks to those who read these verses—and, in so doing, bring them back to life.[77]

# The knowing mirror of *Prudentia*

In Laux Furtenagel's contemporary portrait Mr and Mrs Burkmair's gaze is answered by two death's-heads in the mirror with the words: "Know thyself."[78] With the appearance of the death's-heads, the reflection takes on a preternatural life of its own. Ancient religions ascribed to mirrors, above and beyond mere reflection, the magical ability to reveal the human soul. This power of revelation is connoted by the Hebrew word for mirror, *re-a-i*.[79] In his portrait of the couple, Furtenagel envisions their bodily decay. Behind the pictorial surface lie the moral claims of the reflected soul (*speculum conscientie, mirror of consciousness*). The reflection is no longer the visual duplication or representative continuation of the gazer's world. The true mirror of life disposes of the beguiling illusion of the present tense: time and death step in between the picture and viewer. The image attains independence. Picture and image, or body and shadow, cease to coincide.

A woodcut entitled *The Devil's and Angel's Mirror* should also be mentioned in this connection.[80] On the left-hand side an evil angel is holding up a picture of the world to a couple; his tempting words are given below: "Look happily at this mirror. It promises that you have many years yet to live." On the right-hand side, however, a good angel is showing a mirror with a death's-head to another group of people, entreating them as follows: "O, man, gaze long upon [this], for you shall be as this thing is ... And warn the people against worldly extravagance; so shall thy soul be ready for God."

This juxtaposition of life and death can be traced back to the tradition of pictures stretched upon strips of wood and suspended from a string in the church. On one side of the picture is a handsome couple looking at themselves in the mirror, on the other side is a picture of death. The picture would turn with every draught of air, suggesting the swift transition between life and death.[81] In the antithetical composition of *The Ambassadors*, Holbein has directly juxtaposed these two aspects, the worldly mirror and the admonitory appearance of death.

## Vanitas: an ambiguous element of the picture

In *The Ambassadors* the skull becomes an independent detail that undermines the homogeneity of the composition. A contemporary example of a similarly ambiguous detail occurs in the engraving *Nude on a Death's-Head* by Master M. Z.[82] Set in a slightly hilly landscape of woods and meadows, the woman is holding in her right hand a portable sundial and a small globe upon which the Greek letter *tau* is engraved. She is standing on a skull. Similarly, the Roman goddess Fortuna was often represented standing on a ball to indicate the uncertainty of human fortunes. The German Master is playing on the correspondence between the sphere and the skull. The similitude is based on an asserted resemblance between things that provides the basis for their association and generic designations. Hence the ambivalence that allows Fortuna and death to be combined in a single pictorial level. This toying with ambiguity is part and parcel of the artistic endeavour. Like one of the Fates, the woman warns against the peril of apparent luck that leads the unwitting into corruption; her tiny wobbly pedestal is an intimation of death.

It should be stressed that from Aristotle to Erasmus, the idea of change, time and transience was symbolized by the shape of the sphere. In his *Adagia*, Erasmus quotes a saying that goes back to Varro and Lucian: "*homo bull*" (man is bull). The soap bubble symbolizes the illusory nature of the world. "What is life but a light bubble? a passing draught of air? that flies off like a shadow … Death advances at the instant of birth and likewise the end follows upon the beginning."[83]

The crystalline globe at the feet of God the Father and his Son in the *Trinity* by Hugo van der Goes represents the world, whose shimmering transience may be likened to that of Erasmus' soap bubble.[84] Given its position in the painting, the skull anamorphosis in *The Ambassadors* carries on the above-described pictorial tradition of the sphere, which thus serves to augment its significance.

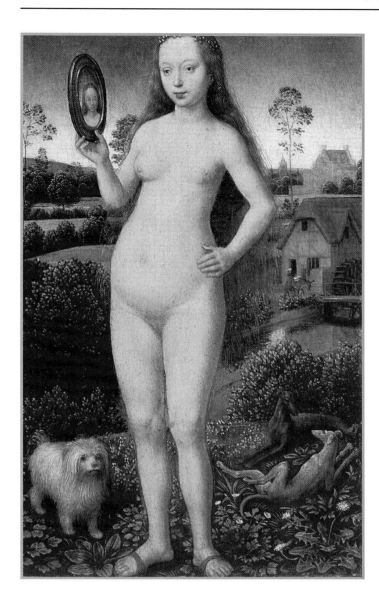

Studio of Hans Memling
*Vanity*, c. 1500
Oil on oak, 22 x 14 cm
Museum of Fine Arts, Strasbourg

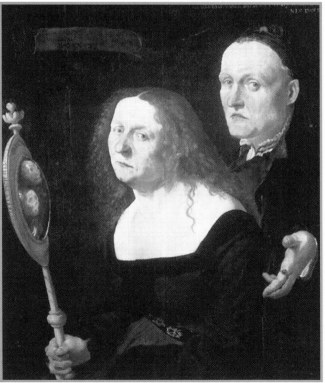

Laux Furtenagel
*The Burkmairs*, 1529
Wood, 60 x 52 cm
Museum of Historic Art, Vienna

# The skull anamorphosis: a stumbling block

Another point of tension in the picture, again a matter of visibility and concealment, is the anamorphosis at the aesthetic boundary between the viewer and the two protagonists. Whereas the amorphous figure serves to draw the viewer's attention to that boundary, the approaching viewer is faced head on by the Ambassadors. They do not seem at all concerned about the

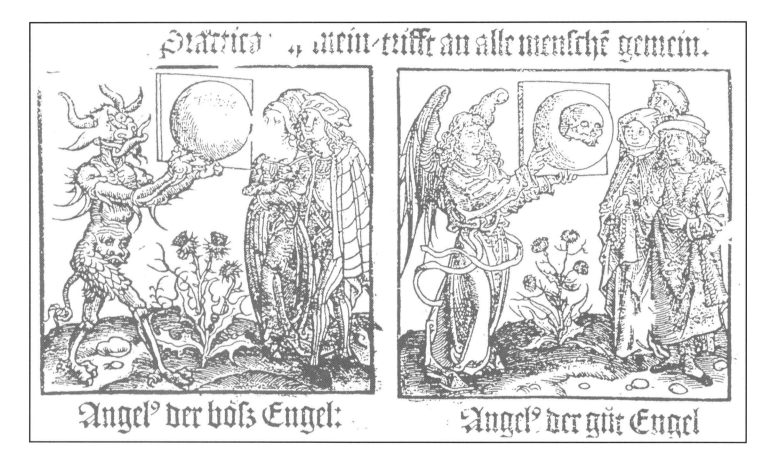

abstruse object at their feet. In purely formal terms, Holbein establishes a meaningful parallel from the viewer's perspective in the resemblance between the shape of the beret worn by Jean de Dinteville and that of the anamorphosis. At this formal double level of pictorial details, he heightens the metaphorical links by visual means, creating a viewer-oriented system of references.

Plato declared the head to be the most divine of man's parts by virtue of its spherical shape and its orientation towards the heavens. Aristotle writes in his treatise on the body parts of animals that man is the only animal that bears himself upright, looks face to face and aims his voice in the same direction as his eyes.[85] Time and again Erasmus reverts to the struggle between the head and the recalcitrant body.[86]

*The Devil's and Angel's Mirror*
Woodcut, late 15th century
Württembergische Landesbibliothek,
Stuttgart

Hans Baldung Grien
*The Three Ages and Death*, 1509–1510
Oil on linden, 48,2 x 32,7 cm
Museum of Historic Art, Vienna

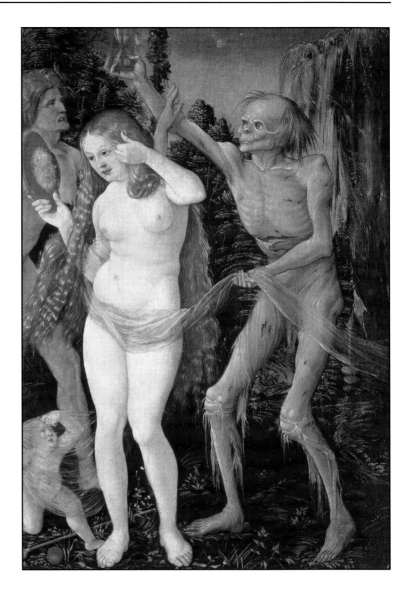

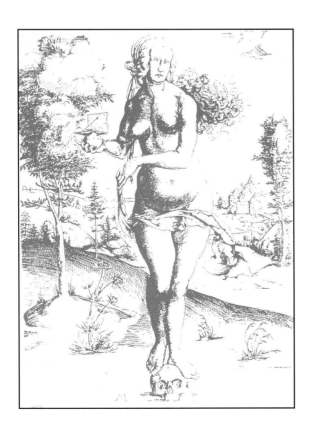

Master M. Z.
*Nude on a Death's-head*,
16th century, 7,3 x 5,1 cm
National Gallery of Art, Rosenwald Collection,
Washington D.C.

The skull lying on the floor in *The Ambassadors* is therefore all the more surprising.[87] Elucidation of Holbein's ambiguous detail may be found in the link to the deadly stone in the Old Testament: "… lest thou dash thy foot against a stone" (Psalm 91:12).[88] Those who are unaware of the fleeting nature of their earthly existence will trip on the biblical "stumblingstone" (or stumbling block

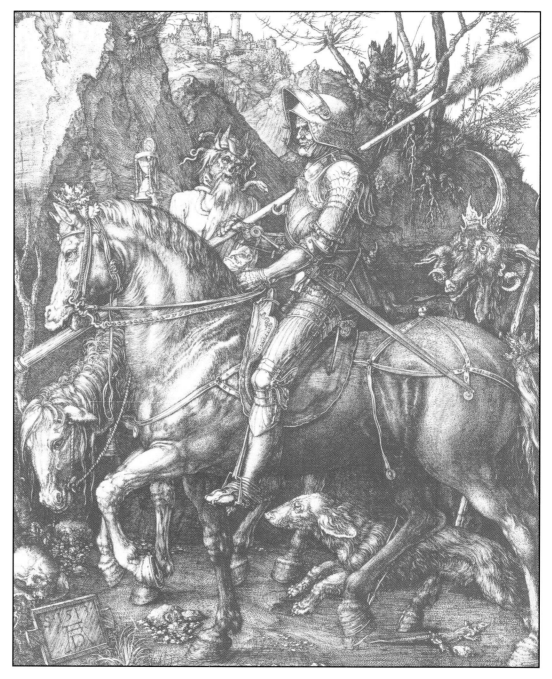

Hans Holbein the Younger
*Christ Beneath the Cross*, c. 1520
Woodcut, 17,3 x 27,8 cm
Public collection, Department of Engravings,
Art Museum, Basel

Albrecht Dürer
*Knight, Death and the Devil*
Copper engraving, 24,5 x 19 cm
Staatliche Museen, Preußischer Kulturbesitz, Berlin

in modern English). In the captions to *Les Simulachres et Historiées faces de la mort*, Jean de Vauzelles wrote the following lines concerning the cornerstone: "*Qui est ce qui a laissé la Pierre angulaire, dist Job (38) sus lesquelles parolles fault noter que la pierre est dicte en Latin lapis, qui vient selon son ethimologie de lesion de pied. Car aux cheminans quelque foys se rencontrent les pierres ... Souvent font trebucher les gens.* (Who leaves the stone, said Job, and the stone means *lapis* in Latin, which is the lowest part of the body near the foot) [W]ho laid the corner stone thereof," asks Job (38:6).[89]

The etymological connection here between *lapis* (stone) and *lapsus* (slipping and falling) is revealing; this pun was taken up by the then widely-read Isidore of Seville (*Etymologies* XVI, ch. 3) and put into circulation in the phrase: *Lapis autem dictus, quod laedat pedem.*

*Skeleton with a Sphere*
French woodcut, 11 x 16 cm
Metropolitan Museum of Art, New York

# DES·ERAS-
## MI ROTERODAMI

*liber cum primis pius, de præparatione*
*ad mortem.*

*Declamatio eiuſdem de morte.*

*Concio de puero Ieſu.*

*Carmen de caſa natalitia pueri Ieſu, cum aliſs quis*
*buſdam pñs ſimul et doctis eiuſdé autoris uerſibus.*

*Omnia per autorem diligenter recognita.*

### THEOBALDVS PAGANVS EXCV₈
### DEBAT LVGDVNI,
### M. D. XXXIX.

Frontispiece by the engraver Theobaldus Paganus
*'Erasmus de praeparatione ad mortem'*, 1539
Lyon

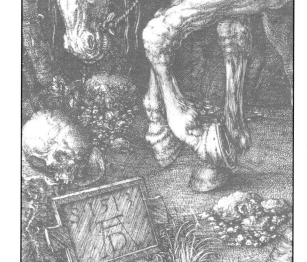

Albrecht Dürer
*Knight, Death and the Devil*
Detail

Holbein's *Christ in the Tomb* ought to be mentioned in this context. Holbein affixed his signature above the feet of the corpse.[90] The foot was regarded as the basest part of the human body, with which a person comes into contact with the earth and the dirt on the ground. The skull anamorphosis as a stumbling block permits a new interpretation, in hindsight, of Dürer's 1513 engraving, *Knight, Death and the Devil*. The devil and death, in the form of a semi-decomposed corpse, are lying in ambush for the knight on horseback.[91] They represent the dangers of the world to which the knight is exposed on his pilgrimage along paths far from God. These perils—and this is what creates the dramatic tension— are visible only to the viewer, who perceives both the knight and the devil, and thus the intended moral. Only those who are prepared for the fatal stone, symbolized by the tree stump on the far left next to Dürer's signature and the death's-head, will be spared eternal death.

This interpretation is corroborated by the printer's mark of Theobaldus Paganus on the frontispiece to Erasmus' *De Praeparatione ad mortem*.[92] It shows a man on horseback. On the ground is a Janus-faced stumbling block—half skull, half profile of a man— which a snake is approaching. "You do not know yourself and, in your short-sightedness or absent-mindedness, you do not notice the ditch or stone at your feet," writes Erasmus,[93] relating self-knowledge to awareness of the stumbling block, i.e. knowledge of death.

In his commemorative woodcut *Erasmus*, which dates from 1538, Holbein shows the deceased beneath a triumph-like Renaissance arch with his emblem, Terminus, the Roman god of boundaries, on whose head Erasmus has wisely placed his hand. Holbein has substituted the figure of Terminus for the skull anamorphosis here.[94] The scholar looks on pensively with his right hand resting on the herm, a symbol of death, which in turn seems to be looking the viewer in the eye.

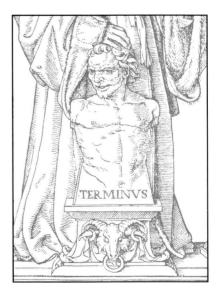

Hans Holbein the Younger
*Erasmus of Rotterdam*, late 16th century
of Veit Specklin, Woodcut, 28,6 x 14,8 cm
Public collection, Department of Engravings, Art Museum, Basel

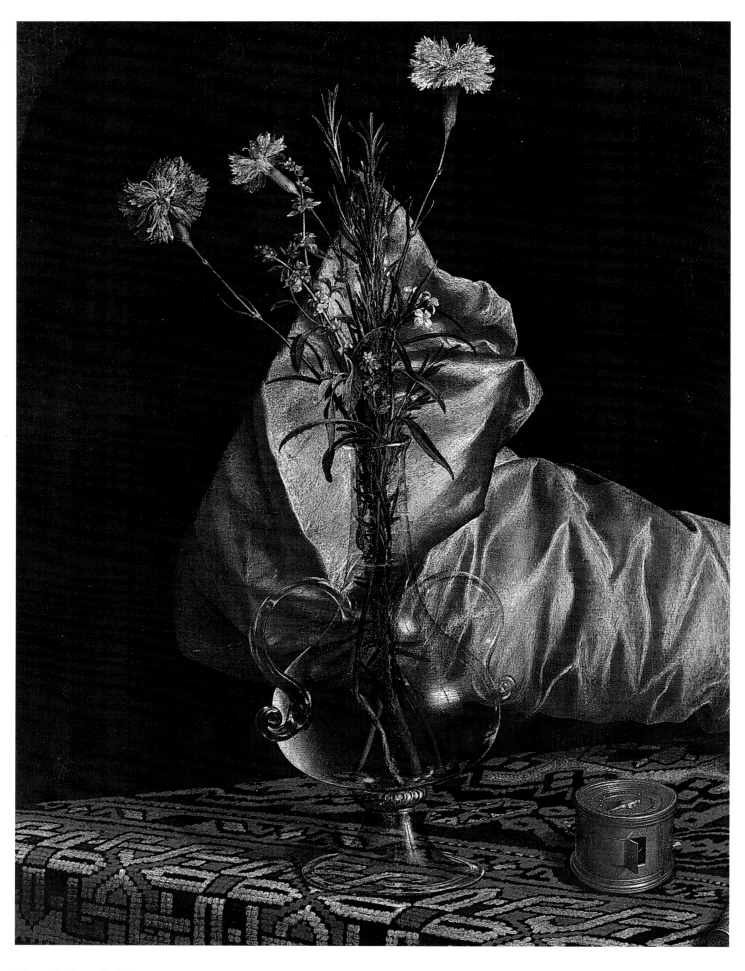

Hans Holbein the Younger
*Portrait of Georg Gisze*
Detail

# The significant shadow

In the *Portrait of the Merchant Georg Gisze*, Holbein bestows equal attention on the glass vase, the pewter ink pot with quills, the heavy light-brown book fastened with a dark-red belt to the left of the subject, the white letters with writing in black ink and the metal nails on the vertical light-green wooden slats on the walls, enabling the viewer to discover these objects in their substantive pictorial reality. This richness of detail reflects the affluence of Holbein's subject as well as his own dazzling artistic ability to create the illusion of reality.

In the apparently unruffled world the artist presents, however, minute incongruities confound the viewer's perception. Two small pewter vessels with pens and a broad can filled with coins are thrust to the fore on the right-hand side. The white quill and the indentation in the ornamental rug suggest that the table ends here and that the objects are in danger of falling. This appearance of still-life elements slipping away from the world of the picture was later to become an artistic convention. It is part of an attempt to do away with the aesthetic boundary between the viewer and the world portrayed in the picture. As in Holbein's *Dance of Death* woodcuts, the viewer cannot help wishing to stave off the impending "ruin: of the depicted world. But what about the trough-shaped hollow in the rug covering the table? Is it a rebus, i.e. a visual conundrum, punning on the name "Hol-bein" (literally hollow bone)?

It may be noted in passing that the pattern of the Greek cross[95] in the Anatolian rug that serves as a tablecloth had been previously used for mosaic decor in Hans Holbein the Elder's *Fountain of Life*.[96] The concavity of the rug at the edge of the table contrasts with the magnified convex portion perceived through the glass vase. This depression and curvature break up the stasis of the picture surface and bring it to life—while providing a fine demonstration of the artist's acumen.[97]

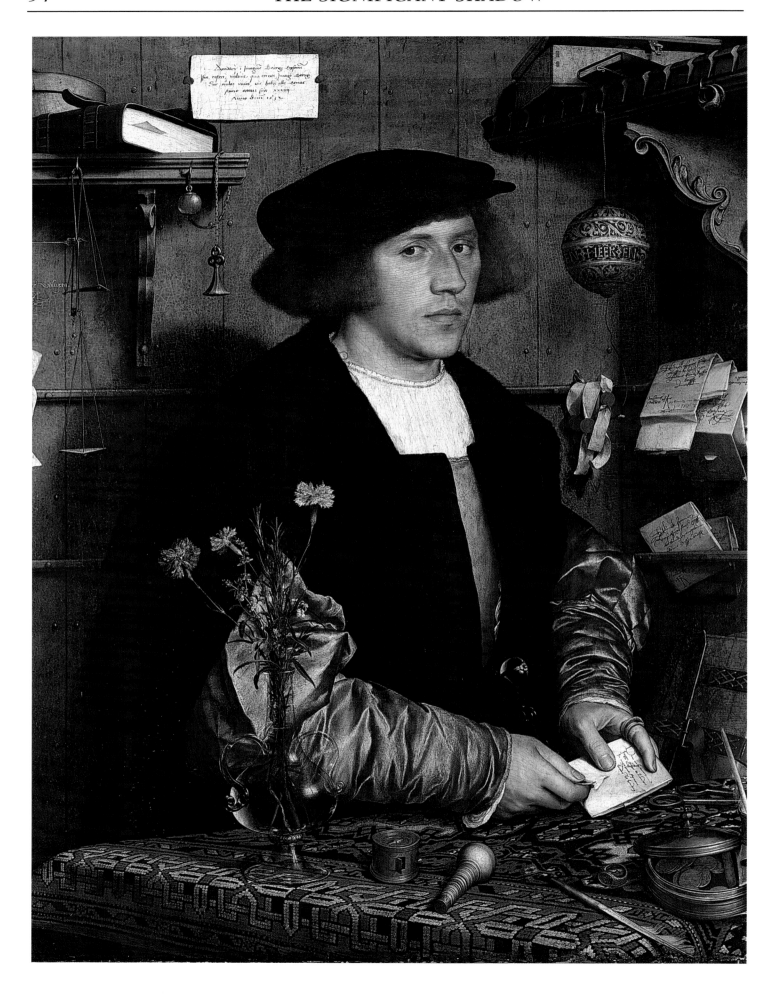

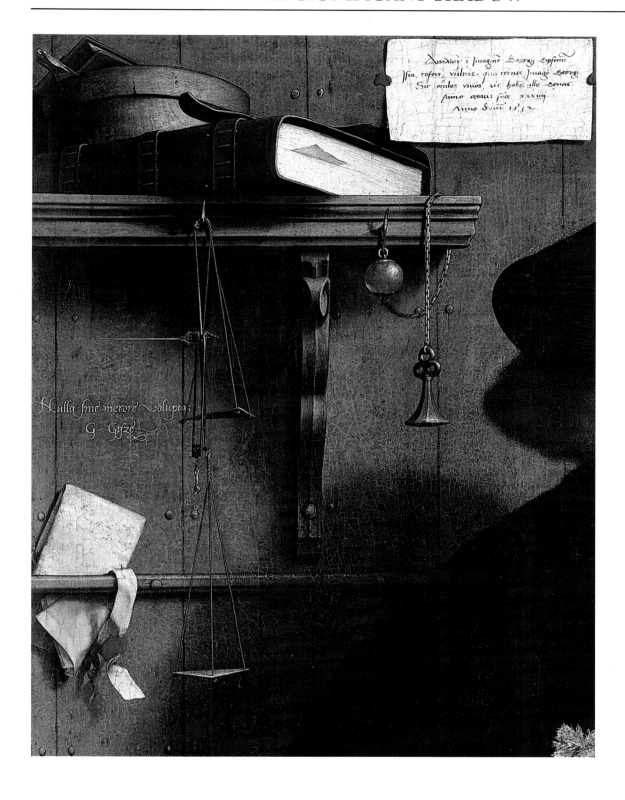

Opposite page:
*Portrait of Georg Gisze.* 1532
Oak, 96,3 x 85,7 cm
Staatliche Museen, Gemäldegalerie, Berlin
Above: Detail

Two reflections on the vase indicate light emanating from a source on the right. The ball of yarn hanging on a string from the upper shelf, artistically embellished with green and yellow floral patterns, and Gisze's upper body cast shadows on the light-green rear wall. Paradoxically, no shadow is cast by the other objects—the scale and the little bell with the ornamental ball on the left. What is the explanation for this inconsistent handling of light and shadow that accords temporal and spatial dimension only to certain elements of the picture? Dangling on a string at the sitter's eye-level, the ball of yarn bears the words "EN HEER EN" (to the Lord), which lends this otherwise practical object a moralizing quality in allusion to Gisze's spiritual gaze.

The admonitory writing on the wall, which Holbein frequently employs as a two-dimensional space for commemorative purposes, provides a word to the wise: "NVLLA SINE MERORE VOLVPTAS G. GISZE" (no pleasure without price). The adage is at odds with the colourful sensual world of the sitter in his three-dimensional vitality. The cartellino added by Holbein in the background also refers to this opposition, addressing the viewer as follows: "*DISTIKON. In Imaginem Georgii Gysenii/Ista refert vultus, quam cernis. Imago Georgi/sic oculos vivos, sic habet ille Genas/Anno aetatis suae XXXIIII/Anno Dom. 1532*" (This portrait you see shows the features of Georg, so lively is his eye, thus are his eyes shaped). A sense of immediacy is engendered by directly addressing the viewer in the present tense. Thus, Gisze, at the age of 34 years in the year of our Lord 1532, has shining eyes and healthy cheeks. The vivacity of the eyes refers to Gisze's gaze inward into his soul. The notion of the eyes as "windows of the soul" goes back to Cicero[98] and Lucretius,[99] who wrote: "We have two windows that go from the soul to the eyes." Body and soul meet in the eye.[100] Otherwise invisibly sealed off within the body, the soul is rendered visible here on the threshold between inside and out in Gisze's gaze, which suggests his inner life. By means of these articulate eyes, moreover, Holbein overcomes the opposition inherent in the two-picture doctrine between the life within and without, the portrayable body and unportrayable mind.[101]

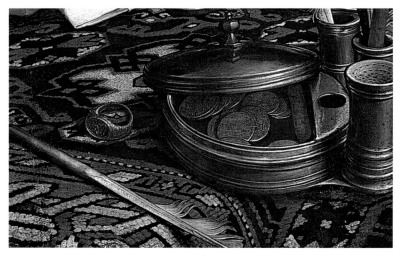

*Portait of Georg Gisze*
Detail

Another instance of significant handling of light and shadow involving the eyes and the divine gaze is the *Portrait of William Warham, Archbishop of Canterbury*. At first glance one notices that the subject is framed by multiple insignies: to his right a golden processional crucifix, his coat of arms and the inscription "*Auxilium meum a Domino*"; to his left a mitre lavishly studded with pearls and precious stones, and in front of him an open book. His hands are placed on a cushion embellished with floral patterns in black and brown. Beneath the mitre cap and the books lies an Anatolian rug, which swathes the scene in luxurious adornment: it is thrown over a kind of chair-back on the right-hand side and falls straight down on the left. The backdrop is covered by a green and black brocade curtain falling in loose folds. The close decor in this overloaded composition precludes any sense of space.

The use of the processional cross and mitre may be drawn from the *Portrait of the Cardinal of Bessario*[102] in the Albergo della Scuola della Carità in Venice. This, the second portrait of the cardinal, is a copy executed by Gentile Bellini to replace the first, which had been stolen. *The Portrait of the Chancellor Guillaume Jouvenel* by Jean Fouquet, another possible model, shows the subject absorbed in prayer with a book and cushion.

An explanation for the paradoxically youthful appearance of Warham's hands on the cushion may be culled from a passage in Erasmus' *Enchiridion*, in which the latter extols divine knowledge of the Scriptures while fulminating against those who set about reading them though their feet and hands are unwashed. He warns: "Yet for all that, it must always be borne in mind that one may touch the divine books only with washed hands, that is to say with pure hearts."[103]

Another hint regarding the enigma of the shadow is the observation that only the processional crucifix casts a shadow on the heavy brocade curtain—all the more astonishing in view of the absence of any shadow cast by Warham's body. Where the latter is expected, one finds a fall in the folds of the curtain instead, above which a cartellino is affixed. The shadow of the crucifix, particularly its horizontal arm, is at the subject's eye-level, thus emphasizing here as well his divine gaze.

One final example is Holbein's painting of the *Device of Erasmus of Rotterdam*. It harks back to a medallion of Erasmus as well as a ring of his, both bearing busts of Terminus with the horizontal inscription "CONCEDO NULLI" (I submit to no one).[104] To the criticism of his contemporaries that he was struck by hubris, Erasmus replied that he was not 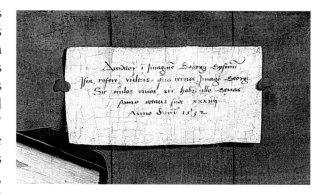 the one speaking here, "but the ancient god of boundaries, death himself,"[105] admonishing him that his "last little hour is nigh".[106] These words sound contradictory coming from Erasmus, who was generally sceptical about Holbein and pictorial art, but this statement endows the picture of his device with the autonomy of a cult object that speaks with a voice of its own.[107] This animated figure is similar to the skull anamorphosis in *The Ambassadors* in that it transgresses the aesthetic boundary of art.

Holbein placed the ancient herm on a pedestal, much like the Christian cornerstone, with the inscription: "Terminus." Erasmus described the Terminus in a letter, dated 1 August 1528, to Alfonso Valdes: "One sees a column on the seal: below, it is a block; above, a young man with his hair streaming back."[108] He also refers to the analogy between Terminus and a death's-head: "One will say you could have engraved an inscription on a death's-head."[109] Half sculpture, half man, this figure stands on the threshold between light and dark, life and death.[110] A bright streak of light falls into the dark pictorial space and enlivens the figure, which stands on shady ground. The haloed man is facing in the direction of this supernatural light source. The portraits of Gisze and Warham

*Portait of Georg Gisze*
Detail

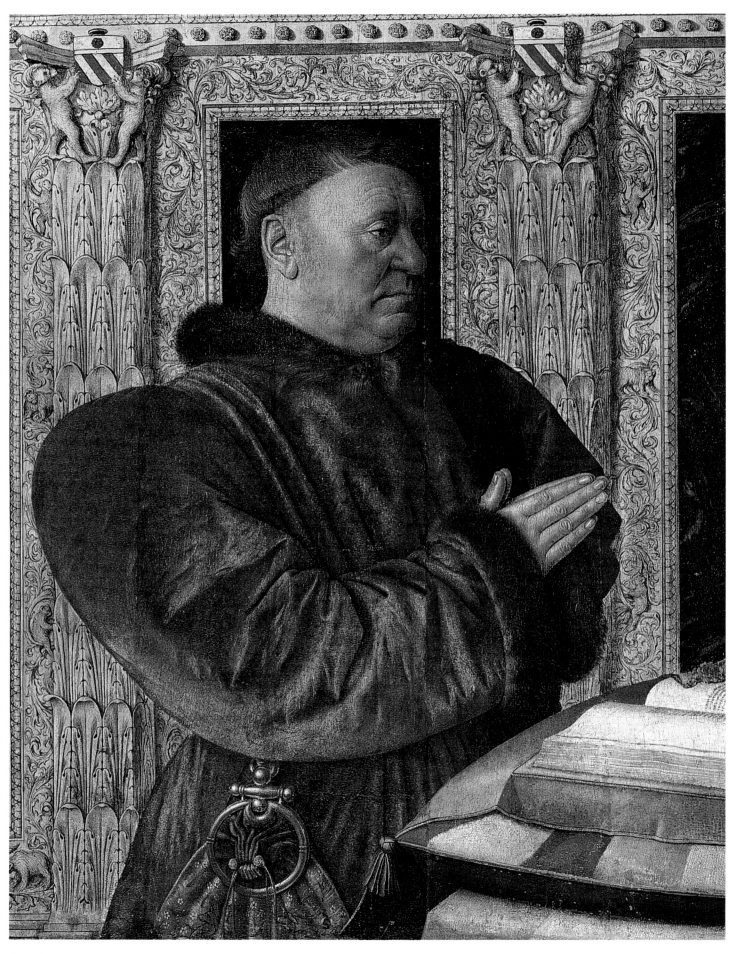

Jean Fouquet
*Portrait of Guillaume Jouvenel des Ursins*, 1460
Wood, 96 x 73 cm
Louvre, Paris

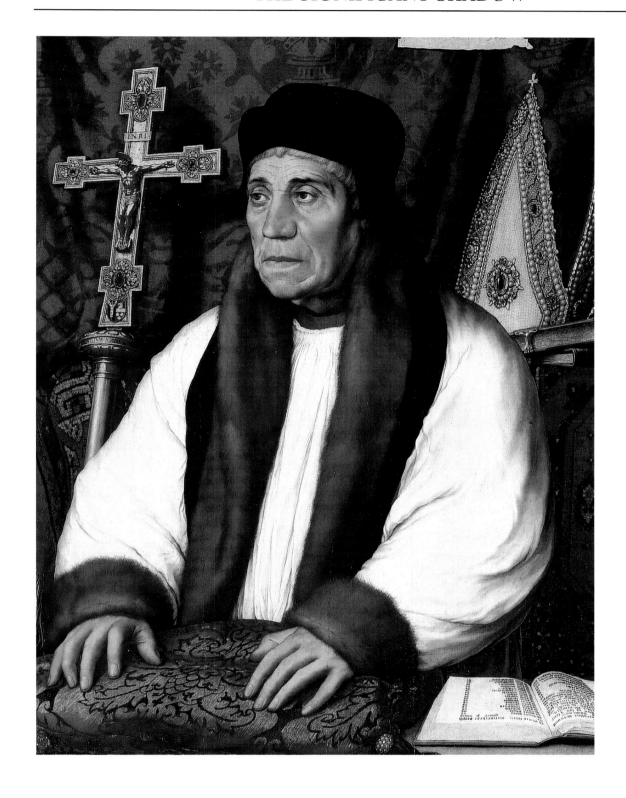

Hans Holbein the Younger
*Portrait of William Warham, Archbishop of Canterbury*, 1527
Oak, 82 x 67 cm
Louvre, Paris

Gentile Bellini
*Portrait of the Cardinal of Bessario*
Albergo della Scuola della Carita, Venice

as well as the stained-glass design for Erasmus demonstrate that *The Ambassadors* is not the only work of Holbein's in which light and shade are used for meaningful effect.

While opening up the perspective in the background was an important achievement of Renaissance painting, Holbein stresses the foreground in *The Ambassadors* by means of the anamorphosis and in the *Virgin with the Family of the Mayor Jakob Meyer* by means of the crinkled rug. In the latter, which is an altarpiece, the family of the Basel, Jakob Meyer zum Hasen, has gathered round the Virgin Mary seeking protection: to her right is Meyer with his two sons, to her left are his first and second wives and his daughter.[111] John, his younger son, is motioning with his hand towards the unusual wrinkle in the rug, thereby drawing attention to this enigmatic detail.[112] Formally reiterated by the folds in the Madonna's robe, the buckling of the rug suggests that she is in motion, having risen slightly from her throne with one foot a little forward.

A crinkled rug in the foreground is likewise found in *The Virgin and Child* by

Hans Holbein the Elder. The Latin word for fold, *sinus*, provides a cogent clue to the rebus. A concave fold describes at once the protective lap of the Mother (*in sinu gestare*), the miraculous Conception and the gesture of turning towards the faithful.[113]

Another significant fold occurs in the *Madonna on the Balcony* by Hans Holbein the Elder, which dates from c. 1519, one of the first depictions of the Madonna and sleeping Child north of the Alps.[114] The so-called *Maria lactans* is holding her sated Child at her naked breast. The motif of the Virgin and the sleeping Child is deemed a prototype for the *pietà* scene where Mary laments her dead Son. Sleep is a metaphor for the Passion from whose sleep of death the Son of God will awake.

Golden letters are embroidered on Mary's blue velvet dress, which, according to the German art historian Wilhelm H. Köhler, recall the words of the Marian antiphon recited during the mass at Easter: REGINA CAELI, LAETARE, ALLELUIA, QUIA QUEM MERUISTI PORTARE, ALLELUIA, RESURREXIT SICUT DIXIT, ALLELUIA ORA PRO NOBIS DEUM, ALLELUIA. But the words are only sporadic, some hardly recognizable: REGINA C[AELI] (Queen of Heaven) and RESURREXIT are written beneath the foot of the sleeping Child.

Hans Holbein the Younger
*Terminus with the Device of Erasmus of*
*Rotterdam*, 1532, Oak, 21,6 x 21,6 cm
Cleveland Museum of Art, Ohio

Lorenzo Lotto
*Portrait of a Young Man*, 1506–1508
Wood, 42,3 x 35,3 cm
Museum of Historic Art, Vienna

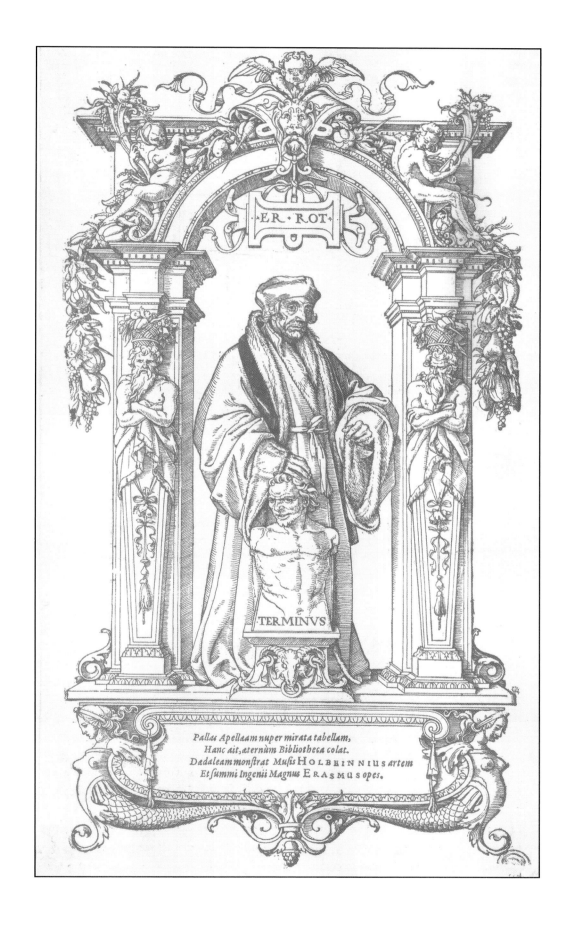

·ER·ROT·

TERMINVS

*Pallas Apellæam nuper mirata tabellam,*
*Hanc ait, æternùm Bibliotheca colat.*
*Dædaleam monstrat Musis* HOLBEINNIVS *artem*
*Et summi Ingenii Magnus* ERASMVS *opes.*

Hans Holbein the Younger
*Erasmus of Rotterdam.* late 16th century
of Veit Specklin, Woodcut, 28,6 x 14,8 cm
Public Collection, Department of Engravings,
Art Museum, Basel

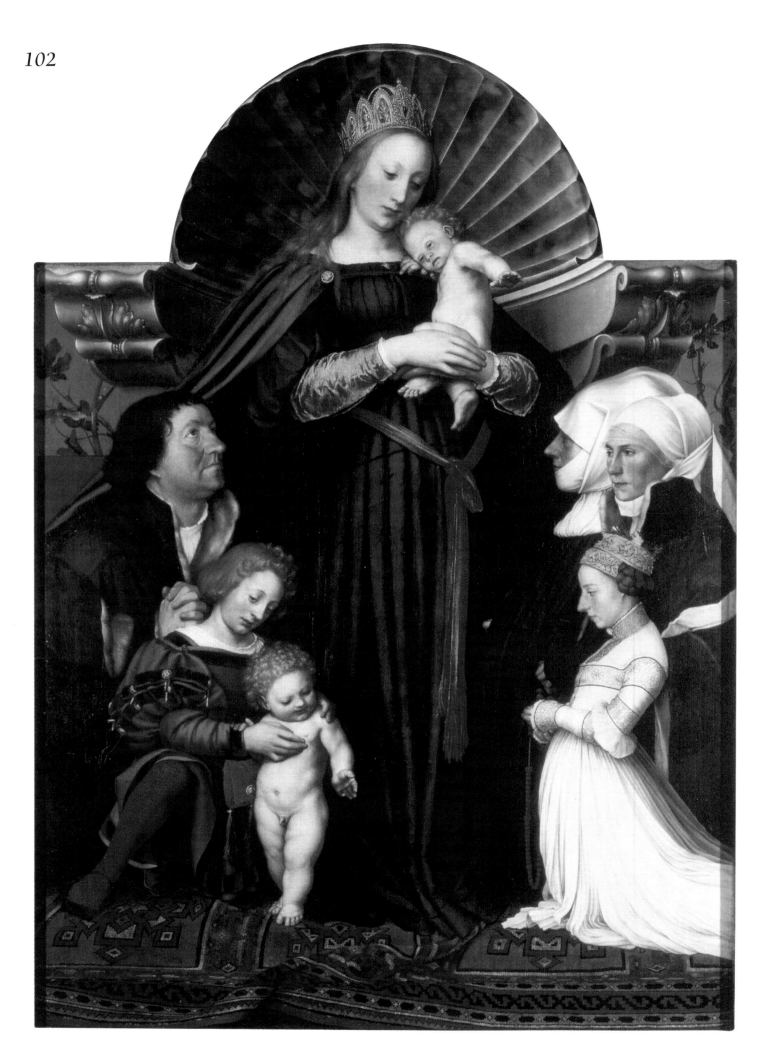

Hans Holbein the Younger
*Virgin with the Family of the Mayor Jakob Meyer*, 1526–1530
(*'Darmstadt Madonna'*)  Linden, 146,5 x 102 cm
Collection of the Princes von Hessen and von Rhein
Darmstadt Castle

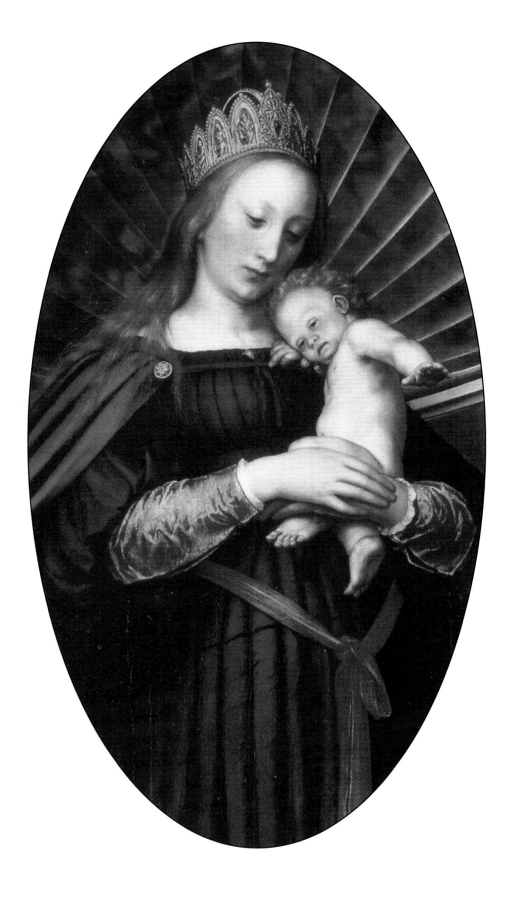

Hans Holbein the Younger
*Virgin with the Family of the*
*Mayor Jakob Meyer.* Details

Heaven) and RESURREXIT are written beneath the foot of the sleeping Child. The word LAETARE is written on Mary's lap, although the "A" is concealed by a fold. Yet contrary to the interpretation advanced by Köhler, who thinks this reveals Holbein's insufficient knowledge of Latin, a highly subtle homonym is involved here. The word LAETARE, or *laetus*, refers to milk, fertility and a full harvest, connoting joy and happiness. LETARE, on the other hand, derives from *letum*, meaning death, dying. Hence, the word LETARE inscribed in the fold on the Mother's lap suggests that the fruit of her womb is bound to die.

The inscription on Mary's cloak falls back on a long-established convention practised particularly by Jan van Eyck, although here it comprises quotations of hymnal exclamations, not the kind of punning at which Holbein's father was so adept. A *contretemps* disturbs the harmony of this Mother-and-Child scene, however. Above them both, three amoretti are holding up a gold-brocaded baldachin, green on the outside, bluish, blackish and grey on the inside. Next to the infant Christ hovers a virtually identical putto, from whose hands has just slipped the ring with which he was holding the precious veil. This mishap eases the hieratic solemnity of the scene; a more or less human gaffe serves as comic relief in this otherwise perfect celestial realm.[115]

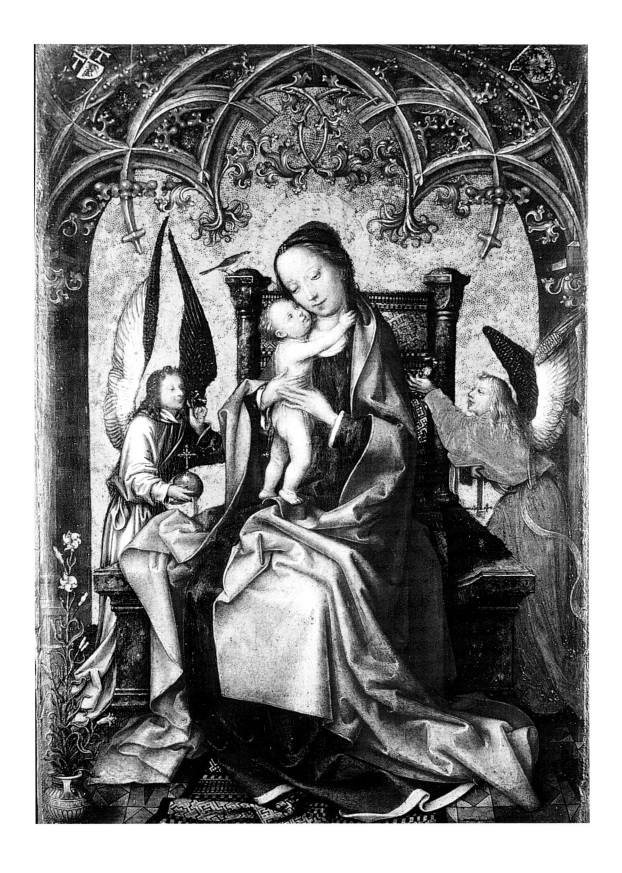

Hans Holbein the Elder
*The Virgin and Child*, 1499
Wood
Germanisches Nationalmuseum,
Nuremberg

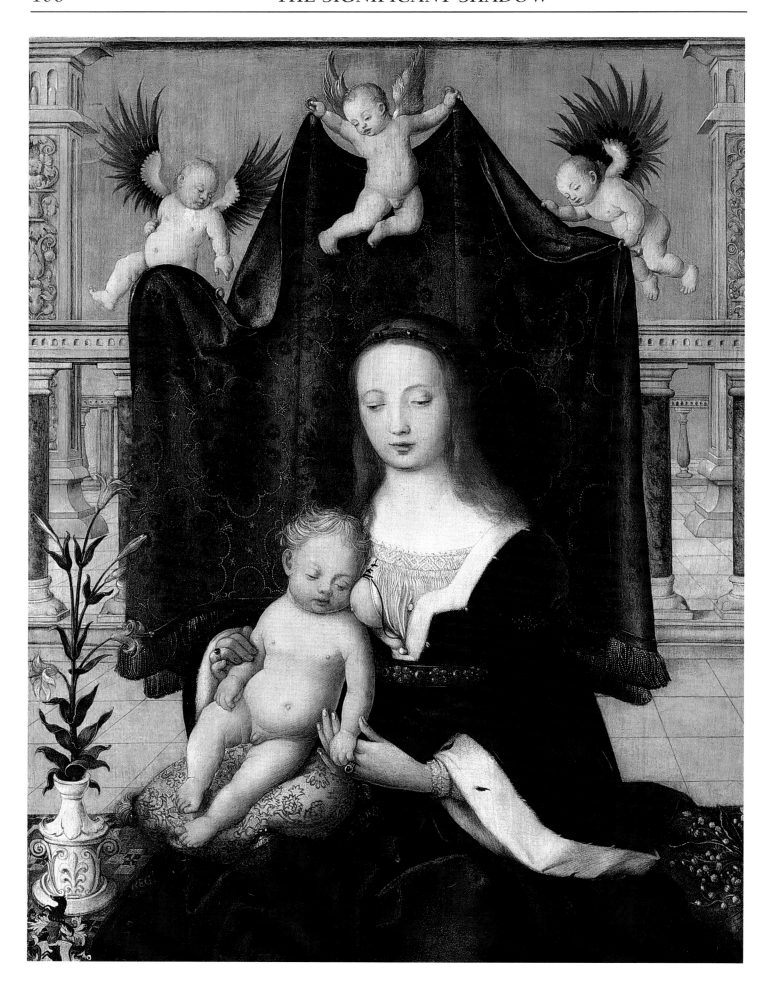

The nakedness of the child calls to mind the words of Job 1:21: "Naked came I out of my mother's womb, and naked shall I return thither"—just as, in a moment, the falling celestial cloth will cover up the sleeping child again.[116] In allegorical terms, this comical detail anticipates the hour of Christ's death (Matthew 27:51), in which the veil covering the holy of holies of the temple is "rent in twain".

At Christ's death, the hitherto occult scriptural meaning of the Old Testament is revealed in terms of the divine dispensation and spiritual history of mankind. In this context, the bearer of the inscription, i.e. the above-mentioned hem of the Virgin's cloak, is of allegorical import. The artist uses the folds to suggest the concealment of divine wisdom and the unfolding, or *explicatio*, thereof.

Opposite page:
Hans Holbein the Elder
*Madonna on the Balcony*
Staatliche Museen, Gemäldegalerie, Berlin

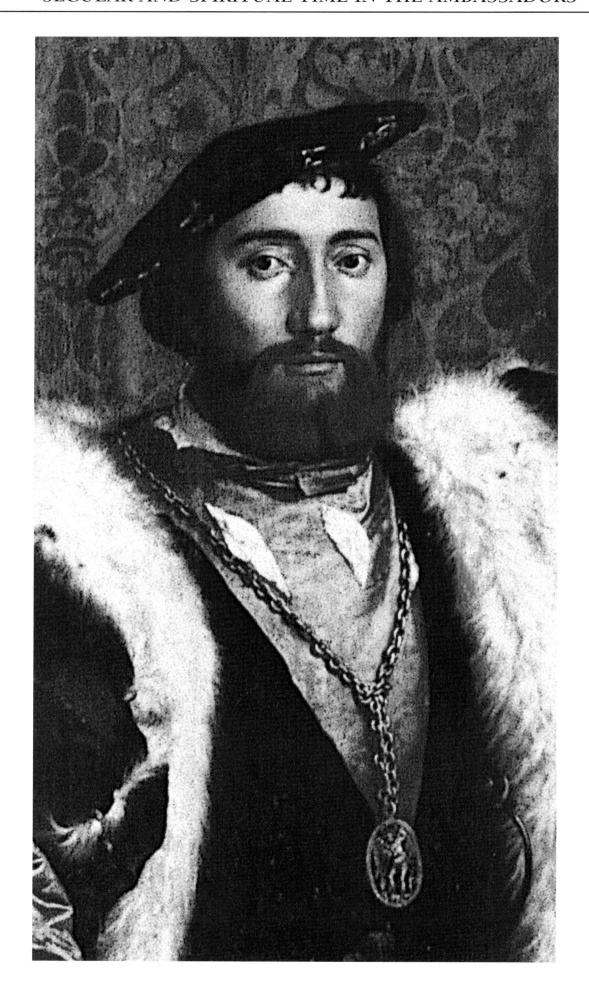

*The Ambassadors*
Detail

# SECULAR AND SPIRITUAL TIME IN THE AMBASSADORS

One detail of *The Ambassadors* that has yet to be mentioned is the brooch attached to Jean de Dinteville's beret, which is adorned with gold pins. It shows a death's-head, which seems a miniature of the anamorphosis in the foreground.[117] Jean de Dinteville responds to the worldly domain of politics and history with a personal motto concerning physical death: "Bear the end in mind." Alciati mentions the tradition of affixing to a brooch one's emblems, like a secret thought, in the form of mute signs.[118]

In a letter to Alfonso Valdes, Erasmus stresses the encoded form of Terminus, "who possesses the peculiar quality of symbols, namely that of being enigmatic."[119] The emblem has a twofold function: both ornamental and social. On the one hand, it emphasizes the individuality of the wearer and presents his moral qualities and military *virtus* in the form of the picture of a device. On the other hand, it stands for the personal maxim of the wearer, who defines himself by means of this "picture"-medallion, the meaning of which, however, remains

Hans Holbein the Younger
*Christ as the True Light*, c. 1526
Woodcut, Public collection,
Department of Engravings, Art Museum, Basel

concealed from the other, the viewer. Demonstratively displayed for all the world to see, this enigmatic "picture" nonetheless reveals nothing about the wearer, thus underscoring the paradoxical process of showing and simultaneously removing what is shown by means of obscuration. The death's-head on the beret testifies to the stoic attitude of its wearer, who lives conscious of his own transience, i.e. of the first death awaiting him.[120] The skull anamorphosis, in contrast, alludes to everlasting death.

## *The Ambassadors* and their attributes

The only object that simultaneously forms part of the still life and figures as a symbolic attribute is the book on which Georges de Selve is resting his elbow. Another attribute is the dagger in Jean de Dinteville's hand. *Aetatis suae 29* is written on the dagger, *aetatis suae 25* on the book. The contents of this book, unlike the others in the still life, are withheld from us. Why is such prominence given to these two objects?

Erasmus called his "little manual of a Christian soldier" the most widely read edifying Christian treatise of its day, *Enchiridion militis Christiani*.[121] The Greek word *enchiridion* (*enchir* means "hand") refers at once to the handbook and to a dagger.[122] The work is addressed to his *amicus aulicus* (friend at court) Johannes Poppenreuter, Charles V's supervisor of the

*The Ambassadors*
Details

royal iron foundry, to whom Erasmus presents the wisdom of the Christian way of life as a spiritual weapon. Inspired by Paul's *militia topos* (Ephesians 6:10–18), Erasmus perceives the life of every Christian as a *perpetua quaedam militia*, a perpetual struggle against sin, by which he means the sinful Adam in each and every one of us. Hence his resolve to issue this call to Christianization with a meditation on death. The nexus implicit in *The Ambassadors* between the dagger and book, the weapons of a Christian soldier, symbolizes the inseparability of the two friends, particularly in the fight of *militis Christiani*.

# The shadow of the future

The skull anamorphosis in the foreground casts a paradoxical shadow that indicates the point of view from which the corrected form of the anamorphosis is discernible. What is decisive here is the independence accorded to the shadow. Transcending its purely optical and derivative nature, the shadow becomes a *res agens*, a sign pointing to a second level of meaning involving pictorial semantics as set forth in the writings of St. Augustine.[123]

The theological interpretation takes its cue from the hymnal, *Geystliches Gesangk-Buchleyn*, beneath the lute in the still life. *Der heilige Geyst und Gottes lichtes glast* (The Holy Ghost and the shining of God's light) corresponds to the vantage point of the viewer, to whom the death's-head appears from the perspective of the divine light source.[124] *In deinem Glanze sehe ich* (In your shine I see) comes from the Old Testament: *In lumine tuo videmus lumen.* (Psalm 35: 10).

There is a similar passage in Augustine's commentary on the metaphysics of light: "Whence you see that the above-mentioned is not true, that is the true light. In this light you see the One that enables you to judge; the other thing you see may well be one as well, but not the One, because it is mutable."[125] The fleeting nature of the world is contrasted with seeing the one true light. Augustine distinguishes here between the *regio dissimilitudinis,* the highest degree of dissimilarity, which is the ultimate foundation of all deception, and the *regio similitudinis*, the realm of similarity, which is revealed in striving for unity with God.[126]

The multitude of various parts, and the indecipherability of the anamorphosis from a frontal position, mark the domain of dissimilarity in *The Ambassadors*. It is in turn contrasted with the realm of unifying similarity with the appearance of the death's-head. God remains indiscernible to mortals. True equality and similarity cannot be perceived with mortal eyes or any other sense, but only with the *mente intellecta*[127] (discerning mind) or *alter oculus* (the other eye).[128] "Double vision" entails seeing by means of the spirit as well as the senses. In his

*The Ambassadors*
Detail

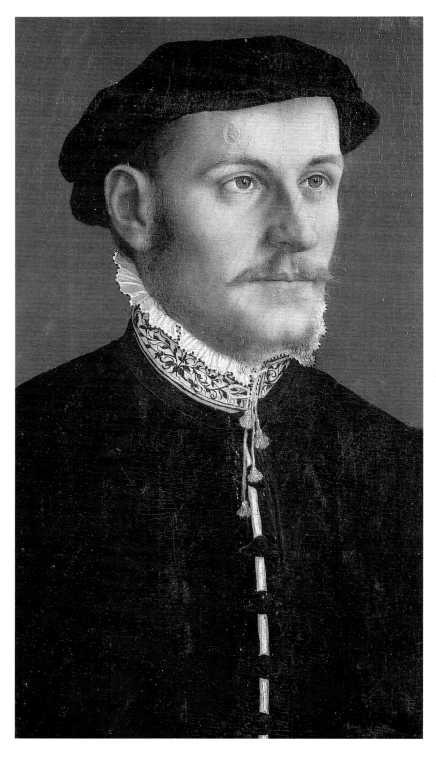

*Enchiridion*, Erasmus writes that "Christ is the true light and drives out the night of worldly folly".[129]

Only in turning from the outward to the inward world, to God, the true light, do all the oppositions and variations of worldly thought collapse to form *una religio*. God can be seen only through self-awareness and eschewal of the world, through the experience of death.

The shadow of the anamorphosis, an *umbra futurorum*, points towards this other, unworldly temporal dimension. A theoretical view of the celestial globe also suggests this other time, which will pass judgement on the processes implicit in the picture on a Good Friday in the year 1533.

School of Hans Holbein the Younger
*Portrait of Sir Thomas More*, c. 1490
Uffizi Gallery, Florence

Albrecht Dürer
*Portrait of Erasmus
of Rotterdam*, 1526

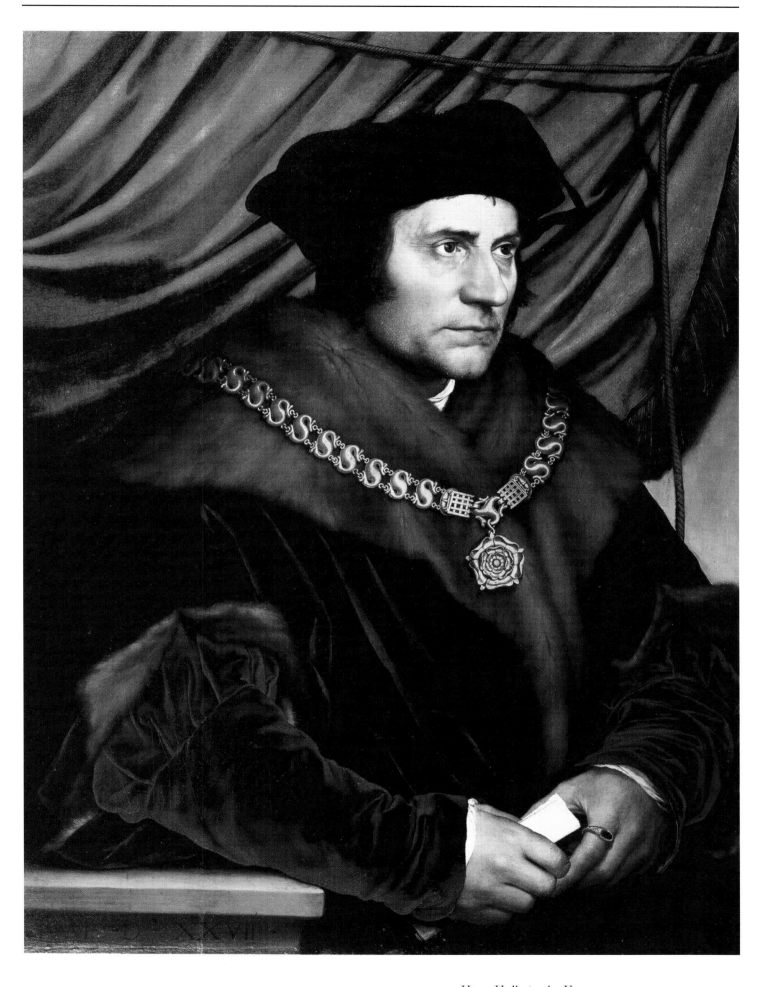

Hans Holbein the Younger
*Portrait of Sir Thomas More.* 1527
Oak, 74,9 x 60,3 cm  Frick Collection, New York

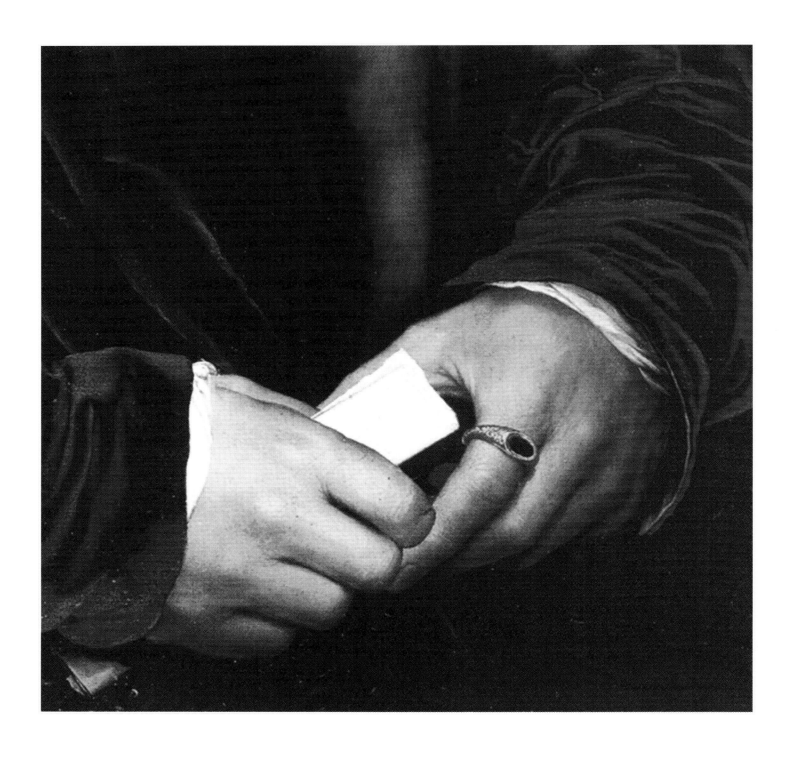

*Portrait of Sir Thomas More*
Detail

# Sir thomas more's utopia

L et us compare Sir Thomas More's *Utopia*[130] and Holbein's *The Ambassadors*. At the very outset of his letter to Pierre Gilles, More owns up to the nature of his work, i.e. fictitious—*mendacium dicere*, which means he is saying a lie—as opposed, however, to *mentiri*, meaning to commit a lie.[131] The former is an ironic form of dissociation that plays on the acquiescence of the reader as a kind of accomplice and is, in that sense, not really a lie, whereas More dissociates himself from the latter, the despicable act of lying as such. If the report of the seafaring philosopher Raphael Hythloday appears to be veracious, the fanciful neologisms he employs betray its fictional nature.[132] The dialogue between More and the stranger are based on the latter's particular point of view and his graphic and highly specific descriptions of political, economic and social life in Utopia.

The second edition of *Utopia*, which was published in Paris, contains an introductory letter by Guillaume Budé, a renowned French scholar. The latter outlines Utopia thus: "The isle of Utopia is a non-place outside the earthly sphere and earthly time," or, as he explains, a *nusquama*, a nowhere. The name of the city *Amaurote* is from the Greek word meaning "eclipse", obscuration. This Utopian city is at once real and inconceivable, like the river *Anydre*, which literally means "without water". In a letter from Pierre Gilles, the latter characterizes More's work as a *velut in specuol* (mirror). According to this, More holds up to the reader the mirror of an ideal society—as related to him in great detail by the voyager Raphael. Yet ultimately the reader must shatter the mirror, for the ideal state of Utopia is attainable only in the world to come.

The need for renouncement was known to Ambrosius and Hans Holbein, who drew the circular island of Utopia for the first edition, but then provided its mirror image for the second. More, the author himself, is seen on the opposite spit of land; Hythloday (originally Hythlodaeus, a "chatterer of nonsense") is pointing the island of Utopia out to him with his index finger. But the drawing itself is a paradox, for it shows what does not exist in the world. The mirror derives from Paul's famous metaphor: "now we see through a glass, darkly" (1 Corinthians 13:12). Only in the hereafter is the hope of a world like Utopia realizable, for concord and harmony are not of this world.

Ambrosius / Hans Holbein the Younger
More's *Utopia*, first edition, 1516
Dirk Martens

Similarly, the anamorphosis in *The Ambassadors* exposes the realistic representation of the two men and the still life as but an illusion. The eclipsing or obscuring anamorphosis suggests the incomprehensibility of death, which is not understood by the viewer, if at all, until he enters the world to come. The function of the anamorphosis in *The Ambassadors*, like that of the reversal of Utopia, is to engender an inner *conversio*, a striving for a world beyond, which in turn results in estranging the viewer and reader from his own world.

Ambrosius / Hans Holbein the Younger
More's *Utopia*, second edition, 1518
Joh. Froben, Basel

Die schöpffung aller ding.

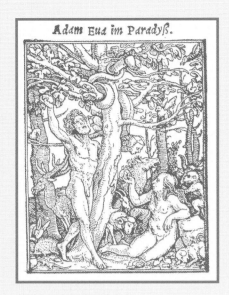

Adam Eua im Paradyß.

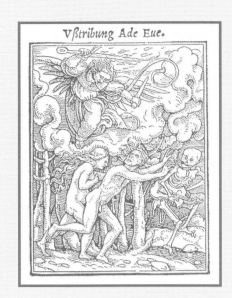

Vßtribung Ade Eue.

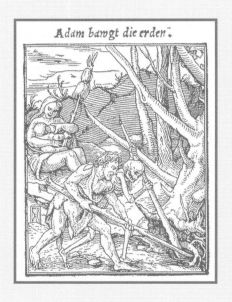

Adam bawgt die erden.

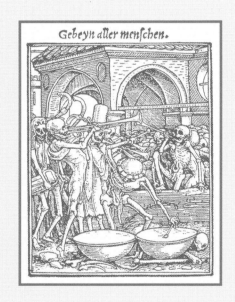

Gebeyn aller menschen.

Der Bapst.

Der Keyser.

Der Künig.

Der Cardinal.

# THE DANCE OF DEATH

T he English art historian Hervey considers the skull anamorphosis to be a reference to the name Holbein.[133] The inwards trough-shaped hole is *hohl* (German for hollow, *cavus* in Latin). *Bein* is German for leg, which is *os* in Latin as well as crus or *tibia*, the bones of the lower leg and foot.

In *The Ship of Fools*, Holbein's contemporary Sebastian Brant writes:

> *Hans is also death.*
> *The word Hans means death.*
> *He who disregards Hans,*
> *however strong, fair or young he may be,*
> *shall be seized and shaken,*
> *and taught the leap of death.*

In other words, both the first and the last name, Hans Holbein, imply death and summarize, as in Brant's verse, the programme of the picture series in the *Dance of Death*.

Holbein's *Dance of Death* woodcut cycle was printed in Lyon 1538 by Melchior and Gaspar Trechsel with a text by Jean de Vauzelles under the title *Les Simulachres et Historiées faces de la mort, autant élégamment pourtraictes, que artificiellement imaginées*. Vauzelles dedicated the work to Jehanne de Touszele, abbess of the St. Pierre convent in Lyon. The book comprises 41 quatrains by Gilles Corrozet accompanied by Holbein's illustrations, which were cut by Hans Lützelburger; Holbein's name, however, goes unmentioned.

Hans Holbein the Younger
*The Images of Death*, 1524–1525
Woodcuts
Department of Engravings, Art Museum, Basel

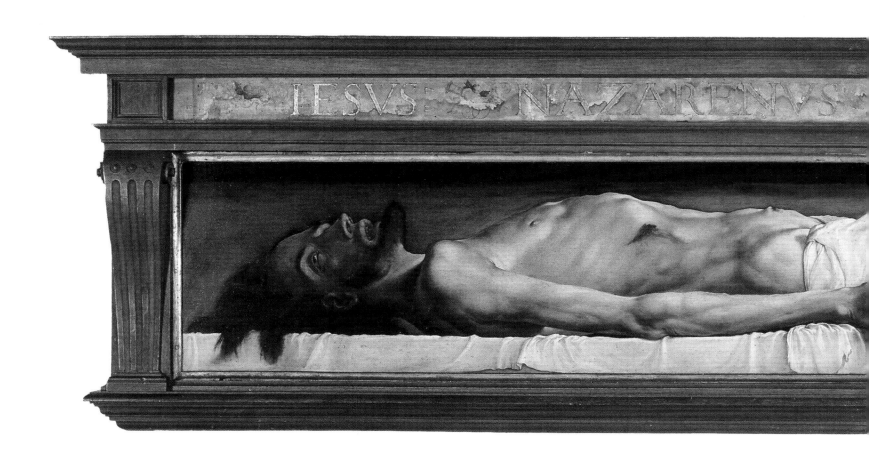

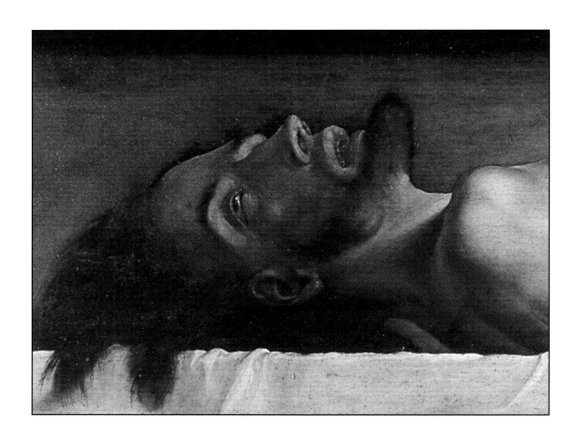

Hans Holbein the Younger
*Christ in the Tomb*, 1521–1522
Linden, 30,5 x 200 cm
Public collection, Art Museum, Basel

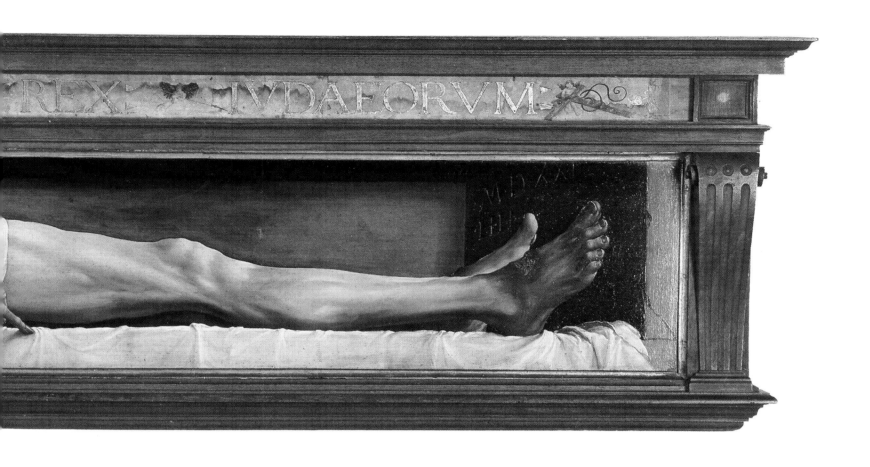

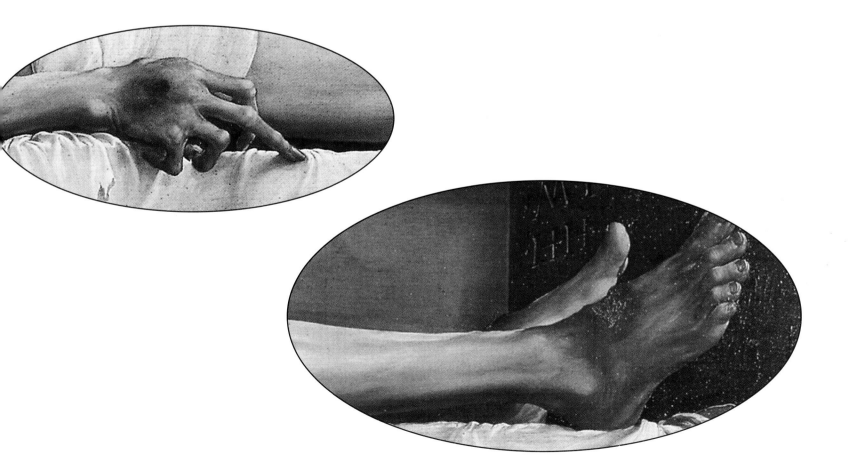

In two further texts, *Figures de la Mort moralement descriptes* and *Les diverses Morts*, Vauzelles discusses whether or not death can be depicted.

Strictly speaking, this series of woodcuts is not a *danse macabre* in the sense of the old mystery plays, but it does take up certain elements thereof. There were two famous *danses macabres* on the Upper Rhine: in Grossbasel (the part of Basel on the south bank of the Rhine) on the churchyard wall of the Dominican monastery (c. 1445) and in Kleinbasel (on the north bank) in the cloister of the Klingenthal convent (second half of the 15th century). Karel van Mander later told of a third, which he erroneously ascribed to Holbein:

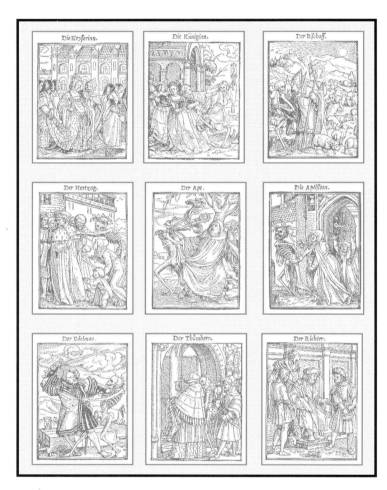

Besides other artistic works by him, there is in the town hall the very beautifully painted and meticulously executed dance of death, consisting of various sections, showing how death strikes people of every estate, each of whom is occupied with his own affairs and—as it appears—thinks he will yet work miracles. Some, warriors and others, resist death, but they must be pierced by him.

On the other hand, death snatches the beloved child from its mother, insensitive to the parents' grief, or he beats the drum in war. In a word, he spares no one, from Pope to peasants and poor devils. Like representations are to be found in a little book with woodcuts—likewise of his invention—a pretty little work.[134]

These woodcuts, however, were indeed by Holbein. The first frescoes of *danses macabres* appeared in graveyards. They are impressive chiefly by dint of the life-sized proportions of the figures.

In the 14th century, however, death abandons the cemetery and calls on the living in their dwellings. Life and death enter into a running scene-by-scene dialogue.[135] The *memento mori* in this context invites contemplation of death, which should ultimately foster a pious life. But Holbein's cycle of woodcuts goes further, presenting the stages of human development from the first Paradise to the Last Judgement with the *Dance of Death* forming the centrepiece, as it were.

The first woodcut, entitled the *Creation of All Things*, shows the moment of nuptial blessing named after St. Augustine[136] the *Creation of Eve*. God took a rib from Adam while he was sleeping and made it a woman and "brought her unto the man". The second scene is of Adam and Eve standing in Paradise in front of the Tree of Knowledge. It depicts the Fall of Man as related in the third chapter of Genesis. Around the apple tree with fig leaves slithers a serpent with a woman's head, observing Eve with the bitten apple.

The third scene is the expulsion from Paradise. The archangel Gabriel has drawn his sword, while death waits, playing the lute, on the right-hand side.

In the fourth cut, Adam is tilling the soil with a skeleton by his side; Eve is suckling her child while holding a broom as a symbol of constant toil; the sandglass in the field symbolizes their mortality.

In the fifth scene, *Everyone's Skeleton*, the skeletons strike up a dance of death on the drums and trumpets.

In the subsequent sequence of images, Holbein shows that everyone, whether priest, king or peasant, is bound to die: death is no respecter of persons.

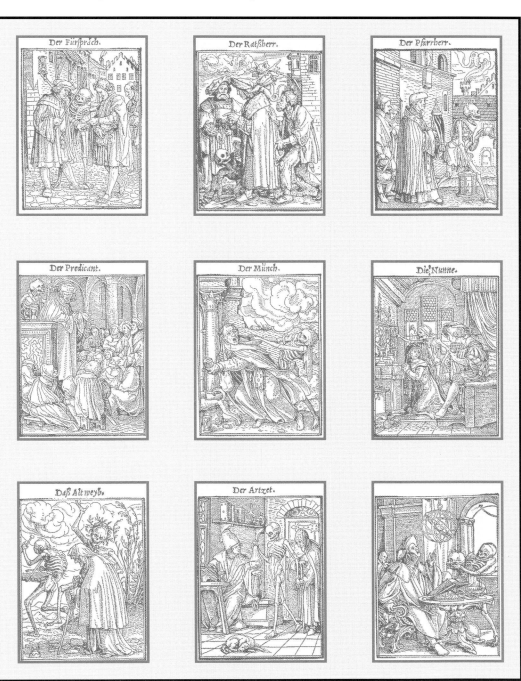

Der Schiffman.

Der Alt man.

With the exception of *Paradise* and *The Last Judgement*, the beginning and end of the cycle, death steals into the scene like a thief and grabs his victims by the hair. The satirical and concomitantly didactic element consists in the trick of having the skeleton appear as a *doppelgänger* and quasi-accomplice, attired in the garb appropriate to the given situation, to expose the sinner with his own weapons: he gallantly seduces nuns and robs misers of their money.

Holbein's two-tiered structure operates by means of semantic antitheses: the sleeping duchess is woken up to die, for example.[137]

The viewer, who cannot help identifying with the people portrayed, is horrified by the peril portended by the appearance of this antagonist. The suspense is generated as in a Punch and Judy show: he would like to warn the unwitting victims of the danger that lies ahead—the same end that awaits the viewer himself.

Holbein's penultimate woodcut is of the great adoration in heaven. The *Vision of the Throne* (Revelation 4:1–8) portrays the Supreme Judge on a celestial globe with a rainbow above him, his face shining like the sun. He is being hailed by his naked children on earth, who can now look upon him "face to face". Their nakedness symbolizes their regained innocence. To the left and right of the sea of clouds, he is venerated by the Saints and Apostles who have found their place in the heavenly ranks. The Swiss medievalist Alois Haas is right in stressing that the picture of the Last Judgement is one of the first scenes in the history of Christian iconography to admit man into the immediate presence of the Almighty.[138]

The last page shows *Death's Coat of Arms*, a pendant to the introduction to the whole cycle. The scene is set in front of a curtain, with a couple striding in, apparently unaware of the skeleton beside them inviting them to dance.

The last woodcut is of this same couple, although their light-heartedness gives way here to realization of their own mortality. This image is accompanied by the following words from Ecclesiastes in Latin: "*Memorare novissima, et in aeternum non peccabis*", followed by "Bear your end in mind". The central motif of this closing page is bipartite: in the foreground the blazon with the skull and above it a helmet, upon which rests a sandglass. Two skeletal arms are holding up a stone over the sandglass like the rock over Tantalus' head.[139] The same couple as before, now lavishly attired, are standing on each side.[140] The man has turned his face away from the woman. He is looking leftwards, or back, i.e. towards the preceding scenes in the cycle, although motioning with his hand towards the sandglass. The woman on the right is looking at the sandglass with her hand on the helmet.

# Christ in the Tomb

The problem of death is omnipresent in Holbein's works, one of the most renowned examples of which is his *Christ in the Tomb*. "The picture covers almost exactly as much space as is allotted to a dead man: it is two metres long and 30.5 centimetres high, not much higher [i.e. deeper] than a person's rib cage. The corpse is painted from a point of view located to the left and very much from below."[141] The main emphasis in art criticism to date has been on Holbein's shocking depiction of the Son of God in the initial stages of decomposition. Holbein's interest in the macabre has been placed in the tradition of Matthias Grünewald's treatment of the *Mourning and Interment of Christ*.[142] Max Imdahl points out the elements of the picture that transgress the aesthetic boundary of the image: the white shroud, the hair and the outstretched hand in a state of rigor mortis, which seem to be placed physically within reach of the viewer.

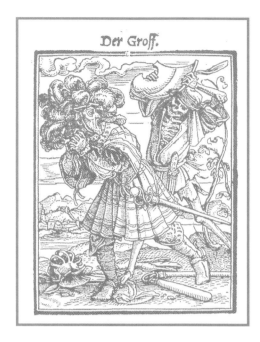

But I should like to go into a different aspect, namely that of the ambiguity of this *imago Christi*, which involves the state of absolute death, on the one hand, and the body crammed into the tomb, on the other. Holbein does not show a corpse spread out on a stone altar here, nor the interment, but a moment, invisible to mortal eyes, the three days in which the Son of God lay as a mortal man in the grave.

The laying bare of the body in this condition is all the more astounding in light of the radical changes Philippe Ariès has noted in burial practices after the 13th century. The face of the deceased was subsequently concealed from view, the entire body wrapped in the shroud, and the deceased laid to rest in a wooden or lead coffin. Substitute images, such as death masks, were used in funeral ceremonies.[143] The corpse itself was considered menacing. Out of fear of the evil eye, the eyes of the deceased were closed, as was his mouth, lest his spirit seize the living and drag them down with him into death.[144] It became a burial custom, for example, not to permit relatives to see the dead body.

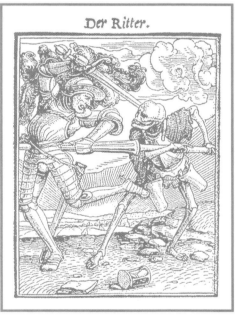

Werner Überwasser rightly points out, in contrast, the liturgical tradition in churches along the Upper Rhine of displaying a sculpted *corpus Christi* on Good Friday.[145] By showing the Son of God with shattered wide-open eyes and gaping mouth, Holbein uncovers the essence of death. Another quotation from Erasmus may be adduced by way of elucidation: "Christ is the head that joins and keeps the whole body together. And we are all mutually limbs. Connected limbs form the body. The head of the body is Jesus Christ."[146] The believer at the time was only body in *imitatio Christi*. "For as the body is one, and hath many members, and all the members of that one body, being many, are one body: so also is Christ."[147] The individual death fuses in the picture of Christ.

*The Images of Death*

But the brutality of Holbein's portrayal consists not only in the macabre representation of the divine corpse, which resembles that of any dead mortal, but in the architectonic enclosure of the body in this cramped sepulchre. The body is, at it were, a tomb. Paraphrasing Plato, Erasmus writes: "*Sepulcrum patens est guttur eorum (Ps.V, II). Soma sema.*"[148]

The confinement of the body in this sepulchral case is analogous to that of the soul in the body: body and soul become visual homonyms. The Greek word *sema* is both the sign and the tomb of the mortal body, whose transience lies at the very basis of art. In this sense, Holbein is operating on a plane between the artistic and spiritual levels. Through a kind of *trompe l'oeil*, the picture frame becomes the lining of the tomb in which the body of Christ lies; the sculptural power of this lifelike portrayal, however, seems to burst through the aesthetic boundary of the picture surface.

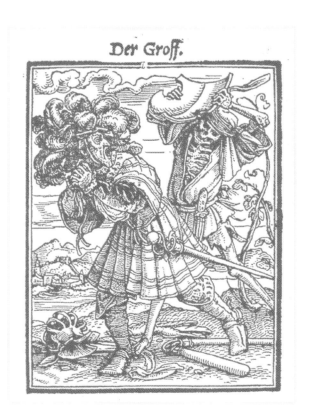

Hans Holbein the Younger
*The Death Alphabet*, c. 1523–1524
Woodcuts by Hans Lützenburger
Public collection, Department of Engravings,
Art Museum, Basel

# *A*dam and Eve

In lieu of the usual depiction of the Fall of Man, Holbein reverts to a tradition of bust portraiture in his *Adam and Eve*. The identity of the subjects is betrayed only by the nakedness and intimacy of the couple, as well as the apple in the foreground. The representation of the shameful Fall of the first parents becomes a secular double portrait. This overlap of the sacral and secular domains is a fundamental and daring move in Holbein's work. Adam's features are marked by melancholy; Eve is holding the apple in her hand with the bitten side turned towards the viewer.

So how are we to interpret Holbein's novel approach? Taking the form (sound) and content (meaning) of words as its point of departure, medieval etymology looked for polysemantic word chains or alternative derivations. A case in point is the pun on *mors* (death) and *morsus* (bite) which informs one of the most widely read poems of the 15th century, *Le Mors de la Pomme*.[149] Man's first bite of the apple, *pomum* or *malum*, brought death into the world. *A morsu primi hominis, qui vetitae arboris pomum mordens mortem incurrit*.[150] In the picture of Adam and Eve, the black spots on the apple may be the first traces of rot or a worm.

*Christ in the Tomb*
Details

Der Krämer.

Der Ackerman.

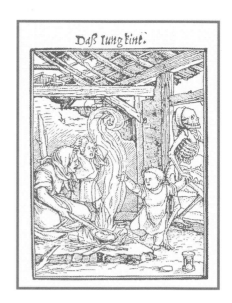

Daß Iung kint.

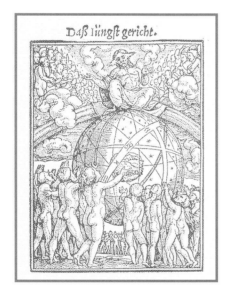

Daß lüngst gericht.

Die wapen deß Thotß.

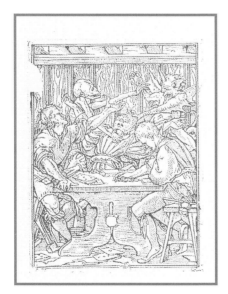

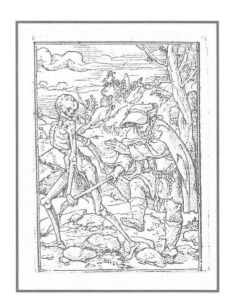

*The Images of Death*
*Armorial bearings*

If we turn the picture on its head or behold it from above, i.e. from God's point of view, the bite takes the shape of a grimacing face with long teeth. This informal detail is by no means clearly visible, however; indeed, there appear to be no limits on the possible projections. The fatal bite is like an *imago dissimilis*: the beauty created in God's image gives way to traces of corruption and grimacing images of the devil, leaving to mankind, now that he has eaten of the Tree of Knowledge, free choice between good and evil.

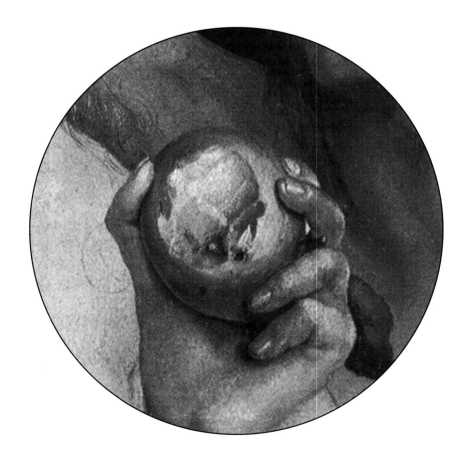

Opposite page:
Hans Holbein the Younger
*Adam and Eve.* 1517
Oil on wood, 30 x 35,5 cm
Public collection, Basel
Right: *Adam and Eve.* Detail

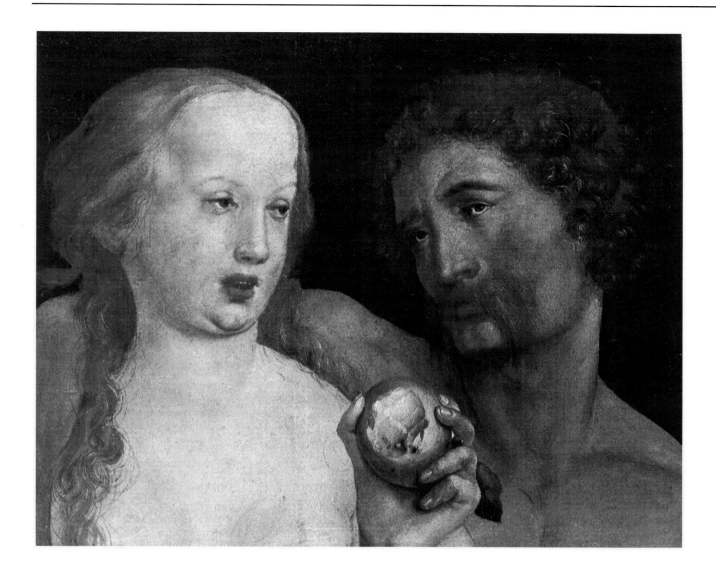

*The Images of Death*
*Adam and Eve*

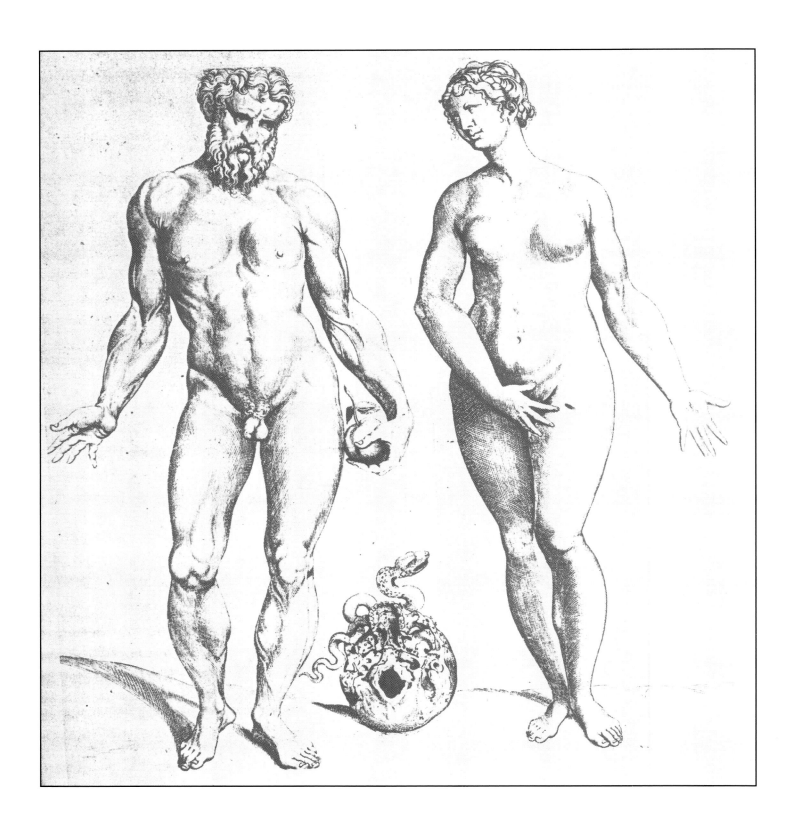

Andreas Vesalius, *Adam and Eve*
*'De Humani Corporis Fabrica'*, 1543
Woodcut, libri septum, Basel

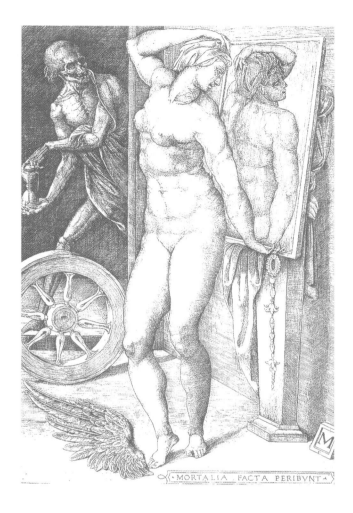

Italian School, *Allegory of Vanity.*
*Death Surprising a Woman.* 16th century
Engraving, 35,5 x 26,3 cm
British Museum, London

Bartem Beham
*Allegory of Death and Sin*
German engraving, 15th century
Bibliothèque Nationale, Paris

134

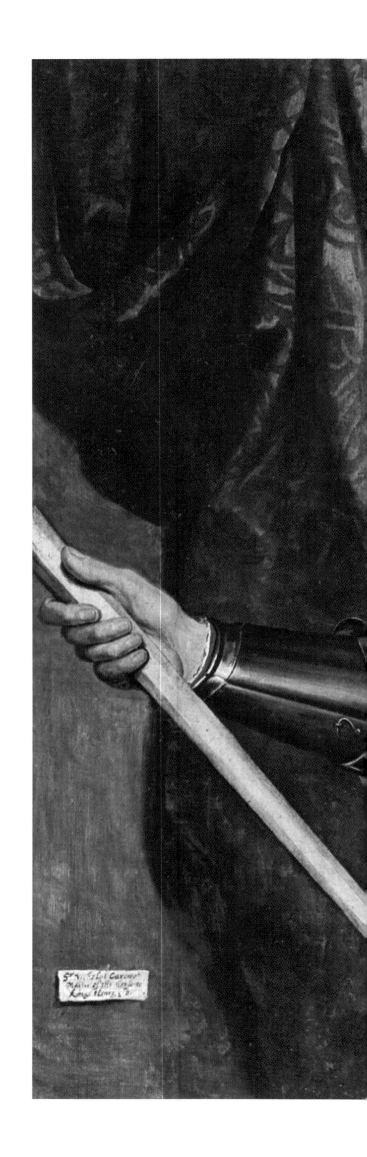

Hans Holbein the Younger
*Portrait of Sir Nicholas Carew.* 1532–1533
Oil on wood, 90,8 x 101,5 cm
Collection of the Duke of Buccleuch, Drumlanrig Castle

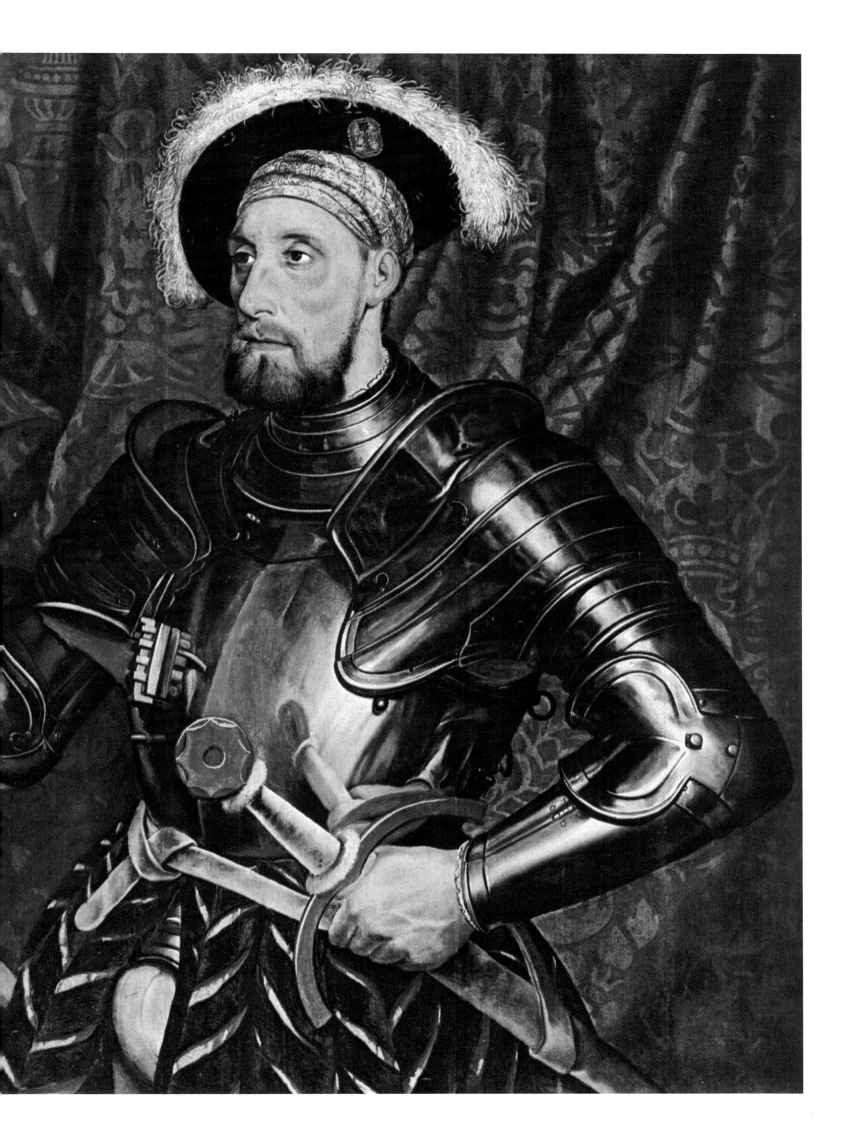

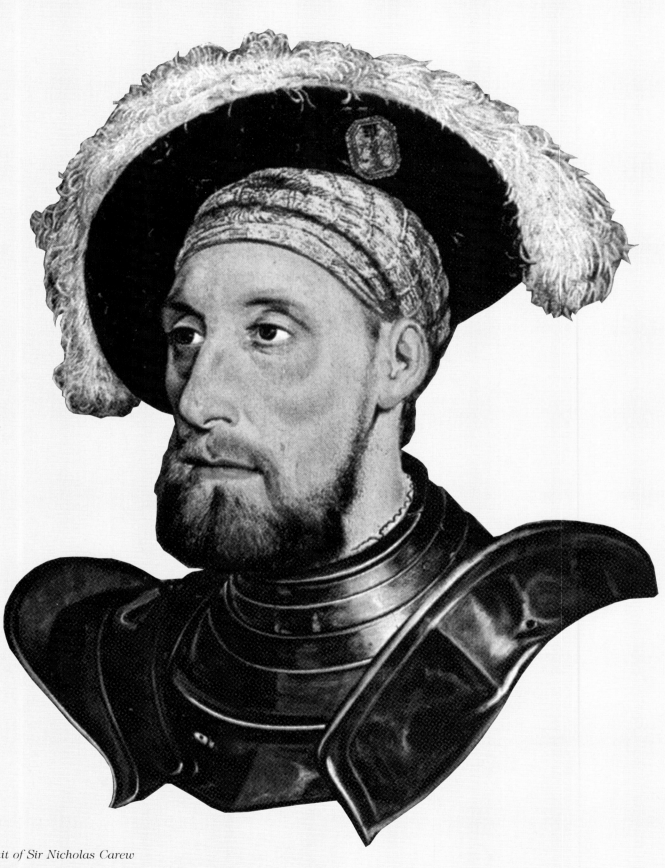

*Portrait of Sir Nicholas Carew*
Detail

# THE INTELLECTUALISM OF HOLBEIN, THE ARTIST

H olbein shows consummate mastery in the uniqueness and impressiveness of his visual effects. His compositions are characterized by tension between various visual realities and temporal dimensions, but also between various media, such as pictures and text, and materials. The representation of form becomes a dynamic process in Holbein's work.

Ever since Alberti, the illusory reality of painting has made it "a negation of the wall".[151] Holbein and his age, however, played with ways of exposing the fiction of the canvas, or "pictorial wall". The famous anecdote of the fly Holbein subsequently painted on one of his pictures as a *trompe l'oeil*, which others then attempted in vain to remove,[152] testifies to Holbein's ability to play two dimensions off against each other, the painted surface *per se* and the illusion thereby created.

## Historical temporality and the presentness of the creative act

In *The Ambassadors*, Holbein placed the inscription HOLBEIN PINGEBAT ANNO 1533 on the Cosmati mosaic underneath the crucifix, in the shadow of the man who commissioned the work, Jean de Dinteville. The use of the Latin imperfect tense here is at odds with the temporal fact of the work's completion.[153] This incongruity may be traced back to a tradition Pliny the Elder recounts in his *Historia Naturalis*. Artists such as Apelles or Polykleitos signed their completed works in only a non-committal manner, "as if the works of art were still in the initial stages and unfinished, so that the artist was

always left the option of justifying himself against the critics' various attacks by claiming he was just about to improve everything that was still unsatisfactory when he was interrupted."[154] The work of art thus remains temporally open until the artist's death.

There is a painted surface that appears virtually unfinished is the *Portrait of Sir Nicholas Carew*. The curtain is drawn aside on the right-hand side to reveal a coarse brown-ochre wall with a cartellino on it. This mat, unevenly painted wall surface contrasts with the magnificently shimmering green brocade curtain, in front of which the subject is posing in shining armour. Two styles are opposed here again, manifest in the thin-layered finely-painted elements of the portrait and the surface of the picture that lays bare the painting process, retaining traces of the artist's hand. The physical nature of the picture plane is exposed to view, whereas the people and objects are rendered with miniaturesque precision, reinforced by the gleaming coat of glaze. There is some question as to whether this surface might not in fact be unfinished, but the cartellino would seem to militate against this hypothesis and suggest that Holbein in fact intended this clash between completely different styles of surface articulation. The unfinished appearance calls to mind an ancient dispute well-known in Holbein's day, in which Apelles reproaches his colleague, Protogenes, for ruining his work by an excess of meticulousness. Likewise, Erasmus' saying *manum de tabula* admonishes the artist to remove his hand from the work in good time.[155]

In the *Panel of Apelles*, a printer's mark for Valentinus Curio, two sitting and two standing putti are holding a huge escutcheon. A hand holding a pen is reaching out of the escutcheon and drawing a fine line on a little panel.[156] In this woodcut, too, one finds the two-tiered composition peculiar to Holbein: one tier comprises a lifelike depiction of a vaulted space behind a portal façade with two twisted columns, garlands and other decorative elements as well as the four putti; the other tier is that of the hand drawing a line.[157] Here Holbein juxtaposes the momentary motion of the pen with the completed condition of the rest of the architectural composition, while the putti wait in suspense for the picture in process on the panel.[158]

Like this skilled hand that protrudes from the picture plane and casts a shadow, the skull anamorphosis in *The Ambassadors* is placed in the foreground of the picture. The *mise en abyme* of the escutcheon is supplanted by the motif of the skull anamorphosis, the perfect line becomes a stain that turns the solidified canvas into a palette. The skull anamorphosis unites the creative process of the artist with the *fecit*, death, which, as perceived by the viewer, puts an end to the seemingly unfinished work.

*Portrait of Sir Nicholas Carew*
Detail

Yet besides this representation of the artistic act, a spiritual and theological level may also be considered. For the printer's mark with the hand of Apelles is found on the title page of the above-mentioned *Enchiridion* by Erasmus. But the writing hand here fits in with the overall composition.[159] Holbein has placed the panel in the crown of an arched gate above a picture of a ghastly banquet. A theological interpretation of this mysterious hand may be derived from a passage in the Book of Daniel: "Belshazzar the king made a great feast to a thousand of his lords ... In the same hour came forth fingers of a man's hand, and wrote over against the candlestick upon the plaster of the wall of the king's palace ..." (Daniel 5:1–5). The terrified king had all the wise men of Babylon brought to him to interpret this mysterious writing. But only the prophet Daniel could read the words: MENE, MENE, TEKEL, UPHARSIN, and prophesied the decline of the Babylonian empire.

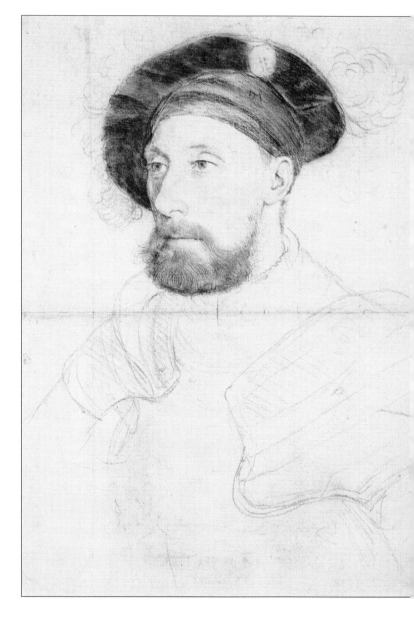

Holbein's frontispiece does not show Belshazzar's feast, however, but the banquet of the Greek gods Jupiter, Ceres and Mercury. This is from the story of Tantalus, the son of Jupiter and father of Pelops, who, being of Olympian descent, was admitted to the table of the gods. But this honour went to his head, and so he decided to put the gods to a test: he served them his own son for dinner. Ceres alone was deceived and ate the shoulder of the ill-used child. Erasmus describes the legendary torments (tantalization) with which Tantalus was punished as follows:

"He stands in a river and suffers thirst; for when he stoops to drink, the water flows away from his lips at once; above his head is a tree laden with fruits, but as soon as he reaches for them with his hand, they elude his grasp."[160]

At the bottom left, the title page shows Tantalus' "head" sticking up out of the pond in hell.[161] On the opposite side, Ceres is fitting a new shoulder made of ivory on the reanimated Pelops. Above, Mercury and Jupiter are looking towards the left side of the picture at Tantalus, who is standing remorsefully with his hands folded in supplication; at his feet lies the dismembered body of his son, and above him towers a chimera in a niche in the wall. A siren is staring at the depicted goings-on from the opposite side of the picture.

Holbein drew a chimera in 1515 in the margin of the manuscript of *The Praise of Folie* by Erasmus.[162] Oskar Bätschmann and Pascal Griener interpreted this as a sign of the painter's assertion of his right to engage in fanciful invention.[163] Yet Tantalus' transgression lies precisely in deception.[164] The common ground of the

Hans Holbein the Younger
*Portrait of Sir Nicholas Carew*, c. 1527
Coloured chalks, 54,8 x 35,5cm
Public collection, Department of Engravings, Basel

Greek myth and the biblical story is hubris. King Belshazzar, who appropriates the gold and silver vessels of the temple and worships gods of gold, silver, bronze, iron, wood and stone, has succumbed to idolatry. Tantalus thinks he can deceive Jupiter, his own father, and the other gods. In his depiction of Tantalus, Holbein shows the torments that await these oversubtle artists. The siren, on the other hand, previously enthroned on the Corinthian capital in the *Portrait of Erasmus,* reminds us of the earnestness of Christians.

Thus, this emblem was familiar to Holbein, as was the biblical passage about the hand writing on the wall, which Jean de Vauzelles mentions in Simulachres in the *Chapitre de la tierce face de la Mort*. The mysterious hand is the hand of God, who will weigh men's souls "in the balances": *Mene* meaning numbered, *Tekel* weighed, *peres* divided. Daniel is the fourth and last of the great prophets. Jewish eschatology is typologically juxtaposed with the Last Judgement in the New Testament.

High-handedness in an artist is particularly questionable in an age of iconoclasm. Holbein's well-considered frontispiece warns the artist against the chimeras of art and reminds the reader of the weighing hand of the Judge at the Last Judgement.

# The signature of death

Van Eyck attests to the veracity of his works by including himself in the picture;[165] Holbein, however, signs in the name of death. The figurative, albeit masked, incorporation of the artist into the depicted scene,[166] a technique he now uses himself, is based on a long-standing tradition that can be traced from Donatello's *David* (c. 1430), in which the severed head at David's feet is a self-portrait of the artist, Giorgione's *David* (c. 1504) and *Judith* (c. 1509–10), to Caravaggio's *David*.[167]

Immortalizing his acumen, the artist erects a monument which, to paraphrase Horace, will last longer than bronze and therefore outlive him.[168] Horace's *monumentum aere perennius* (the monuments are eternal) and Hippocrate's saying, *ars longa, vita brevi* (art is enduring, life is short), celebrate the endurance of art as against the swiftly fleeting nature of life. The artist saves the living from death, and death from oblivion. A tradition evolves whereby the artist's mortality is contrasted with the immortality of his work. When Raphael died on his 37th birthday, which occurred on Good Friday, his body was laid out in state in his studio. Above the dead artist's coffin hung the *Transfiguration* he had painted for Cardinal Giulio de Medici. According to Vasari, "the vision of the dead artist and his living work filled everyone who saw this with great sorrow".[169]

Henkel / A. Schöne
*Emblemata.* Gabriel Rollenhagen II, Nr 24
Pen, Nr 1295

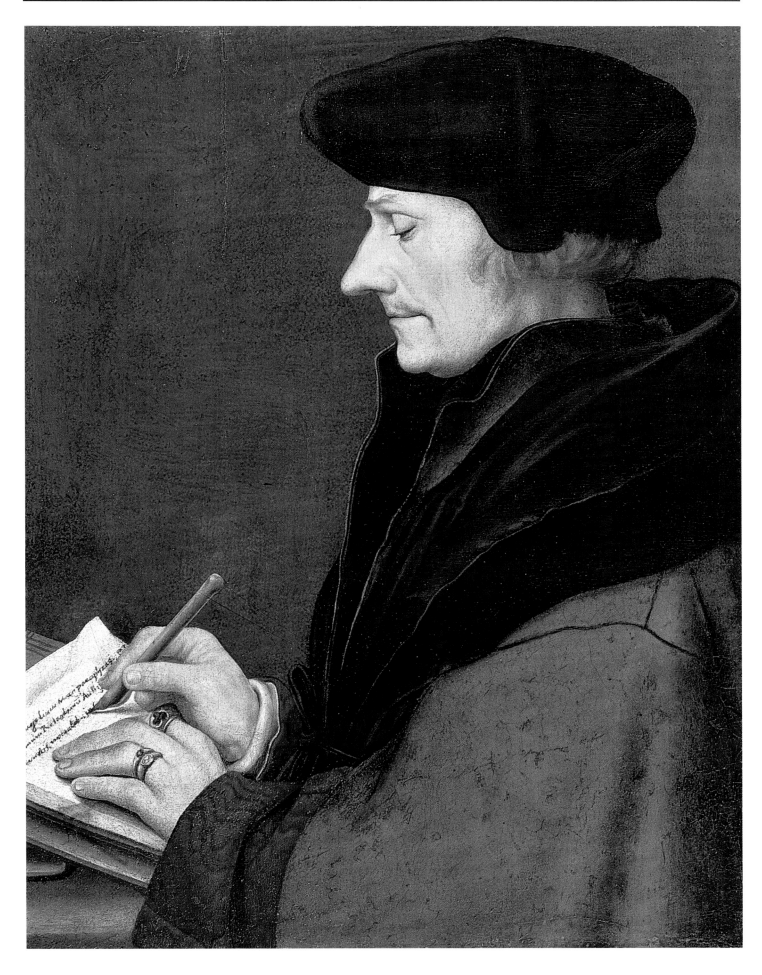

Hans Holbein the Younger
*Portrait of Erasmus of Rotterdam.* 1523
43 x 33 cm, Louvre, Paris

Hans Holbein the Younger
Title of Erasmus of Rotterdam. 1521,
*Enchiridion*
Curio, University Library, Basel

Hans Holbein the Younger
*The Panel of Apelles*, 1521
Printer's mark of Valentinus Curio
Woodcut, 25,4 x 40 cm
Erasmus of Rotterdam, *Enchiridion*
University Library, Basel

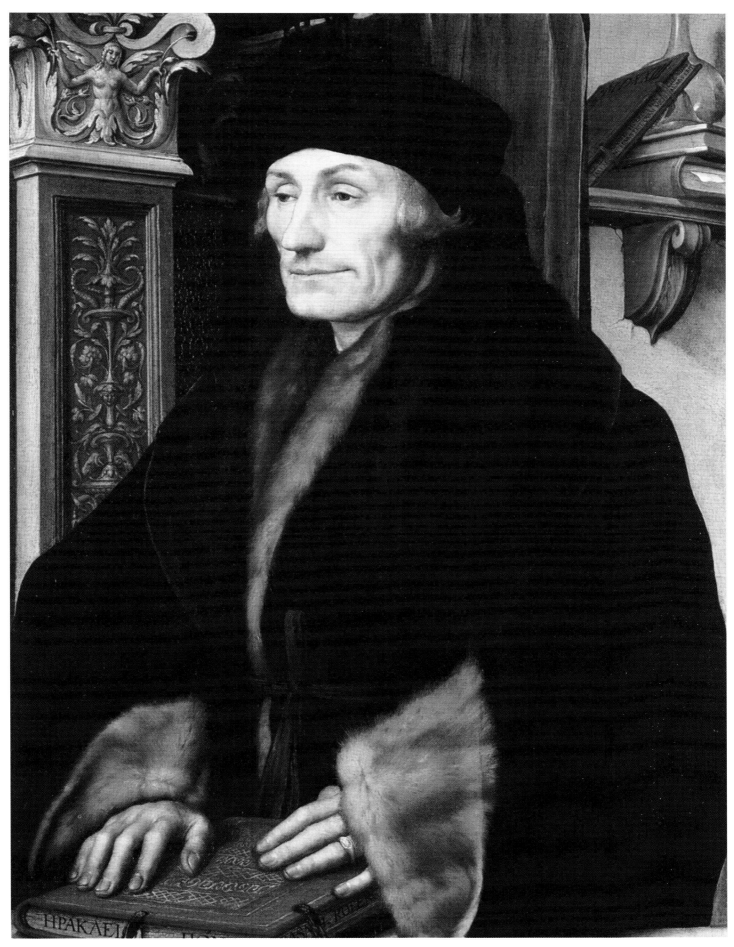

Hans Holbein the Younger
*Portrait of Erasmus of Rotterdam,* 1523
Wood, 76 x 51cm
Private collection

When Piero di Cosimo portrays himself as Prometheus—who brings lifeless pictures to life with the fire of the gods—he assumes the role of the proud Titan who was condemned to eternal martyrdom for disregarding the distinction between mortals and immortals and giving fire to mankind. In his spectacular painting of the *Last Judgement* in the Sistine Chapel, Michelangelo eternalizes himself in the flayed skin of St. Bartholomew. Michelangelo's disguised projection was regarded as a self-portrait *in malo*,[170] but it can also be interpreted as the remorseful expression of the artist's awareness of his own mortality: *Vivo al peccato, a me morendo vivo* (I live in the sin, I die myself).[171] The metaphor of old skin as the transient image of all appearance occurs also in the writings of Erasmus.[172]

Hans Holbein the Younger
*Portrait of Erasmus of Rotterdam*
Detail

Henkel / A. Schöne, *Emblemata*, S. 1699
Joachim Camerarius, IV, Nr 64, *The Siren*

The portrait becomes the shadow of the man who has become aware of his illusory appearance. Death steps in between the living appearance, picture and image. The artist, whose visual imagination is no longer directly under the protection of divine inspiration, humbly signs his works—which are the presumptuous manifestations of his own imagination and rivalry with life—in the name of death. Life as such resembles an anamorphosis, which takes on meaning only in remembrance, that is in the experience of death and contemplation of the Last Judgement.

Hans Holbein the Younger
*Title Page of Erasmus of Rotterdam.* 1521
*Enchiridion.* Detail

Hans Holbein the Younger
*Chimera.* 1515
Pen, Marginal drawing
Erasmus of Rotterdam, '*Moriae Encomion – Stultitiae laus*'
Public collection, Department of Engravings, Basel

Raphael
*Transfiguration of Christ*, c. 1518
Oil on wood, 405 x 278 cm, Pinacoteca Vaticana, Vatican, Rome

Michelangelo
*The Last Judgement*, 1534–1541
Fresco, 17 x 13, 3 metres (including socle)
Sistine Chapel, Vatican, Rome

# NOTES...

Hans Holbein the Younger
*Portrait of Erasmus of Rotterdam*, 1523
Detail

1. M. Hervey, *Holbein's Ambassadors, The Picture and the Men. A Historical Study* (London 1900), p. 80: *Monsr. de Lavor m'offrait cest honneur que de me venir veoir, qui m'esté petit plaisir. Il n'est point de besoing que Monsieur le grand maistre [Montmorency] en entende rien.*

2. Susan Foister (National Gallery exhibition catalogue, *Making and Meaning Holbein's Ambassadors*, S. Foister, A. Roy, M. Wyld, London, 5 November 1997 to 1 February 1998) doubts that Georges de Selve was in London at this decisive point in time and refuses to accept any interpretative approach based on the instruments in the picture. But even if the exact dates of Georges de Selve's sojourn cannot be established, the date explicitly given in the picture remains. Documentable history and depicted historicity are by no means subject to the same logic. The one is based on positivistic knowledge of facts, whereas the other obeys the deliberate fiction of the art work.

3. Alfred Woltmann, *Holbein und seine Zeit. Des Künstlers Familie, Leben und Schaffen* (1866–68), vol. 2, pp. 214–218. E. W. Ives, "The Queen and the painters Anne Boleyn, Holbein and Tudor royal portraits", *Apollo* (July 1994), pp. 36–45. O. Bätschmann / P. Griener, Holbein (Cologne 1997), pp. 86–87.

4. Erwin Panofsky, "Erasmus and the Visual Arts", *Journal of the Warburg and Courtauld Institutes*, vol. XXXII (1969), p. 220: letter of 22 March and postscript of 10 April 1533; Hans Reinhardt, "Nachrichten über das Leben Hans Holbeins des Jüngeren", *Zeitschrift für Schweizerische Archäologie und Kunstgeschichte* 39 (1982), p. 259. Peter Cornelius Claussen, "Der doppelte Boden unter Holbeins Gesandten", *Hülle und Fülle. Festschrift für Tilmann Buddensieg*, A. Beyer, V. Magnago Lampugnani, G. Schweikhart (eds) (1993), p. 179.

5. John Rowlands, *The Paintings of Hans Holbein the Younger* (Boston 1985), pp. 90ff. O. Bätschmann / P. Griener, *Holbein*, pp. 31, 226.

6. Lyon 1538, lib. III Carmen XXI, p. 284.

7. Susan Foister, *Making*, National Gallery, p. 53. There is an optimum viewing point when standing to the right, in a position at a right angle 120 millimetres away from the wall surface, 1040 millimetres from the bottom of the picture, and some 790 millimetres from the right edge of the painting.

8. E. R. Samuel, "Death in the Glass: A new View of Holbein's Ambassadors", *Burlington Magazine* 105 (1963), pp. 436–41, describes a third, indirect way of straightening out the anamorphosis, viz. by holding a glass rod in front of it.

9. I am taking a stance here in opposition to the computer reconstructions that attempt to reconstruct the depicted space in its three-dimensionality. It is precisely the flatness of the picture plane that allows the artist to play with the ambiguity of the motifs.

10. The dimensions of the picture, 207 by 209.5 cm, indicates a slightly asymmetrical displacement of the composition.

11. P. C. Claussen, "Der doppelte Boden unter Holbeins Gesandten", *Hülle und Fülle. Festschrift für Tilmann Buddensieg*, A. Beyer, V. Magnago Lampugnani, G. Schweikhart (eds) (1993), footnote 63.

12. Hervey, *Holbeins Ambassadors*, p. 205, observed the various directions of the shadow cast in *The Ambassadors*.

13. Leon Battista Alberti, *De la Peinture*, French translation by Jean Louis Schefer (Paris 1992) II, 30, pp. 144–145. Kristine Patz, *Von der Täuschung zur Reflexion: Zum pythagoreischen Y im Werk des Andrea Mantegna*, Diss. (Gießen 1993), p. 16.

14. Roy Strong, *Holbein and Henry VIII* (London 1967), p. 42. Exemplary full-length and life-size portraits of rulers are those of the knights and uomini famosi, such as the Pippo Spano by Andrea del Castagno.

15. Leopold D. Ettlinger, *Antonio und Piero Pollaiulo* (Oxford/New York 1978), p. 139.

16. Edgar Wind, "The Christian Democritus", *Journal of the Warburg Institute*, I, 1937, p. 1980.

17. Franco Borsi, *Bramante* (Paris 1990), pp. 165–167.

18. R. Strong, *Holbein*, pp. 45ff, discovered another allusion to Bramante and the structure of the background architecture in the Whitehall picture, scil. the engraving of an ecclesiastical building in ruins by Prevedari according to a design by Bramante.

19. See the exhibition catalogue *Sphaera Mundi. Astronomy Books 1478–1600*. Whipple Museum of the History of Science (Cambridge 1994), pp. 49–53.

20. Peter Apian, *Rechenbuch Eyn Newe und wolgegründte underweysung aller Kauffmanns Rechnung* quoted in *Sphaera Mundi* (exhibition catalogue), pp. 85–86.

21. With regard to the early history of group portraiture, Claussen mentions the portrait of the More family (cf. P.C. Claussen, "Der doppelte Boden", p. 180).

22. Karel van Mander, *Das Leben der niederländischen und deutschen Maler* (from 1400 to c. 1615). Translated, based on the 1617 edition, and notes by Hanns Floerke (Worms 1991), p. 114.

23. John Rowlands, *Holbein. The Paintings of Hans Holbein the Younger* (Boston 1985), pp. 222f. Ch. Müller, *Hans Holbein d. J.*, p. 209.

24. Ruth Norrington, *The Household of Sir Thomas More. A Portrait by Hans Holbein* (1985).

25. Jane Roberts, *Holbein* (London 1979), p. 10. Jane Roberts points out a possible model, viz. the Gonzaga family portrait by Mantegna, in the Camera degli Sposi (1470, Palazzo Ducale, Mantua). Holbein appropriated not only the size of the picture and the portrayal of the family, but also the dwarf, which in Mantegna is the only one to establish eye-contact with the viewer, cast here in the ambiguous figure of the fool.

26. P. C. Claussen, "Der doppelte Boden", p. 180, points out the fool, but does not go into the semantic relation between *More* and *moriae*.

27. *und mach die Sache der Moria zu Deiner eigenen ...*: see the letter to More with which Erasmus prefaces his *Praise of Folie*. Erasmus of Rotterdam, *Das Lob der Torheit, Encomium Moriae*, translated (into German) and edited by Anton J. Gail (Stuttgart 1992), p. 6.

28. P. C. Claussen, "Der doppelte Boden", p. 176, draws this comparison.

29. Cf. Heinrich Alfred Schmid, *Hans Holbein der Jüngere. Sein Aufsteig zur Meisterschaft und sein englischer Stil* (Basel, 1948), p. 396; Roy Strong, *Holbein and Henry VIII* (London 1967), p. 48.

30. Norbert Schneider, *Das Porträt* (Cologne 1992), p. 6.

31. In particular Stephanie Buck, *Holbein am Hofe Heinrich des VIII* (Berlin 1997), pp. 173–178, 241.

32. Ernst H. Kantorowicz, *The King's Two Bodies: A Study in Medieval Political Theology* (Princeton 1957).

33. Arthur B. Chamberlain, *Hans Holbein the Younger* (1913), vol. 2, p. 51; Fritz Grossmann, "Holbein Studies I and II," *Burlington Magazine* vol. 93 (1951), p. 39, footnote 6; R. Strong, *Holbein*, p. 49; and S. Buck, *Holbein*, p. 177: On the first pictorial level, the text serves to "illustrate" the pictorial program, but is then in turn called into question by the substantive emptiness of the vocabulary of form employed.

34. S. Buck, *Holbein*, p. 166.

35. John Rowlands, *The Paintings of Holbein* (Oxford 1985), p. 225. *SI IVVAT HEROVM CLARAS VIDISSE FIGVRAS SPECTA HAS MAIORES NVLLA TABELLA TVLIT. CERTAMEN MAGNUM, LIS, QVAESTIO MAGNA PATERNE FILIVS AN VINCAT. CERTAMEN MAGNUM, LIS, QVAESTIO MAGNA PATERNE FILIVS AN VINCAT. VICIT VTER QVE QVIDEM. ISTE SVOS HOSTES, PATRIAEQVE INCENDIA SAEPE SVSTVLIT, ET PACEM CIVIBUS VS QVE DEDIT. FILIVS AD MAIORA QVIDEM PROGNATVS ABARIS SVBMOVET INDIGNOSI (INDIGNOS) SVBSTITVIT QVE PROBOS CERTAE VIRTVTI PAPARVM AVDACIACESSIT, HENRICO OCTAVO SCEPTRA GERENTE MANV REDDI TA RELIGIO EST, ISTO REGNANTE DEI QVE DOGMATA CEPERVNT ESSE IN HONORE SVO.*

Hans Holbein the Younger
*Portrait of a Lady*, 1536–1540
Oak, 74 x 51 cm  Art Museum, Toledo, Ohio

36. See S. Buck, *Holbein*, p. 192; O. Bätschmann / P. Griener, *Holbein: Zur Solothurner Madonna als Epitaph*, p. 107.

37. Michel Butor, *Les mots dans la peinture* (Paris 1969), p. 109.

38. P.-Kl. Schuster, *Dürers Denkbild* (Berlin 1991), p. 134.

39. Erwin Panofsky, *Grabplastik* (Cologne 1964). Kurt Bauch, *Das mittelalterliche Grabbild* (Berlin/New York 1976), pp. 98, 198–202: "North of the Alps, the deceased is always represented as though alive or sleeping in the French graves. It accords with the changes in funerary pictures over the course of the 14th century that portraits of the deceased should be displayed independently of the tomb. The epitaph evolved during that period, a poem commemorating the greatness and accomplishments of the dead for posterity. But this commemorative panel also serves a cultic function. It is not the depiction of a saint or a general *Andachtsbild* for private devotion. It is for personal recollection, practically a private intercession, as it were, on the part of those who remember, such as relatives and friends. In some places there were hundreds of such epitaphs."

40. Letters were a vital means of interchange, but also of mutual assistance amongst this nascent elite, which was partly attached to the court, though without really belonging to it. But be careful with letters, Erasmus warned more than once: our critics are just waiting to intercept them. The rhetoric of correspondence sought to imitate the directness of speech. Erasmus, for instance, prefaced his *Hyperaspistes*, a polemical pamphlet opposing Luther published in Basel on 20 February 1526, with a letter to his readers. Epistolary texts are modeled on St. Paul's Epistles to the Corinthians. Nothing is more public than a sermon, but the epistolary form lends it a certain intimacy while setting the author apart in an isolated position whence he addresses his readership. The apparent confidentiality makes the judgement of the individual the criterion by which the world is assessed. The casual tone, moreover, creates a semblance of unvarnished candidness. A kind of conversation is witnessed by the reader, who is capable of comprehending the interlocutors' standpoints. The importance attached to the individual's train of thought attests to the newly gained self-confidence of both the author and his addressees.

41. Hans Belting, Christiane Kruse, *Die Erfindung des Gemäldes. Das erste Jahrhundert der niederländischen Malerei* (Munich 1994), p. 49: "Das Porträt bei van Eyck als rechtmäßiges Dokument", *Leal Souvenir*. "The painter stands surety, as does his model, for the function of a painted document that truthfully attests to the existence of an individual." Van Eyck's portraits serve as legal documents.

42. Angelika Lorenz, "Die Porträts. Inszenierung zwischen Abbild und Bild", Exhibition catalogue entitled *Die Maler tom Ring* (Münster 1996), vol. I, pp. 92–94.

43. Oskar Bätschmann, "Bild-Text: problematische Beziehungen", *Kunstgeschichte—aber wie?* (Berlin 1989) *Fachschaft für Kunstgeschichte München,* pp. 27–46. The portrait of Giovanna Tornabuoni by Ghiberti (41 x 27 cm, wood, Uffizi, Florence) is one of the first examples of a portrait with a cartellino, which indicates the date: 1488, namely the year of the subject's death.

46. Pomponius Gauricus, *De sculptura*, annotated and translated by Robert Klein, André Chastel (Paris 1969), I, p. 25.

47. The *Dictionarium* of Ambrogio Calepino (1570 edition), *scribo/plumo*, pp. 1137/967 respectively.

48. M. and G. Trechsel for J. and F. Frellon, 4°, (Lyon 1539). The 1535 woodcut was used as early as 1536 in another work by Bourbon, *Opusculum puerile sive Paidagogeion* (Lyon), J. Barbous, 8.

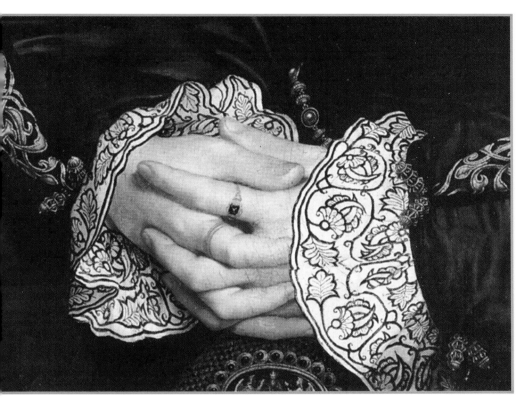

49. Pierre Vaisse, *Holbein le Jeune* (Paris 1972), Fig. 134 attributes the miniatures to Holbein. Mark Roskill/Craig Harbison, "On the Nature of Holbein's Portraits", *Word and Image* 3 (1987), pp. 18f. The assertion that it is a self-portrait of Holbein is rejected by S. Buck (*Holbein*, p. 71); she suggests Lucas Horenbout might have been responsible for this erroneous ascription. J. Rowlands, *The Paintings*, p. 239, also sees only copies here, as opposed to J. Roberts, *Holbein*, ill. 91.

50. Sir Thomas More, *Utopia*, p. 14. In the letter from Pierre Gilles of Antwerp to his teacher, Jérôme Busleiden.

51. Oskar Bätschmann and Pascal Griener, "Holbein-Apelles Wettbewerb und Definition des Künstlers", *Zeitschrift für Kunstgeschichte* 4, 1994, p. 635.

52. See David Summers, "On the Hand" in *The Judgement of Sense* (Cambridge 1987), p. 243.

53. Martin Warnke, "Der Kopf in der Hand", exhibition catalogue entitled *Zauber der Medusa, Europäische Manierismen* (Vienna 1987), p. 58. Michael Baxandall, *Giotto and the Orators* (Oxford 1971), cites as the earliest source of the skilful hand the poem by Roberto Orsi on a miniature by Giovanni da Tano: *doctas possidet ille manus*. Peter-Klaus Schuster, *Individuelle Ewigkeit. Hoffnungen und Ansprüche im Bildnis der Lutherzeit. Biographie und Autobiographie in der Renaissance*, Wiesbaden 1983, pp. 137ff.

54. P.-Kl. Schuster, *Dürers Denkbild*, pp. 224-240. "Like Dürer's *Melancholy* engraving, however, Holbein's painting is generally misunderstood as setting up an opposition between the scientific instruments and *vanitas* references, as though the awareness of transience were to negate science and render it meaningless."

Hans Holbein the Younger
*Portrait of a Lady* Detail

55. J. Baltrusaitis, *Anamorphoses ou magie artificielle des effets merveilleux*, Paris 1969, (überarbeitete Fassung des Buches von 1959), pp. 58, 62; and P.C. Claussen, "Der doppelte Boden", p. 181.

56. Kenneth Charlton, "Holbein's Ambassadors" and "Sixteenth-Century Education", *Journal of the History of Ideas* 21 (1960), pp. 99–109.

57. I take the information here regarding the instruments from: Michael Levey, *The German School. National Gallery Catalogues* (London 1957), pp. 50–51. The first instrument tells the time of the day from the altitude of the sun, its design varying with the altitude at which it is to be used. For the history of the sundial, see René R.J. Rohr, *Die Sonnenuhr* (Munich 1984).

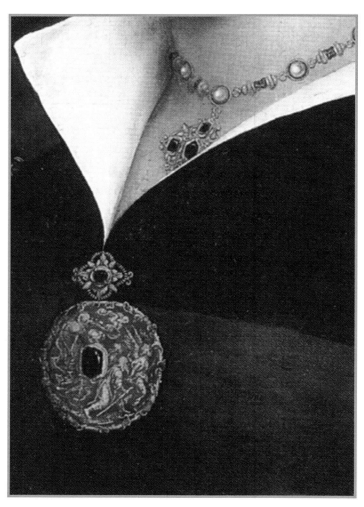

58. Nicholas of Cusa had such a torquetum. This instrument is used to determine the position of the sun and stars and, once they are known, the time.

59. Elisabeth Foucart-Walter, "Les peintures de Hans Holbein le Jeune au Louvre", *Les dossiers du département des peintures*, 29, (Paris 1985) pp. 44–48. In the backdrop to the portrait of Nicolas Kratzer, the cylindrical sundial points to the months of March, April and May with the signs Pisces, Taurus and Gemini. According to Elisabeth Foucart, it is quite possible that the picture was executed during that time.

60. M. Hervey, *Holbein's Ambassadors*, p. 210. Henry Stevens of Vermont found the owner of the terrestrial globe.

61. Siegmund Günther, *Peter und Philipp Apian* (Prague 1882).

62. Andrea Alciati, *Emblematum Liber* (Augsburg), Heinrich Steiner (reprint of D. Tschizewskij and E. Benz [Hildesheim 1977]) A2v–A3r. M. Hervey, *Holbein's Ambassadors*, pp. 228–232. William S. Heckscher, "Reflections on Seeing Holbein's Portrait of Erasmus at Longford Castle", *Essays in the History of Art presented to Rudolf Wittkower*, London (1967), pp. 128–148. Sergiusz Michalski, "Die zerissene Saite. Zur Symbolik von Streichinstrumenten". *Kunst und Antiquitäten* No. 5 (1992), p. 26.

63. On the left side: *Kom heiliger geyst herregott / erfüll mit deiner gnaden (gut) / deiner gleubgen hertz, mut un sin / dein brustig lib entzünd versamlet hast / das volck aller welt zungen / (des sey) dir Her zu lob gesungen.* And on the right side: *Mensch wiltu leben seliglich / und bei Gott bleiben (ewiglich) Soltu halten die Zehen Got / die uns gebeut unser Gott* Markus Jenny, "Ein frühes Zeugnis für die kirchenverbindende Bedeutung des evangelischen Kirchenliedes", *Jahrbuch für Liturgik und Hymnologie* 8 (1963), pp. 123–128.

64. K. Hoffmann, *Hans Holbein d.J.*, p. 137 and footnote 22.

65. Henri Busson, *Le Rationalisme dans la littérature française de la Renaissance* (1533–1600) (Paris 1971), p. 78.

66. In an earlier portrait, namely that of Kratzer, the latter holds a compass in his hands.

67. M. Rasmussen, "The case of the flutes in Holbein's The Ambassadors", *Early Music* (February 1995), pp. 114–123.

68. Gisela Luther, "Stilleben als Bilder der Sammelleidenschaft", *Stilleben in Europa* (exhibition catalogue) (Münster and Baden-Baden 1980), p. 87. Julius von Schlosser, *Die Kunst und Wunderkammern der Spätrenaissance*, 2nd ed. (Braunschweig 1978). Charles Sterling, *La nature morte. De l'Antiquité au XXè siècle*, 2nd ed. (Paris 1985); Horst Bredekamp, *Antikensehnsucht und Maschinenglauben. Die Geschichte der Kunstkammer und die Zukunft der Kunstgeschichte* (Berlin 1993) (Kleine kulturwissenschaftliche Bibliothek, 41).

69. K. Charlton, *Holbein's Ambassadors*, pp. 99–109.

70. Hans Belting, Dagmar Eichberger, *Jan van Eyck als Erzähler* (Worms 1983), p. 100.

71. Alois M. Haas, *Todesbilder im Mittelalter, Fakten und Hinweise in der deutschen Literatur* (Darmstadt 1989), p. 179.

72. Luther's sermons. 1524. *Sämtliche Werke* (Weimar 1900), p. 300. Jean Wirth, *Luther, Etude d"histoire religieuse* (Paris 1981). Pierre Chaunu, *Le Temps des Réformes* (Paris 1978).

73. Erasmus, *Das Lob der Torheit*, p. 63.

74. *La Mort et la Résurrection sont opposées sur le même axe, tracé de biais, avec pour base le crâne qui flotte dans le registre inférieur.* J. Baltrusaitis, *Anamorphoses*, p. 100.

75. This portrait, which Dürer executed in Antwerp in 1521, was commissioned by the Portuguese *feitor* (consul) Rodrigo Fernandes. Max J. Friedländer, *Die Altniederländische Malerei XII* (Leiden 1935), p. 70. On his first journey to England, Holbein travelled via Antwerp, where he could have seen Dürer's *St. Jerome*.

76. The crucifix is an argument for this assertion. It also emblematizes the word of the sermon. Hans Belting, "Der sichtbare Inhalt der Predigt" in *Bild und Kult. Eine Geschichte des Bildes vor dem Zeitalter der Kunst* (2nd ed.) (Munich 1992), p. 522.

77. I refer the reader here to the debate between Werner Weisbach and Erwin Panofsky about the speaking tomb: Erwin Panofsky, "Et in Arcadia ego", *Gazette des Beaux-Arts* (1937); Werner Weisbach, "Et in Arcadia ego", *Gazette des Beaux-Arts* (1937), pp. 287–296; and Erwin Panofsky, "Et in Arcadio ego et le Tombeau parlant", *Gazette des Beaux-Arts* (1938), p. 306.

78. Ludwig Baldass, "Laux Furtenagels Bildnis des Ehepaares Burkmair", *Pantheon XVII* (1936); G. von der Osten, "Lukas Furtenagel in Halle", *Wallraf-Richartz Jahrbuch XXXIV* (1972). More's *vincit* motto on Mr. Burkmair's signet ring underscores the latter's awareness of mortality.

79. Jurgis Baltrusaitis, *Le Miroir* (Paris 1978), p. 71.

80. Cf. Alexis Donetzkoff, "Une Vanité de Jan van Hemessen (v. 1500–1560) entre au musée des Beaux-Arts de Lille", *Revue du Louvre* 4 (1995), p. 61.

81. Alfred Woltmann, *Holbein und seine Zeit* (Leipzig 1868), p. 82.

82. Exhibition catalogue entitled *Images of Love and Death in Late Medieval and Renaissance Art*, William R. Levin, The University of Michigan Museum of Art (1975–76), p. 45.

83. Erasmus, *Adagia* 1248.

84. Liselotte Müller, "Bildgeschichtliche Studien zu Stammbuchbildern, II. Die Kugel als Vanitassymbol", *Jahrbuch der Hamburger Kunstsammlungen*, 2 (1958).

85. Aristotle (III, 1, 662b 19) cf. Jean-Pierre Vernant, *L'individu, la mort, l'amour* (Paris 1989), p. 118.

86. Erasmus, *Enchiridion*, p. 65 of the German version.

87. The head is characterized as a *fortuna fragilis* in *Anatomie moralisée* as well. P.-Kl. Schuster, *Dürers Denkbild*, p. 205.

88. P.-Kl. Schuster, *Dürers Denkbild*, p. 206. To Plato (*Theaitetos*, 174A) is attributed the legend that Thales, immersed in his thoughts about celestial phenomena, fell into a well.

89. "As it is written, Behold, I lay in Sion a stumblingstone and rock of offence: and whosoever believeth on him shall not be ashamed." Romans 9:33 with allusion to Isaiah 8:14. J. Jeremias, "Der Eckstein", *Angelos I* (1925), pp. 65–70; G. B. Ladner, "The Symbolism of the Biblical Corner Stone in the Medieval West", *Medieval Studies IV* (1942), pp. 43–60.

90. Anne Marie Lecoq, L'art de la signature, *Revue de l'Art* 26 (1974), p. 19. *"Placer son nom aux pieds de la figure sainte est également une marque de dévotion et d'humilité. La signature prend ainsi la valeur d'un petit ex-voto."*

91. See in particular Heinrich Theissing, *Dürers Ritter, Tod und Teufel* (Berlin 1978). *Physiologus* (Berlin 1981), p. 9.

92. Printed in Lyon in 1539.

93. Erasmus, *Das Lob der Torheit*, p. 70.

94. Exhibition catalogue entitled *Hans Holbein d. J. Die Druckgraphik im Kupfer-stichkabinett* (Basel 1997), p. 238.

95. With regard to Holbein's self-portrait in the blazon of death, see Alfred Woltmann, *Holbein und seine Zeit*, 2. A., vol. I (Leipzig 1876), p. 278; Ganz, 1956, Fig. p. XVI, Dr. jur. Hans Holbein, *Die Holbeiner, Ein Überblick über eine 700 jährige bürgerliche Familiengeschichte mit Stammbäumen* (Leipzig 1905).

96. Museu Nacional de Arte Antiga, Lisbon.

97. Christian Müller stresses that concavities and convexities in the painted surface are Holbein's principal artistic problem. "Hans Holbein d. J. Überlegungen zu seinen früheren Zeichnungen", *Zeitschrift für Schweizerische Archäologie und Kunstgeschichte* 46 (1989), pp. 113–129.

98. Tusculanes I, XX, 46–47: *uiae quasi quaedam sunt ad oculos … quasi fenestrae sunt animi quam tu sapientem esse uis duo lumina ab animo ad oculos perforata nos habere uoluisset.*

99. *non eas partis quae quasi fenestrae sint animi.* Lucretius, *De Natura rerum* III, 9; III, 408–416.

100. Dolce later reverts to the classical *topos* of the eyes speaking to the viewer, which may be regarded as windows. Hans-Jürgen Horn, RESPICIENS PER FENESTRAS, PROSPICENS PER CANCELLOS. "Zur Typologie des Fensters in der Antike", *Jahrbuch für Antike und Christentum* 10 (1967), pp. 30–60. Lodovico Dolce, "Aretino oder Dialog über die Malerei", *Quellenschriften für Kunstgeschichte und Kunsttechnik des Mittelalters und der Renaissance* (Osnabrück 1871), R. Eitelberger (ed), p. 21.

101. In his well-known copper engraving of 1526, Albrecht Dürer shows Philipp Melanchthon with an object poem and in his transient outer appearance. Yet the reflection of the window in the subject's eyes attests to his contemplative soul.

102. Jürgen Meier zur Capellen, *Gentile Bellini* (Stuttgart 1985), p. 141, Cat. No. B 11.

103. Erasmus, *Enchiridion*, pp. 85–87

104. Edgar Wind, "Aenigma Termini", *Journal of the Warburg and Courtauld Institute* I (1937/38), pp. 66–69; Erwin Panofsky, "Erasmus and the visual arts", *Journal of the Warburg and Courtauld Institute* XXXII (1969), p. 215. John Rowlands, "Terminus, The Device of Erasmus of Rotterdam: A Painting by Holbein", *Bulletin of the Cleveland Museum of Art* (February 1980), pp. 50–54.

105. Erasmus describes the seal in a letter to Alfonso Valdes on 1 August 1528; Allen, vol. VII, No. 2018, pp. 430–431.

106. Quoted in Ch. Müller, *Hans Holbein d. J.*, p. 160: letter of 1 August 1528, to the imperial private secretary Alfonsus Valdesius. P. S. Allen, H. M. Allen and H. W. Garrod, *Erasmi Roterodami Opus Epistolarum* VII (Oxford 1906–1947), No. 2018. As in *The Praise of Folie*, where Erasmus prefaces: Folie speaks.

107. H. Lochner, *Raffael und das Altarbild der Renaissance. Die Pala Baglioni als Kunstwerk im sakralen Kontext* (Berlin 1994), p. 134, footnote 93.

108. Letter to Pirckheimer dated 15 July 1529, Allen, vol. VIII, No. 2196, pp. 230–236.

109. Letter dated 1 August 1528, Allen, vol. VII, No. 2018, p. 433.

110. Ch. Müller, *Hans Holbein d. J.*, p. 160.

111. Christl Auge, "Zur Deutung der Darmstädter Madonna", *Bochumer Schriften zur Kunstgeschichte* (Frankfurt a. M., Berlin, New York, Paris and Vienna 1993), Max Imdahl/Manfred Wundram (eds), vol. 19. There are various stories about Meyer's motivation for commissioning this work. The burgomaster Jakob Meyer was relieved of his office in 1521 for accepting French money. But even after his dismissal he retained his leadership of the counter-Reformation party with the backing of the Roman Catholic constituency. This portrait was supposed to bear witness indirectly, as it were, to the faith of Meyer and his family. Max Imdahl, "Hans Holbein's 'Darmstädter Madonna': Andachtsbild und Ereignisbild", *Wie eindeutig ist ein Kunstwerk?* (Cologne 1986), M. I. (ed), pp. 9–39.

112. Max Imdahl infers from the buckling of the rug and the folds in the Madonna's robe that Maria is turning towards the subjects in this precarious situation. Imdahl, *Wie eindeutig ist ein Kunstwerk?*, p. 27.

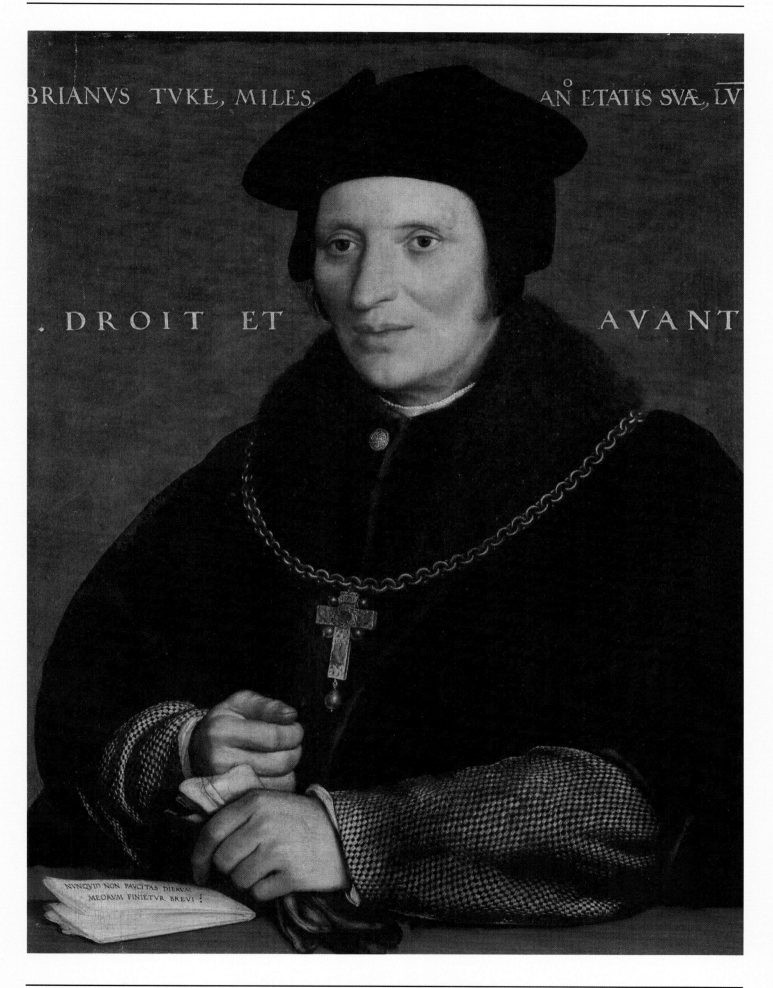

Hans Holbein the Younger
*Portrait of Sir Bryan Tuke.* c. 1532  Oak, 49 x 39 cm
Andrew W. Mellon Collection, National Gallery of Art, Washington D.C.

113. James Hall, *Dictionnaire des Mythes et des Symboles* (Paris 1994). In *sinu ejus, sinus* means fold.

114. Another example is *Pala di Santo Stefano* (Bergamo) by Lorenzo Lotto.

115. Wilhelm H. Köhler, *Hans Holbein der Ältere Die Madonna auf dem Altan* (Madonna Böhler), Staatliche Museen zu Berlin, Preussischer Kulturbesitz, Kulturstiftung der Länder (Berlin 1993), p. 13.

116. W.H. Köhler, *Hans Holbein der Ältere*, p. 13.

117. P.C. Claussen, "Der doppelte Boden", p. 182. *Emblemata. Handbuch zur Sinnbildkunst des XVI. und XVII. Jahrhunderts* (Stuttgart 1967), Arthur Henkel/Albrecht Schöne (eds),

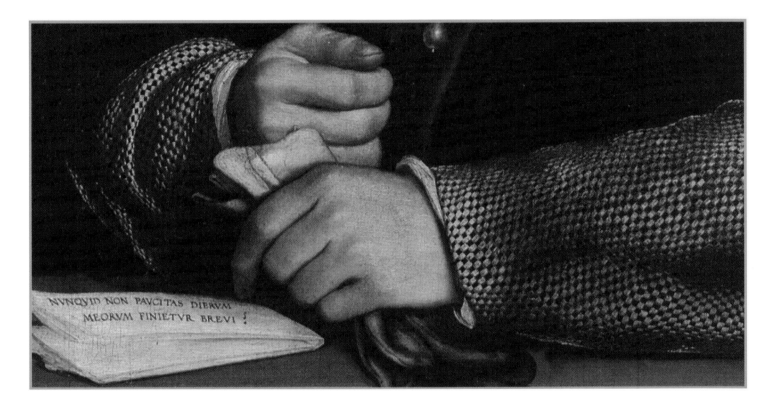

p. XI. "For its forms and motifs, heraldry drew chiefly on the knightly vogue for insignia and imprints which had developed towards the end of the 14th century in Burgundy and France, took hold in Italy after the French occupation of Milan (1499) and passed rapidly from the nobility to patricians and scholars as well."

118. P. Laurens, André Alciat, *Les emblèmes* (Paris, 1997) Introduction, pp. 30–31.

119. Letter dated 1 August 1528, Allen, vol. VII, No. 2018, pp. 430–431.

Hans Holbein the Younger
*Portrait of Sir Bryan Tuke*
Detail

120. In his *Predica dell'arte del bene morire* (i.e. "sermon on the art of dying well"), Girolamo Savonarola called on the faithful to make spectacles with a death's-head so as always to keep death in view. Pierre de Luques tells of pious persons who kept a skull in a safe place at home, with which they would hold long conversations several times a week. See Alberto Tenenti, *Sens de la mort et amour de la vie. Renaissance en Italie et en France*, French trans. (Paris 1983), pp. 92, 280.

121. *Enchiridion Militis Christiani saluberrimis praeceptis refertum* (Antwerp, February 1509), 4°, Dirk Martens. Pierre Chaunu, *Histoire religieuse et système de civilisation. La Réforme protestante* (Paris 1975), p. 352.

122. Erasmus of Rotterdam, "Enchiridion Militis Christiani", *Ausgewählte Schriften*, vol. 1, German trans. by Werner Welzig (Darmstadt 1968), see Einleitung X and p. 99: "Doch, weil du so willst, und um dir zu entsprechen, habe ich dir ein Enchiridion, das ist ein kleines Handschwert verfertigt." Erasmus' conception of the ambiguity of the dagger as a moral weapon is noted by Konrad Hoffmann, "Holbeins Todesbilder", *Festschrift Donat de Chapeaurouge, Ikonographia: Anleitung zum Lesen von Bildern* (Munich 1990), p. 106.

123. St. Augustine, *De doctrina christiana* II, 28, 44, see Georg Didier-Huberman, *Fra Angelico, dissemblance et figuration* (Paris 1990), p. 46.

124. *Im Hyperaspistes diatribae adversus arbitrium M. Lutheri* (1526), *Opera omnia*, vol. X, Erasmus quotes the 19th Psalm: "the commandment of the Lord is pure, enlightening the eyes." St. Peter likens the prophetic word "unto a light that shineth in a dark place" (II Peter 1:19); St. John's God is a "shining light" (John 5:35), Christ "the light of the world" (John 8:12).

125. St. Augustine, *De vera religione* XXXIV, 64, 181; Horst J. Spitz, *Die Metaphorik*, p. 27; Mark Roskill, Craig Harbison, "On the Nature," pp. 1–26.

126. Margot Schmidt, "Einflüsse der 'Regio Dissimilitudinis' auf die deutsche Literatur des Mittelalters," *Revue des Etudes Augustiniennes* 17 (1971), pp. 299–313; Thomas Dittelbach, *Das monochrome Wandgemädes. Untersuchungen zum Kolorit des frühen 15. Jahrhunderts in Italien* (Hildesheim, Zürich, New York 1993), p. 153.

127. St. Augustine, *De vera religione* XXX, 151, 52, 456.

128. Cf. Fernand Hallyn, "La mort en abyme", p. 10, *Gentse Bijdragen tot de Kunstgeschiedenis* XXV (1979–80). Erasmus, *De preparatione ad mortem liber unus* (Antwerp). Gilles Coppens de Diest (1551), B3r.

129. Erasmus, *Enchiridion*, p. 103. I am referring here to Holbein's woodcut of Christ as the True Light.

130. *Editio princeps*, 4°, Dirk Martens (1516), and the second ed., Joh. Froben (Basel 1518).

131. My analysis of *Utopia* is based on André Prévot, *L'Utopie de Thomas More* (Paris 1978), (Sir Thomas More to Pierre Gilles, p. 20) and especially the essay by Jean Céard, "La Fortune de L'Utopie de Thomas More en France au XVIè siècle," *Nel Dibattito Politico Europeo del' 500* (Florence 1995). Robbin S. Johnson, *More's Utopia Ideal and Illusion* (New Haven/London 1969).

132. See Louis Marin, *Utopiques: Jeux d'Espaces* (Paris 1973), ch. IV.

133. M. Hervey, *Holbein's Ambassadors*; see also Erwin Panofsky, *Galileo as a Critic of the Arts* (The Hague, Nijhoff 1954), p. 14. I discussed this idea with Jean-Claude Lebensztejn, who agreed but could not endorse it in his publication owing to Chastel's objections. André Chastel "La signature emblématique", *Revue de l'art* (1974), vol. 26, p. 31: "Hypothèse qu'il n'a aucune raison d'accepter; propice apparemment à l'hyper-interprétation psychoanalytique." Peter Cornelius Claussen, "Der doppelte Boden", p. 182, questions the widespread notion of Holbein's signature, arguing that the crucifix, death's-head agraffe and skull anamorphosis are all on Dinteville's side and therefore oriented towards him. I reject his argument, which assumes a picture surface with a corrected perspective, on principle. The artist uses a two-dimensional surface; the tension between the second and third dimensions is *de facto* his artistic scope.

134. K. van Mander, *Das Leben*, p. 106.

135. A personification of death is the Grim Reaper, who roams the country with a scythe and axe or on horseback with a bow and arrow, killing as he goes in a triumph of death. In the second half of the 13th century, the legend spread of the encounter between three living and three dead people, in which the dead urge the living to bear death in mind: "What you are we used to be. What we are you shall be." Hedwig Gollob, "Holbein und die Danses Macabres", *Zeitschrift für Kunstgeschichte* (1954), p. 89.

136. St. Augustine, *The City of God* (Book 14:21).

137. On the ambivalence of linguistic as well as graphic pictoriality in Holbein, see Konrad Hoffmann, "Holbeins Todesbilder, Anleitung zum Lesen von Bildern", *Festschrift Donat de Chapeaurouge* (Munich 1990), pp. 97–110.

138. Al. M. Haas, *Todesbilder*, p. 70.

139. *Quae quasi saxum Tantalo semper impendet.* Cicero, *De Finibus* I, C. 18. Gisèle Mathieu-Castellani, *Emblèmes de la mort: le dialogue de l'image et du texte* (Paris 1988), p. 40, compares this stone to a skull, though I cannot agree with this observation.

Hans Holbein the Younger
Plate of *Instrument of Both Lights*
Sebastian Münster, *'Canones super novem instrumentum luminarum'*
A. Cratander, March 1534

140. J. Baltrusaitis, *Anamorphoses*, p. 100, notes the affinity between the composition of *The Ambassadors* and this woodcut.

141. Exhibition catalogue entitled *Die Malerfamilie Holbein in Basel* (Basel 4 June–25 September 1960), pp. 189–90. Werner Überwasser, ZAK, vol. 18, p. 187, and "Holbeins Christus in der Grabnische", *Festschrift für Werner Noack* (1959), p. 125. Heinz Klotz, "Holbeins Leichnam Christi im Grabe", *Öffentliche Kunstsammlung Basel, Jahresberichte 1964–1966*, pp. 111-32. On the reception of the picture, see Victor Stoichita, "Ein Idiot in der Schweiz. Bildbeschreibung bei Dostojevski", *Beschreibungskunst—Kunstbeschreibung. Ekphrasis von der Antike bis zur Gegenwart* (Basel 1995), Gottfried Boehm, Helmut Pfotenhauer (eds), pp. 425–444.

142. O. Bätschmann/P. Griener, Holbein, pp. 88-89. Max Imdahl, "Hans Holbeins Darmstädter Madonna: Andachtsbild und Ereignisbild," *Wie eindeutig ist ein Kunstwerk?* (Cologne 1986), pp. 236–238.

143. Philippe Ariès, *Geschichte des Todes* (Munich/Vienna 1980) (2), p. 216.

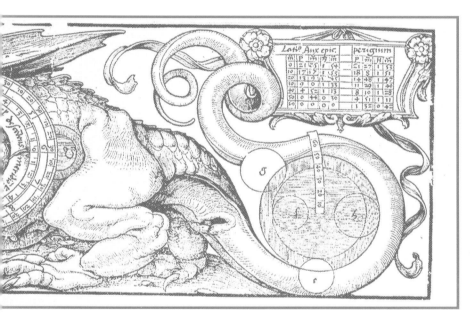

144. Al. M. Haas, *Todesbilder*, p. 61.

145. W. Überwasser, *Holbeins Christus in der Grabnische*, pp. 111–132.

146. Erasmus, *Enchiridion*, pp. 273–277.

147. I Corinthians 12:12 ff.

148. Erasmus, *Enchiridion*, p. 71 (Plato, *Gorgias* 492d–493A). "At present we are dead, our body is our tomb. Who knows whether living is not dying and dying living? … The breast is the tomb, the throat and mouth are the openings of the tomb."

149. F .E. Schneegans, "Das Gedicht Le Mors de la Pomme", *Romania* (1920), 46, pp. 537–570. R. Klinck, *Die lateinische Etymologie des Mittelalters* (Munich 1970), pp. 108 ff.

150. "Die unheile Welt. Zu einer christlichen Etymologie des Mittelalters", Willy Sanders, *Verbum et Signum, Beiträge zur mediävistischen Bedeutungsforschung*, H.Fromm, W.Harms, U. Ruberg (eds), p. 335.

151. For the definition of the picture as an open window (*aperta finestra*), see Alberti, *De Pictura* I (Paris 1992), 19, p. 115, German trans. by J. L. Schefer; and V. Stoichita, *L'instauration du tableau* (Paris 1993), p. 34.

152. J. Baltrusaitis, *Anamorphoses*, p. 97, quotes H. Walpole, *Anecdotes of Painting in England* (London 1762), vol. I, p. 119.

153. Vladimir Juren, "Fecit faciebat", *Revue de l'art* (1974), No. 26, pp. 27–29.

154. Pliny, *Naturalis Historiae* libri XXXVII, lib. I, 26-27, vol. I, 20–21, Latin/German: *Naturkunde*, Book 35, R.König and G. Winkler (eds), (Munich and Darmstadt 1978) quoted in O. Bätschmann/P. Griener, "Holbein-Apelles", p. 638.

155. The oldest source is Pliny, *Naturalis Historiae* XXXV, 81, and L. B. Alberti, *De la Peinture*, III, 61. Desiderius Erasmus, *Adagiorum Proverbiorum Chilias* (Basel 1523), 96. *conveniet in quosdam scriptores, plus satis accuratos, & morosae cuiusdam diligentiae, qui sine fine premunt suas lucubrationes, semper aliquid addentes, adimentes, immutantes, & hoc ipso maxime peccantes, quod nihil peccare conantur.* O. Bätschmann / P. Griener, "Holbein-Apelles", p. 634.

156. As Bätschmann and Griener have demonstrated, this motif goes back to a topos in art theory, viz. that of the legendary contest between the Greek painters Apelles and Protogenes to see who could make the finest line, the linea summae tenuitatis. Oskar Bätschmann and Pascal Griener, "Holbein-Apelles Wettbewerb und Definition des Künstlers", *Zeitschrift für Kunstgeschichte 4* (1994), p. 633.

157. A. Henkel/A. Schöne, *Emblemata, Feder mit der eine Linie gezogen wird*, No. 1295 NULLA DIES SINE LINEA (Abb.), with a quotation from Pliny: "No day goes by without a line being drawn. Practice alone makes perfect" (*Naturalis Historiae* XXXV, 84).

158. A variation on this theme is found in the above-mentioned portraits in which the subjects themselves are holding a pen; the finished nature of the picture is called into question by the suggestion of action on the part of the sitter.

159. On the subject of the hand, Erasmus writes: "in which the good Creator has stamped that law of virtue with his finger, i.e. with his mind." Erasmus, *Enchiridion*, p. 141.

160. Erasmus, *Adagia*, Tantalusqualen II 6,14, p. 527.

161. Erasmus, *Enchiridion*, p. 191. "if, in his thirst, Tantalus teaches you that he who would greedily amass treasures is the poorest man of all."

162. The first owner of this copy was Oswald Molitor of Lucerne, a pupil of Erasmus whom he called Myconius. Erasmus wrote a marginal text about the chimeras in Horace, in Homer's *Iliad* and in Lucrece. Myconius' manuscript (*ut oblectaretur in ea Erasmus habuit*) also attests to Erasmus' delight when he beheld the illustration. *Alois Gerlo, Erasme et ses portraitistes Metsijs Dürer Holbein* (Brussels 1940), p. 40. Erika B. Goodman Michael, *The Drawings by H.H. the Younger for Erasmus' Praise of Folly* (University of Washington 1981), Footnote 3, p. 39, believes Holbein had some knowledge of Latin.

163. Bätschmann/P. Griener, *Holbein*, p. 14.

164. Holbein used two skeletal hands with a stone in the last engraving of the *Simulachres*. Here, it is the rock suspended above Tantalus' head.

165. V. Stoichita, *L'instauration*, p. 174: Van Eyck's convex mirror is a microcosm that unites painted and real space in miniature. Decorated with ten scenes from the Passion, its frame lends it a sacral character, turning it into a *speculum passionis*. It serves van Eyck at once as a kind of visual signature and as the place where the depicted events take on symbolic significance.

166. V. Stoichita, *L'instauration*, p. 220. *"L'auteur masqué" est la modalité d'autothématisation la plus répandue dans l'art du bas Moyen Age et de la Renaissance. Le peintre 'joue le rôle d'un personnage présent dans une historia.*

167. John Shearman, "Only Connect ... Art and the Spectator in the Italian Renaissance," *Bollingen Series* XXXV (Princeton 1992), 37, pp. 26–28. According to Shearman, this self-portrait reflects the kind of self-pity that originated in Petrarch and Boccaccio. In his 36th sonnet, Petrarch writes: *Que' che 'n Tesaglia ebbe le man si pronte.*

168. H. Belting/Ch. Kruse, *Die Erfindung*, p. 28.

169. Giotto's death was the point of departure for this *topos*. Giorgio Vasari, *Les Vies des meilleurs peintres, sculpteurs et architectes* (Paris 1983); Louis Marin, *Des pouvoirs de l'image* (Paris 1993), see the chapter on "Transfiguration–Défiguration". pp. 250ff.

170. V. Stoichita, *L'instauration*, p. 224.

171. *Michel-Ange, "Poèmes choisis"*, présentés et traduits par Pierre Leyris (Paris 1983), Fragment IX. "I live for sin and live in death."

172. A. Gerlo, *Erasme*, p. 54.

Hans Holbein the Younger
*Apollo Kills the Children of Niobe*, 1515–1516
Marginal drawing, Pen
Erasmus of Rotterdam, '*Moriae Encomion – stultitiae laus*', 1515
Public collection, Department of Engravings, Art Museum, Basel

# BIBLIOGRAPHY

M. Ainsworth, "Patterns for physiognomy, Holbein's portraiture reconsidered", *Burlington Magazine*, CXXXII, No. 1044, 1990, pp. 173–86.

C. K. Aked, "The Ambassadors", *Antiquarian Horology*, Winter 1976, pp. 70–77

Ch. Anderssohn, "Hans Holbein d. J., Zeichnungen aus dem Kupferstich-kabinett der öffentlichen Kunstsammlung Basel", *Burlington Magazine*, Bd. 131, 1989, pp. 426

J. Baltrusaitis, *Anamorphoses ou magie artificielle des effets merveilleux*, Paris 1969 (translation of the book of 1959)

F. Bächtiger, *Vanitas-Schicksalsdeutung in der deutschen Renaissancegraphik*, Zürich 1970

O. Bätschmann/ P. Griener, *Hans Holbein*, Cologne 1997

E. Billeter-Schulze, "Zum Einfluss der Graphik von Dürer und Hans Holbein in der französischen Kunst des 16. Jahrhunderts", Diss. Basel 1960; *Basler Zeitschrift für Geschichte und Alterumskunde,* vol. 62, 1962, pp. 39–85, vol. 63, 1963

S. Brigden, *London and the Reformation*, Oxford 1989

S. Buck, *Holbein am Hofe Heinrich des VIII*, Berlin 1997

B. Bushart, *Hans Holbein der Ältere*, Augsburg 1987

M. Butor, *Répertoire III*, Paris 1968
— *Les mots dans la peinture*, Paris 1969

M. V. Cadarso, *La clave de "Los embajadores" de Holbein et Joven*, Madrid 1985

O. Calabrese, "L'intertestualità in pittura. Nove livelli di lettura degli 'Ambasciatori' di Holbein", *La Macchina Della Pittura*, Bari 1985

L. Cambell, *Renaissance Portraits. European Portrait-Painting in the 14th, 15th and 16th Centuries*, New Haven / London 1990

A-B. Chamberlain, *Hans Holbein the Younger*, 2 Bde, London 1913

K. Charlton, "Holbein's 'Ambassadors' and Sixteenth-Century Education," *Journal of the History of Ideas*, 21, 1960, pp. 99–109

U. Christoffel, *Hans Holbein der Jüngere*, Berlin 1950

P. C. Claussen, "Der doppelte Boden unter Holbeins Gesandten," *Hülle und Fülle. Festschrift für Tilmann Buddensieg*, (eds) A. Beyer, V. Magnago Lampugnani, G. Schweikhart, 1993

N. Z. Davis, "Holbein Pictures of Death and the Reformation at Lyons", *Studies on the Renaissance*, vol. VIII, 1956, p. 115

W. F. Dickes, *Holbein's Ambassadors Unriddled*, 1903

M. Dowling, *Humanism in the Age of Henry VIII*, Beckenham 1986

A. Dülberg, *Privatporträts. Geschichte und Ikonologie einer Gattung im 15. und 16. Jahrhundert*, Berlin 1990

P. Fabbri and F. Grand, *Il tappeto in pittura, relazione inedita al convegno. L'oggetto teorico arte*, Centre Internazionale di Semiotica e Linguistica, Urbino 1981

T. Falk, *Katalog der Zeichnungen des 15. und 16. Jahrhunderts im Kupferstichkabinett Basel*, Part 1, "Das 15. Jahrhundert, Hans Holbein der Ältere und Jörg Schweiger, die Basler Goldschmiederisse", Basel/Stuttgart 1979

J. L. Ferrier, *Holbein: les Ambassadeurs, Anatomie d'un chef-d'oeuvre*, Paris 1977

S. Foister, *Holbein and his English Patrons*, Ph. D. Thesis, University of London, Courtauld Institute of Art, 1981
— *Drawings by Holbein from the Royal Library Windsor Castle*, 1983

R. Foster, *Patterns of Thought. The Hidden Meaning of the Great Pavement of Westminster Abbey*, London 1959

E. Foucart-Walter, *Les peintures de Hans Holbein le Jeune au Louvre*, Les dossiers du Département des Peintures, Paris 1985

P. L. Ganz, *Hans Holbein d. J.: Die Gemälde*, London / Cologne 1949

Al. Gerlo, *Erasme et ses portraitistes Metsijs Dürer Holbein*, Brussels 1940

E. B. Gilman, *The Curious Perspective. Literary and Pictorial Wit in the Seventeenth Century*, New Haven / London 1978

H. W. Grohn, *Tout l'oeuvre peint de Holbein le Jeune*, Foreword by Pierre Vaisse, Paris 1972

F. Hallyn, "La mort en abyme", *Gentse Bijdragen tot de Kunstgeschiedenis*, XXV, 1979–80, pp. 1–13
— "Le Sens des Formes. Etudes sur la Renaissance", *Romanica Gandensia* XXIII, Genf 1994

R. Hammerstein, *Tanz und Musik des Todes. Die mittelalterlichen Totentänze und ihr Nachleben*, Bern 1980

W. S. Heckscher, "Reflections on Seeing Holbein's Portrait of Erasmus at Longford Castle", *Essays in the History of Art Presented to Rudolf Wittkower*, London 1967

G. Heise, *Der Kunstbrief: Die Gesandten von Hans Holbein*, Berlin 1946
— "Die Gesandten", *Werkmonographie zur Bildenden Kunst* 43, Stuttgart 1959

M. F. S. Hervey, *Holbein's "Ambassadors". The Picture and the Men. An Historical Study*, London 1900

F. Hieronymus, *Basler Buchillustration 1500–1545*, Ausstellungsbibliothek, Basel 1984

E. His, "Die Baseler Archive über Hans Holbein den Jüngeren, seine Familie und einige zu ihm in Beziehung stehende Zeitgenossen," *Jahrbücher für Kunstwissenschaft* 3, 1870

K. Hoffmann, "Hans Holbein d.J.: Die Gesandten", *Festschrift für Georg Scheja zum 70. Geburtstag*, Sigmaringen 1975, pp. 133–150
— "Holbeins Todesbilder, Anleitung zum Lesen von Bildern", *Festschrift Donat de Chapeaurouge*, Munich 1990, pp. 97–110

T. S. Holman, *Holbein's Portraits of the Steelyard Merchants: An Investigation*, Metropolitan Museum, New York 1979, vol. 14, pp. 139–158

E. W. Ives, "The Queen and the painters Anne Boleyn, Holbein and Tudor Royal Portraits," *Apollo*, July 1994, pp. 36–45

M. Jenny, "Ein frühes Zeugnis für die kirchenverbindende Bedeutung des evangelischen Kirchenliedes," *Jahrbuch für Liturgik und Hymnologie* 8, 1963, pp. 123–128

M. Kästner, *Die Icones Hans Holbein des Jüngeren*, Phil. Diss. 1985

R. J. Kalas, "The Selve Family of Limousin: Members of a New Elite in Early Modern France", *Sixteenth-Century Journal* XVIII, 1987, pp. 147–172

H. Keller, "Entstehung und Blütezeit des Freundschaftsbildes", *Essays in the History of Art Presented to Rudolf Wittkower*, D. Frevert and H. Hibbard (eds), London 1967, pp. 161–173

J. N. King, *Tudor Royal Iconography*, Princeton, 1989

J. Kristeva, *Soleil noir. Dépression et mélancholie*, Paris 1987, pp. 117–150

H. Krummacher, "Zu Holbeins Bildnissen Rheinischer Stahlhofkaufleute", *Wallraf-Richartz-Jahrbuch*, 1963

Kl. Langheit, *Das Freundschaftsbild der Romantik*, Heidelberg 1952

F. Leemann, *Anamorphosen. Ein Spiel mit der Wahrnehmung, dem Schein und der Wirklichkeit*, Cologne 1975

A. Leroy, Hans Holbein et son temps, Paris 1943

M. Levey, *The German School. National Gallery Catalogues*, London 1957

M. Maloney, (ed) *Hans Holbein der Jüngere. Images of the Old Testament*, Bern, Frankfurt a. M. / Toronto 1973

E. Michael, *The Drawings by Hans Holbein the Younger for Erasmus "Praise of Folly"*, Phil. Diss. Seattle University of Washington 1981

S. Michalski, "Die zerrissene Saite. Zur Symbolik von Streichinstrumenten", *Kunst und Antiquitäten* 5, 1992, p. 26

C. Müller, *Hans Holbein d. J. Zeichnungen aus dem Kupferstichkabinett der Öffentlichen Kunstsammlung Basel*, Basel Kunstmuseum 1988

J. Paris, "Stratégies du visuel—à propos du tableau Les Ambassadeurs," *Coloquio* 32, Lisbon 1977, pp. 34–47

F. Petersmann, *Kirchen- und Sozialkritik in den Bildern des Todes von Hans Holbein dem Jüngeren*, Diss. Osnabrück 1983

D. Piper, "Holbein's Ambassadors", *The Listener*, 12 January 1961, pp. 68–70

J. Pope-Hennessy, *The Portrait in the Renaissance,* London 1966, pp. 250–252

H. Reinhardt, *Toten-Tanz Basel als ein Spiegel menschlicher Beschaffenheit. Nach dem Original von Matthaus Merian*, Heusenstamm, Greno 1975
— "Hans Holbein, Civis Basileensis", *Apollo* December 1976, pp. 461–466;
— "Die holbeinische Madonna des Basler Stadtschreibers Johann Gerster von 1520 im Museum zu Solothurn", *Basler Zeitschrift für Geschichte und Altertumskunde* 81, 1981, pp. 41–70
— "Nachrichten über das Leben Hans Holbeins des Jüngeren", *Zeitschrift für Schweizerische Archäologie und Kunstgeschichte* 39, 1982, p.259

J. Roberts, *Holbein*, London 1975
— Exhibition catalogue, *Drawings by Holbein from the Court of Henry VIII. Fifty Drawings from the Collection of Her Majesty Queen Elizabeth II, Windsor Castle*, The Museum of Fine Arts, Houston 1987

G. Rodis-Lewis, "Anamorphoses: Machinerie et Perspectives curieuses dans leur rapport avec le cartésianisme", *Bulletin de la Société d'Etudes du XVIIè siècle*, 1959

B. Romerat, *La Danza macabra de Holbein*, Madrid, Erison 1986

M. Roskill and C. Harbison, "On the Nature of Holbein's Portraits," *Word and Image* 3, 1987

J. Rowlands, *Holbein. The Paintings of Hans Holbein the Younger*, Boston 1985
— *The Age of Dürer and Holbein: Germain Drawings 1400–1500*, Exhibition catalogue, British Museum, Cambridge 1988

R. Salvini, "Congetture su Holbein in Lombardia", *Mélanges Fra Rinascimento, Manierismo e Realta: scritti di storia dell' arte*, Florence 1984

E. R. Samuel, "Death in the Glass: A new View of Holbein's Ambassadors", *Burlington Magazine* 105, 1963, pp. 436–441

H. A. Schmid, *Hans Holbein der Jüngere. Sein Aufstieg zur Meisterschaft und sein Englischer Stil*, 3 Bde, Basel 1945, 1948.
— *Hans Holbein der Jüngere, Sein Aufstieg zur Meisterschaft und sine englischer Stil*, Basel 1945–1948

J. A. Schmoll, "Zum Todesbewußtsein in Holbeins Bildnissen", *Annales Universitatis Saraviensis*, 1952

P.-K. Schuster, *Dürers Denkbild*, Berlin 1991

A. Smith, *The Ambassadors by Holbein*, London, The National Gallery 1974

D. Starkey, *Henry VIII: a European Court in England's European Court* 1991

V. Stoichita, "Ein Idiot in der Schweiz. Bildbeschreibung bei Dostojevski", *Beschreibungskunst: Kunstbeschreibung, Ekphrasis von der Antike bis zur Gegenwart*, G. Boehm, H. Pfotenhauer (eds), Basel, 1995

R. Strong, *Holbein and Henry VIII*, London, 1966
— Holbein, *The Complete Paintings*, Grenade, London/Toronto/Sydney/New York 1980

M. Victoria, "La clave de 'Los Embajadores' de Holbein el Joven", *Goya*, 1985, pp. 187–188

B. Walbe, *Studien zur Entwicklung des allegorischen Porträts in Frankreich von seinen Anfängen bis zur Regierungszeit König Heinrich II.* Diss., Frankfurt a. M. 1974

W. Waetzoldt, *Hans Holbein d. J. Werk und Welt*, Berlin 1938

M. Wilson, "More and Holbein and the Imagination of Death", *16th Century Journal*, USA 1976, 7(2), pp. 51–58

A. Woltmann, "Holbein und seine Zeit. Des Künstlers Familie", *Leben und Schaffen*, Leipzig 1876

Exhibition catalogue: *Von der Freiheit eines Christenmenschen*, Berlin Charlottenburg 1967

Exhibition catalogue: *Sir Thomas More 1477/78–1535 The King's Good Servant*, National Portrait Gallery, London 1977–1978

Exhibition catalogue: *Artists of the Tudor Court, The portrait miniature rediscovered 1520–1620*, Roy Strong and V. J. Murrel, The Victoria and Albert Museum, London 1983

Exhibition catalogue: *Erasmus von Rotterdam. Vorkämpfer für Frieden und Toleranz*, Historisches Museum Basel, 26 April to 7 September 1986

Exhibition catalogue: *Zauber der Medusa, Europäische Manierismen*, Vienna 1987

Exhibition catalogue: *Sphaera Mundi. Astronomy Books 1478–1600*, Whipple Museum of the History of Science, Cambridge 1994

Exhibition catalogue: *Hans Holbein d. J. Die Druckgraphik im Kupferstich-kabinett*, Kunstmuseum, Basel 1997

Exhibition catalogue: *Dürer, Holbein, Grünewald, Meisterzeichnungen der dt. Renaissanceaus Berlin und Basel*, Kunstmuseum, Basel 1997

Exhibition catalogue: *Making and Meaning Holbein's Ambassadors von Susan Foister, Ashok Roy and Martin Wyld*, National Gallery, London, 5 November 1997 to 1 February 1998

Hans Holbein the Younger
*Clock with Sandglass*
Pen, 41,1 x 21,3 cm
British Museum, London